COMPENDIUM OF THE OCCULT

First published in the United Kingdom in 2025 by
Thames & Hudson Ltd, 181A High Holborn,
London WC1V 7QX

First published in 2025 in the United States of America by
Thames & Hudson Inc., 500 Fifth Avenue, New York, New York 10110

© 2025 Quarto Publishing plc

All Rights Reserved. No part of this publication may be reproduced or transmitted in any form or by any means, electronic or mechanical, including photocopy, recording or any other information storage and retrieval system, without prior permission in writing from the publisher.

Conceived, designed and produced by
The Bright Press, an imprint of the Quarto Group
1 Triptych Place, London SE1 9SH
United Kingdom
T (0)20 7700 6700
www.Quarto.com

Publisher: James Evans
Editorial Director: Anna Southgate
Art Director: Emily Nazer
Managing Editor: Jacqui Sayers
Senior Editor: Dee Costello
Project Editor: Lindsay Kaubi
Design: JC Lanaway
Concept Design: Dana Coleman
Interior Illustrations: Rachel Anna Davies
Cover Illustrations: Robert Brandt
Picture Research: Jane Lanaway and Susannah Jayes

Library of Congress Control Number 2024934762

ISBN: 978-0-500-02814-8

Printed and bound in China

Be the first to know about our new releases, exclusive content and author events by visiting
thamesandhudson.com
thamesandhudsonusa.com
thamesandhudson.com.au

COMPENDIUM OF THE OCCULT

Arcane Artifacts, Magic Rituals, and Sacred Symbolism

LIZ WILLIAMS

CONTENTS

Introduction 6
About This Book 12

Part One
ORIGINS OF WESTERN OCCULTISM 14

Mesopotamian Occultism 16
Egyptian Magic 22
Ancient Greek Magic 28
The Greek Magical Papyri 34
Hermetic Magic 36
Magic in the Roman Empire 42
Celtic Magic 48
Anglo-Saxon Occultism 54
Norse Occultism 60
Kabbalism 66
Alchemy 72
Early Modern and Medieval Magic and Witchcraft 80

Part Two
DIVINATION 88

Egyptian Astrology 90
Greek Astrology 94
Palmistry 96
Runes 98
Renaissance Astrology 100
Tarot 106
Ouija Boards 112
Dowsing 114
Pendulums 116
Scrying 118

Part Three
RITUALS AND RITES 120

Egyptian Rituals 122
Greek Rituals 128
Roman Rituals 136
Saxon Rituals 138
Renaissance Rituals 140
The Black Mass 142
Thelema 144
Rituals of the Golden Dawn 146
Voodoo 150
Satanism 152
Wiccan Rituals 154

Part Four
CHARMS AND TALISMANS 158

The Origins of Charms, Amulets and Talismans 160
The Theory of Correspondences 164
Egyptian Amulets and Charms 170
Greek Amulets 172
Roman Amulets 174
Saxon Snake Stones 176
Grimoires 178
Elizabethan Amulets 184

Part Five
CURSES AND HEXES 188

Egyptian Curses	190
Curses of Babylon and Assyria	192
Greek Curses	194
Roman Curses	196
Saxon and Viking Curses	198
Witch Bottles	200
Demonology	202
Voodoo Dolls	208

Part Six
SECRET SOCIETIES 210

The Knights Templar	212
The Rosicrucians	214
The Freemasons	216
The Hellfire Club	218
The Hermetic Order of the Golden Dawn	220
The Theosophical Society	224
Ordo Templi Orientis	226
Early Wicca	228

Part Seven
SITES OF SIGNIFICANCE 230

Avebury	232
Stonehenge	234
The Pyramids of Giza	236
Glastonbury	240
The Serpent Mound	242
The Brocken	244
Salem	246
New Orleans	248

Glossary	250
Index	252
Picture Credits	256

INTRODUCTION

What does 'occult' mean?

The word 'occult' comes from the Latin *occultus*, which means 'secret' or 'hidden'. It is used to refer to phenomena that lie outside science as we currently understand it, such as magic or the supernatural. In 16th-century Europe, the word was used quite widely to describe astrology, alchemy, natural magic and grimoire magic, but in the 19th century, by which time the principles of the Enlightenment had replaced much magical practice with science, the term 'occultism' began to be used more narrowly to refer specifically to the activities of esoteric groups and individual magical practitioners. The label 'occultist' has been applied to those who seek to alter reality by supernatural means, such as casting spells or summoning spirits to do their bidding, and often with sinister connotations, such as the practising of black magic and Devil worship. Today, the occult is a wide and diverse field, although in the West, many esoteric groups have held that there is a secret philosophy that is the basis of all occult practices.

Now, the word 'occult' is commonly used as an umbrella term to encompass a broad range of esoteric organizations and pursuits, such as Hermeticism, Rosicrucianism, Theosophy, Wicca and witchcraft, the work of the 19th-century Hermetic Order of the Golden Dawn, elements of modern revivalist Druidry and Freemasonry, and Satanism. It also covers the work of writers such as Éliphas Lévi, Aleister Crowley, William Gray, Colin Wilson and Dion Fortune, who were members of some of these organizations at various times, but who also wrote independently on the subject of the occult, in works of both fiction and non-fiction. The beliefs these groups and individuals hold derive from the ancient world, based on principles from Greek philosophy, Egyptian religion, and the beliefs and magical practices of the Celts, Anglo-Saxons and Vikings, among others. We will be exploring these ideas and their influence throughout the course of this book.

Illustration by William Law in The Works of Jacob Behmen *(the Rosicrucian Jacob Boehme),* The Teutonic Theosopher, *depicting the creation of Adam, vol. 1, 1764.*

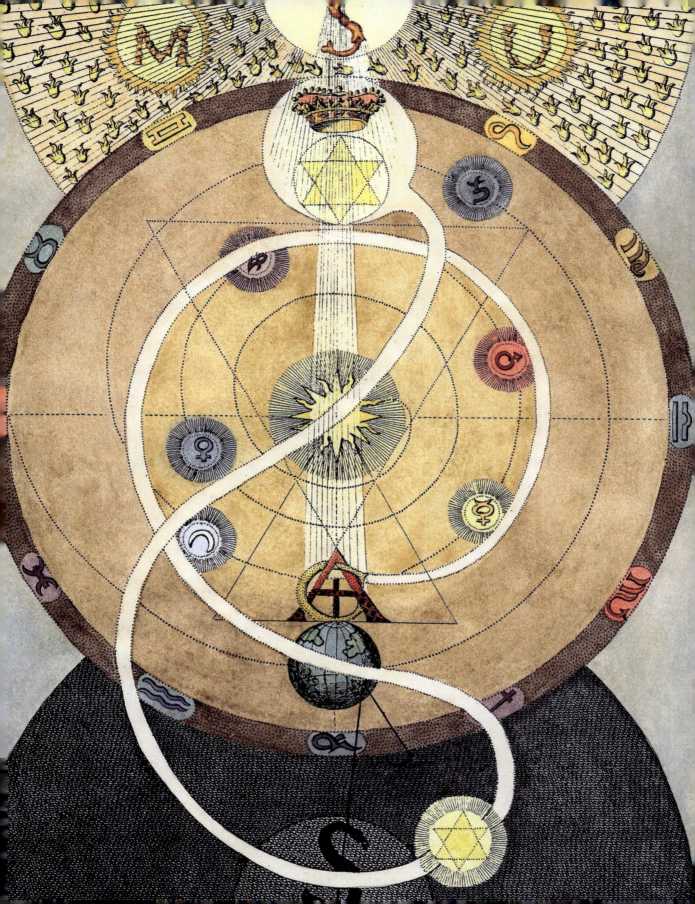

INTRODUCTION

Are magic and the occult the same thing?

Magic and the occult are closely aligned. Magic can be defined as the attempt to make the world around you conform to your will, through methods not currently explained by science. Magic relies upon occult (secret or unknown) forces; but not all occultists practise magic (though most do, in some form). Some see the occult as essentially spiritual rather than magical, aimed at achieving the perfection of the self, and thus rely on practices such as meditation and visualization. Others undertake practices commonly understood as belonging to the realm of magic: casting spells, performing rituals and summoning spirits in order to change reality.

In what is often classed as 'low magic', magicians strive to bring about their personal desires (or those of paying clients), accruing for themselves, for instance, money, love or power. In 'high magic', by contrast, the aim is to change the self, to become the best person that one can be, with the aim of attaining spiritual perfection. These goals are very different, but magicians may on occasion practise both forms of magic. Magic is still practised in many places throughout the world today. In the West, it mainly takes the form of divination (such as astrology or the Tarot), since the solutions that magical practitioners offered in the past to problems such as health or retribution for a crime can now be attained through more conventional, socially integrated means, such as a national health service or the assistance of a police force.

Anthropologists debate whether or not religion and the occult constitute separate types of belief. They question how closely related 'magic' and 'religion' are to each other. One response is that religion is more passive than magic: it relies on prayer and worship rather than on an active attempt to change reality via, for example, a ritual or a spell. Some theologians would argue, on the contrary, that petitioning Catholic saints for a particular outcome, for instance, comes close to performing magic. The answer to the question of the relationship between magic and religion can be answered differently in different societies: in ancient Egypt, magic and religion were closely intertwined; in classical Greece, there was a greater separation between the two; and in medieval Britain, the two were forcefully separated by the Church, which made strenuous efforts to stamp out those forms of magic that were held to cause harm to others. This led to extreme measures, such as the Witch Trials.

Architectural relief of a theatrical mask depicting the god Pan, Archaeological Museum of Córdoba, Spain, 1st century CE.

Where did occult practice in the West begin?

People have been practising magic since ancient times. Some believe that the prehistoric paintings of animals on cave walls are examples of 'sympathetic' magic (the power to create an effect on an object or being by manipulating an image of that object or being), created in order to bring good luck in hunting, or as personal or tribal totems. As more complex societies developed, magic developed with them. Astrologers studied the movement of the stars to predict the future, and magicians devised charms and spells to protect against ghosts and demons, or heal those who had fallen prey to them. Cuneiform records from Mesopotamia are perhaps our earliest evidence for the form that such spells and medicines took. They describe magical practitioners with particular specialisms, such as *ašipu* (exorcists), *asu* (physicians) and *bārû* (diviners). Handbooks such as the Akkadian *maqlû* texts, a series of clay tablets inscribed with measures that can be taken to protect the user against black magic, tell us much about these early forms of magical practice. Babylonian magic was influential, later affecting both Greek and Egyptian beliefs, particularly in astrology.

In pharaonic Egypt (defined here as falling between *c.* 3100 BCE, when the 1st Dynasty was established, and 332 BCE, when Alexander the Great conquered the country), magic was an integral part of mainstream culture and religion. The animal-headed forms of the Egyptian deities are still familiar to us today. Over time, many Egyptian deities were merged with one another, absorbing each other's aspects and qualities, as well as those of deities from other pantheons – for instance, the Greek gods. Thus, we find deities such as Hermes Trismegistus, a combination of the Egyptian god Thoth and the Greek god Hermes. This process is known as syncretism.

Magic, represented by the ancient god Heka (a force that underlies the world itself), was a part of every aspect of Egyptian life, and in the classical world, Egypt was regarded as the home of magic. We have extensive records of Egyptian spells: remedies, curses, incantations and prayers. Magic was viewed as a form of self-defence, given to humans by the gods to help them cope with the misfortunes of everyday life, and the use of apotropaic (protective) charms and amulets was widespread. A woman who was experiencing difficulties in conceiving a child might carry an amulet depicting either the god Bes or goddess Taweret, who specialized in fertility and birth. Disease was seen as having supernatural origins, thus doctors such as *swnw* (general

Egyptian Bes-image protective amulet, often used to protect mothers and children during childbirth, c. 1090–900 BCE.

INTRODUCTION

practitioners) or *heka* (magical practitioners) worked charms to heal their patients. Modern occultists still refer to the Greek Magical Papyri, a series of magical instructions from Greco-Roman Egypt written in Greek; these contain a wealth of spells, hymns, recipes and rituals, dating from 100 BCE to 400 CE.

The Greeks also practised magic, and alchemy and astrology were widespread. The Greek word μάγος (*magos*) referred to a Persian Zoroastrian priest, and has made its way into English as the root of 'magic'/'magician'. In Greek society, however, magic was generally regarded as less respectable than it was in Egypt; magicians were often seen as charlatans (*magos* also means 'trickster'), and magic was less socially integrated. Magical practice was sometimes restricted by the authorities, and held a more ambivalent role than it did in Egypt. Nevertheless, ordinary people relied upon magic, wearing amulets to protect themselves against the ill will of others, or indeed inscribing lead tablets with the name of an enemy and a written curse. Figurines pierced with nails and bound with lead, indicating a binding spell or a curse, seem to have originated in Egypt before being adopted by the Greeks. Magic appears in many areas in Greek society: in the Athenian courts, as part of the initial oath, litigants were asked to 'self-curse' so that they or their families would suffer if they lied.

Magic was also prevalent in Roman society. The Greek term *magoi* (plural of *magos*) was adopted into Latin and used by the Romans to describe witches, diviners, druids and necromancers. As with the Greeks, it had negative connotations, being contrasted with devout religious ritual and the laws of nature. Spells and enchantments are more common in the literature than curses, but as with the Greeks, there was a class element to this: poorer people were more likely to use magic such as curse tablets, because they had fewer resources when it came to power. Recipes for poisons also fall under the magical umbrella in both Greek and Roman society. In general, in the classical world and beyond, magic practised by women and the lower classes was frowned upon, whereas that practised by male elites was sanctioned. We thus see that whoever controls the definition of magic also controls its practice and its lawfulness.

In Northern Europe, the Celts, Saxons and Vikings disseminated their own beliefs. Each culture had its own pantheon of deities and different forms of magic, although we know more about the magic of the Saxons and Vikings than about the practices of the Celts.

Curse tablet made of lead from Edward Dodwell's A Classical and Topographical Tour through Greece, during the Years 1801, 1805, and 1806, *vol. II, London, Rodwell and Martin, 1819.*

Some of this early practice has, in the West, found its way into later texts and beliefs. From the Renaissance onwards, magicians harked back to classical texts. Pharaonic Egypt and the classical world form the platform from which later occult practices in the West have sprung.

What is the Western Mystery Tradition?

Over the last few hundred years, a wide range of occult practices have coalesced among Western magical practitioners, both individually and as members of organizations such as the Hermetic Order of the Golden Dawn. This tradition, which is broad and somewhat loosely defined, is also known as Western Esotericism. Its roots are varied, and go back as far as the classical and early Christian world of the Mediterranean. Elements of Neoplatonism, Hermeticism, Gnosticism and the work of the Greek philosopher Pythagoras were adopted by philosophers and magical practitioners during the Enlightenment. These merged with elements from religions such as Christianity and, in the case of Kabbalah, from Judaism. Practices such as astrology and alchemy also fall under the aegis of the Western Mystery Tradition.

In the 17th century, initiatory societies began to develop, such as Rosicrucianism and Freemasonry, and these have had a substantial influence on the course of contemporary esotericism. So have later organizations, such as the Theosophical Society and the Golden Dawn, in combination with practices such as spiritualism and, in the mid-20th century, Wicca and other varieties of Paganism, such as contemporary Druidry. Aleister Crowley, formerly a member of the Golden Dawn, wrote extensively on ritual magical practices and developed his own magical order, the Ordo Templi Orientis, which was based not only on ancient Egyptian beliefs but also on Freemasonry: candidates must, in both organizations, enter by initiation and progress via a series of elaborate degree ceremonies. Also in the 20th century, Violet Firth, writing under the pseudonym Dion Fortune, published a series of texts on magical self-defence, visualization and initiation. Revivalist movements such as Heathenism, which follows Norse religion and magic, also come under the remit of the Western Mystery Tradition.

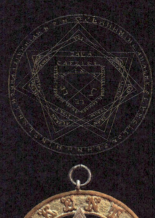

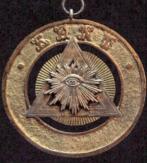

TOP *The Key of Solomon (Clavicula Salomonis), early 18th century.*

ABOVE *Freemasonry's Eye of Providence, Kent Museum of Freemasonry, Canterbury.*

About This Book

This compendium begins with a chronological exploration of Western occultism, starting in Mesopotamia, the land between the Tigris and the Euphrates and defined in relation to the ancient world as the empires of Sumer, Assyria, Akkadia and Babylon. From here, we move to ancient Egypt, and thence to classical Greece and Rome. These Mediterranean and Middle Eastern cultures significantly influenced each other's magical beliefs and practice, as well as their religions, and we will be referencing some of the ways in which they did so.

We will then progress to Celtic, Anglo-Saxon and Norse magical practice. The compendium will consider alchemy and some of the other occult belief systems and practices of medieval Europe, such as astrology and Hermeticism, two of the primary engines of modern occultism. Following this, the book is divided into sections relating to divination, rituals and rites, charms and talismans, curses, secret societies and sacred sites. In these sections we will look at grimoires, the books of spells and spirit summoning that form one of the cornerstones of historical occult practice; we will explore esoteric groups such as the Knights Templar (12th century), the Hellfire Club (18th century) and the Hermetic Order of the Golden Dawn (19th century); and we will visit sites such as Stonehenge, now a seat of Druidry, and Salem, Massachusetts, one of the homes of modern Wicca.

In these sections, you will find examples of each practice or group from a variety of geographical locations and will be able to undertake cross-referencing between sections. The book is intended to give you an overview of occult practice, both historical and contemporary, and form a springboard from which you can undertake more in-depth research.

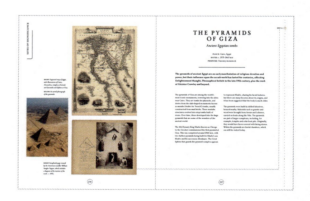

Gallery The compendium contains photographs and illustrations that offer a visual reference to some of the customs and beliefs that we explore. The images are both instructive and compelling and include portraits of prominent figures in the occult, artworks and galleries of artefacts, symbols, emblems and books.

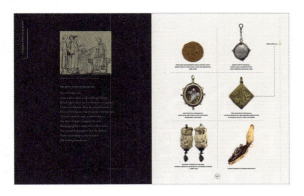

Artefacts There are images of fascinating and relevant artefacts throughout the compendium, including amulets from ancient Egypt and Greece, voodoo dolls, curse tablets and relics of witchcraft.

Quotes Ritual texts, passages from historical edicts, ancient curses, poems and quotes give contemporary context to the times, places, people and practices that are being discussed.

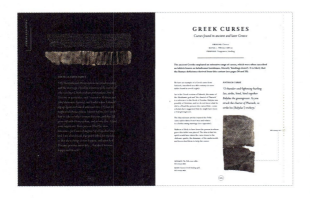

Timeline Each article is accompanied by a timeline, providing a guide to the dating of the events described in the text. The full timescale shown is 5000 BCE to 2000 CE (present day). The year 0 is indicated with a darker dot on the timeline, and this also indicates when the timescale changes. The BCE dots are 250 years apart and those in the CE are 50 years apart. The gold dots highlight the timeframe for the article.

The circle icon connects directly to an artefact or image that illustrates the events being discussed.

LEADERLINE
Connects the date to the image.

CIRCLE
Highlights a specific date connected to an image.

Present Day

CE/BCE

1000 BCE

5000 BCE

PART ONE
ORIGINS OF WESTERN OCCULTISM

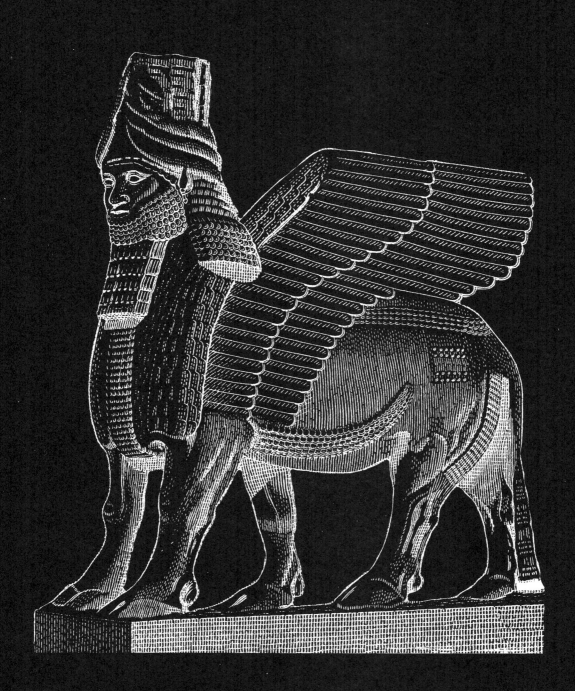

MESOPOTAMIAN OCCULTISM

Magical beliefs in the region of ancient Mesopotamia

ORIGINS: Mesopotamia
DATES: 5000 BCE–*c.* 331–332 BCE
PURPOSE: Divination, ritual, cursing, healing, petitioning the gods

While magic is probably as old as humanity itself, Western magic arguably began in the Fertile Crescent, where people first began to farm their food and settle down together, and in particular the region of Mesopotamia, home to the nations of the Sumerians, Assyrians, Akkadians and Babylonians.

As with most forms of early magic, it had its roots in the natural world and attempts to explain natural phenomena, such as storms and earthquakes, as well as the powerful forces of human emotion, such as love and anger. Magic was part of everyday Mesopotamian life, and would have occupied the roles now adopted by other disciplines such as science and medicine. Magicians and priests interpreted natural phenomena, using it to divine the future, and conducted rituals to appease and propitiate the gods and avert the influence of evil spirits.

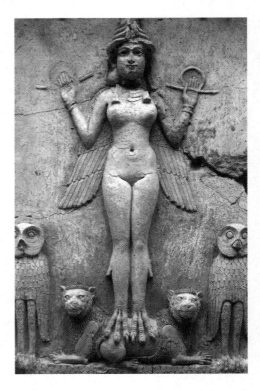

The Queen of the Night (also known as the Burney Relief), Mesopotamian terracotta relief dating from the reign of Hammurabi (1792–1750 BCE).

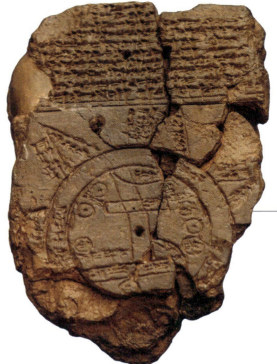

ABOVE *The Babylonian Map of the World, a clay tablet dating from c. 6th century BCE depicts the world known to those in ancient Mesopotamia within a disc, which is surrounded by an outer circle with eight islands or regions. The area between these two circles represents the sea. The text above the map discusses Marduk. This map provides information about the magical worldview of the time, in reference to deities and supernatural beings. The eight regions may also refer to the underworld.*

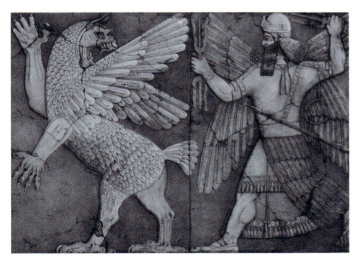

ABOVE *Mesopotamian god battles a monster – may represent Tiamat and Marduk. Engraving of a bas-relief found in a temple at Nineveh, c. 612 BCE.*

CUNEIFORM TABLET INCANTATIONS

OBVERSE REVERSE

INCANTATION TO GULA AND MARDUK TO
CURE A GHOST ATTACK

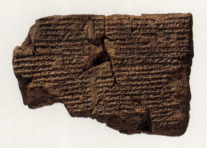

PREVENTION FOR DEMONIC AND GHOSTLY ATTACK
IN THE FORM OF A SCAPEGOAT SACRIFICE

LIST OF MAGICAL STONES USED FOR VARIOUS
PROPHYLACTIC OR MEDICAL PURPOSES

The occult in Sumeria (c. 5000–3000 BCE)

Sumer was the earliest of the civilizations to develop in the Fertile Crescent. We know about early Sumerian magic because the later Assyrian kings took an interest in it and encouraged the keeping of records about it: we therefore have handbooks on magic, written in cuneiform, which describe in detail the practices of early Mesopotamia. These could be found, for instance, in Nineveh's Library of Ashurbanipal, founded in the 7th century BCE by the king of the same name. One of the greatest libraries of the ancient world, it once contained around 30,000 texts pertaining to a variety of occult subjects, passed down through generations of practitioners from the Old Babylonian period onwards. Many of these texts, inscribed on clay tablets, still remain, baked hard so that they have endured through the centuries, and thus we have a fairly comprehensive record of Assyrian and Sumerian society, including its magic, though untold numbers of texts written on perishable papyrus or wooden boards must sadly have been lost.

Sumeria was a theocracy. City-states were governed by priests known as *en/ensi* (which also means 'lord') and priestesses termed *nin*, who lived in temple complexes and carried out the tasks of the state as well as mediating affairs between humans, deities and the supernatural world. There is also mention of magicians, named *uzu*, who were diviners and seers. Practitioners known as *ašipu* (exorcists) or *mašmaššu* in Sumerian and Akkadian (2350–2150 BCE) respectively held an important role, not only as ritualists in charge of magical tasks such as exorcizing demons, but also as royal advisers and physicians. It was their job to predict unfavourable outcomes by interpretating omens, and to try to change the course of events through rituals. They would also diagnose diseases and prescribe medicines. *Baru*, or diviners, had the job of interpreting natural phenomena: they would seek the meaning of celestial events, such

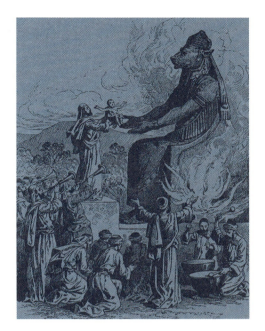

as solar or lunar eclipses, but would also carry out forms of divination such as examining the liver of a sacrificed animal. We have records of the plants and herbs used by physicians. Dreams were interpreted to assess their significance: the hero Gilgamesh is described as having this ability.

The Sumerian pantheon and mythology influenced those of later civilizations in the region. The names of Canaanite gods and demons even appear in much later European occultism, being mentioned in several grimoires, probably via biblical references: Beelzebub, Astarte (the goddess Ishtar), Moloch and Baal all feature as the names of demons.

1000 BCE

ABOVE *A child offered to Moloch: illustration from Charles Foster's* Bible Pictures and What They Teach Us, *1897.*

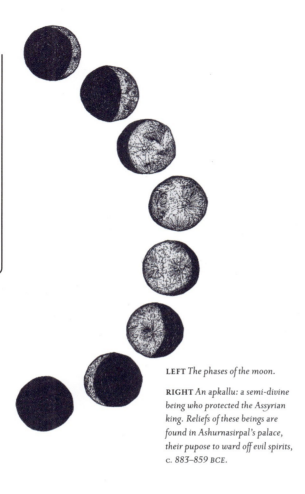

LEFT *The phases of the moon.*

RIGHT *An apkallu: a semi-divine being who protected the Assyrian king. Reliefs of these beings are found in Ashurnasirpal's palace, their pupose to ward off evil spirits, c. 883–859 BCE.*

Divination and daily practice

Astrology was important to the Mesopotamians, and so was celestial divination: the stars were regarded as 'heavenly writing' and were studied in order to foretell the future. There is some evidence that astrology was practised in Sumer, but it was during the Babylonian period that it began to gain ascendency as a science. By the 4th century BCE, mathematics had advanced sufficiently for the Babylonians to be able to predict celestial events and evaluate the movement of the stars and planets. Since the gods were associated with the planets (Marduk, patron deity of Babylon, equates to Jupiter, for example), a perceived negative event (such as an eclipse) was seen as a manifestation of divine displeasure, and the deity would be placated accordingly. The gods could also show the future to petitioners directly, through the practice of impetration, a form of entreaty through prayer in which the deity could be invoked to inhabit and communicate via a medium such as smoke or oil placed in water.

In the Akkadian *maqlû* ritual, which has as part of its aim the punishment of evil magical practitioners, the remains of a burned poppet (human-shaped doll used for magic) would be doused with cold water, then the sodden ashes tossed outside the gates of a house in order to

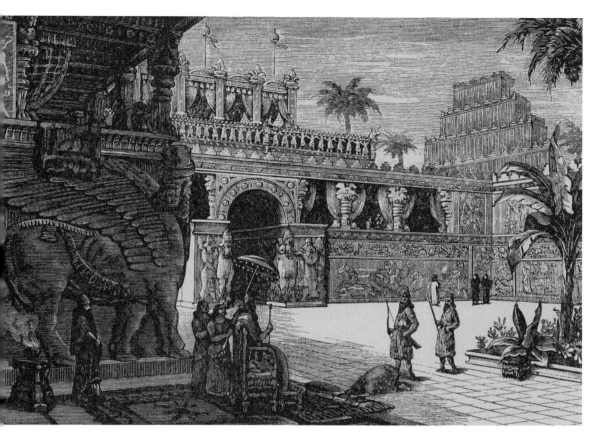

Illustration of lamassu, a celestial being and guardian spirit, from Cassell's Universal History, *1888.*

return the piece of black magic to its maker. The word *maqlû* itself means 'burning'. Later, in Assyrian times, poppets made out of clay or wax were placed around the entrances of houses or buried as a method of protection. Clay figurines might be painted with coloured gypsum and placed in doorways and windows for the same purpose. Still others were made of wax or tallow, which could be easily burned on hot coals. Some magical figurines might have been made of suet or dough and fed to the packs of dogs that roamed the streets of ancient Babylonian cities.

Magical objects abounded throughout the Assyrian empire, ranging from personal talismans to enormous statues like the *lamassu*, the man-headed winged bulls that appear in palaces and temples and were revered as guardians. Images of eagle-headed, powerfully built men were associated with cleansing rituals and also appear throughout Assyrian monumental architecture. In more ordinary homes, little clay figures of gods and animals could be found buried beneath places of spiritual danger, such as corners, to protect the house and its inhabitants.

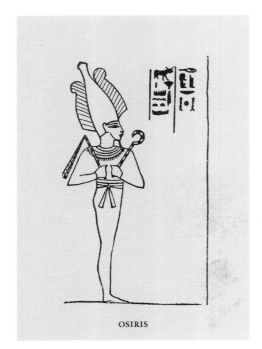
OSIRIS

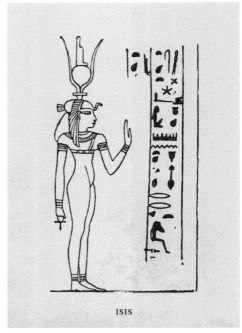
ISIS

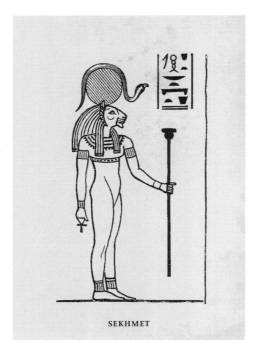
SEKHMET

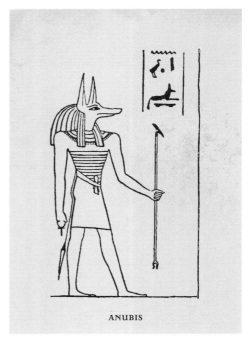
ANUBIS

Illustrations of some of the most prominent ancient Egyptian deities.

EGYPTIAN MAGIC

Supernatural beliefs in ancient Egypt

ORIGINS: Egypt
DATES: *c.* 3100–332 BCE
PURPOSE: Funerary rites, healing, cursing, ritual

Magic dominated the pharaonic world, permeating every aspect of Egyptian life and society. It was closely connected to Egyptian religion, which inevitably changed over time, but contained a core pantheon throughout its long history.

The Egyptian gods and goddesses are still familiar to us: both in humanoid forms, such as winged Isis and mummified Osiris, and also animal-headed, such as their son, hawk-headed Horus; the lioness-headed Sekhmet, goddess of wrath; and jackal-headed Anubis, closely associated with the passage to the afterlife. There is also a god who is the personification of magic itself, named Heka ('magic'): he is depicted as a man carrying a staff around which is wrapped two snakes, and he is said to date from the beginning of time, 'before duality'. His representation may have been influenced by the Sumerian god of healing, Ninazu, and the serpent-twined staff also appears in Greece, associated with the god of healing, Asclepius. Unlike other deities, Heka had very few temples and no cult following; he is thus almost invisible in the archaeological record except for his pervasive presence in magical texts, where he appears in the very earliest period of Egyptian history, the Predynastic (*c.* 6000–*c.* 3150 BCE).

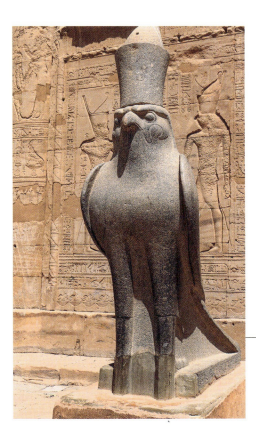

246–222 BCE

Statue of Horus, the god of kingship, healing, protection and the heavens. Edfu Temple, Edfu Town, Egypt, 246–222 BCE.

Funerary magic

Some of these deities oversee a complex afterlife. One of the most famous Egyptian books of magic, the *Book of Coming Forth by Day* (also known as the *Book of the Dead*), features spells to aid the soul's passage to the afterlife – the pivot around which Egyptian culture turned. Heka himself is said to guide souls to the netherworld, the Duat, to which the sun, in the form of the god Ra, travels each night, re-emerging every morning after battling the serpent Apep. It is the realm of the gods and it is the destination of the human soul. Like this world, it contains rivers and mountains, but also fiery lakes and monsters; it is a dangerous realm, to be navigated with arcane knowledge.

In the earliest periods of pharaonic history, life after death was the prerogative of the elite – kings and the courtiers who served them – but during the Middle Kingdom (2040–1782 BCE), the concept of the Duat opened up to include everyone. At this point, it incorporated the concept of punishment. If a soul has led a good life according to the principles set out by the goddess of justice, Ma'at, the forty-two judges of the afterlife will allow that soul entry into the eternal Field of Reeds, Aaru. If the soul has led a bad life, however, it will be dispatched to the Lake of Fire, then snatched by Ammit, the 'devourer of the dead', to undergo a hideous punishment before it is snuffed out of existence. Both the *Coffin Texts* (a collection of Middle Kingdom funerary spells inscribed on coffins and sarcophagi) and the *Book of the Dead* mention this lake. They also offer advice or incantations to protect the soul against falling prey to the many dangers lurking within the Duat. The Egyptians believed that the human soul would split into several parts upon death, such as the *ba* (a bird with a human head), the *ka* (loosely translated as spirit or soul) and the *akh* (the glorified spirit), and certain ones of these would undertake the difficult and dangerous journey to the afterlife, needing spells to help them on their way in order to reunite with that aspect of the human soul that remained with the body after death: if the body rots, then the soul's chances of winning its way through the Duat and reuniting with its separate parts are limited. Thus mummification was intended to preserve the body as long as possible and give the soul its best chance of reunification. The ritual known as the Opening of the Mouth ceremony was designed to restore the powers of the senses to the dead soul to enable its passage through the afterlife.

The judgement of the dead by the god Osiris. The deceased's heart is weighed against the feather of the goddess Ma'at, 1292–1189 BCE.

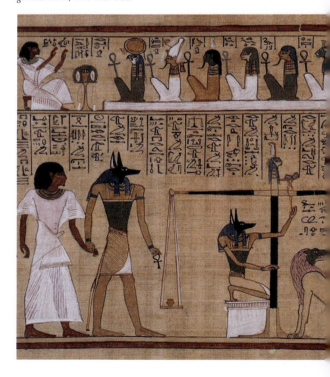

RIGHT *The goddess Ma'at, ruler of order and justice, 664–332 BCE.*

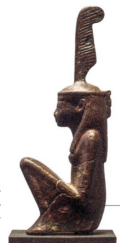

BELOW *Coffin texts: spells to protect the dead on their journey through the afterlife, c. 1919–1800 BCE.*

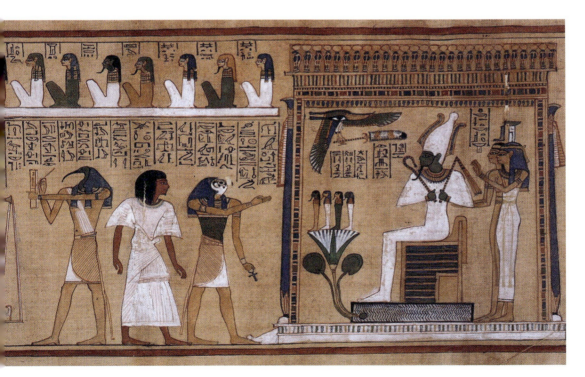

664–332 BCE

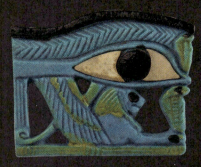

Lion (eye of Horus), c. 1070–664 BCE.

HEADACHE SPELL

This spell is to be said over seven threads of a garment, made into seven knots, placed on the left foot of a man.

'"My head, my head," said Horus. "The half of my head (= migraine), the half of my head," said Thoth. "Act for me, mother Isis and aunt Nephthys! Give me your head in exchange for my head, the half of my head!" (Isis speaks): "Just as I have seen these people (= human sufferers), so I have heard these gods (Horus and Thoth) saying to me on behalf of my son Horus: 'Let there be brought to me your head in exchange for my head.' Let threads be brought from the edge of a garment, having been made into seven knots, placed on the left foot of – Your name here – born of – Mother's name here. What is placed below will cure what is above, for I have elevated what the gods seek."'

Retranslated from: Alessandro Roccati,
Papiro Ieratico n. 54003, Turin: 1970, p. 36 (no. 11, verso, cols. 15–18).

Daily magic

Magic was also seen as a force capable of protecting the living. Its powers were invoked against external threats, such as curses, evil spirits and, at the national level, invading armies. They were also invoked against health-related problems such as illness or injury. Physicians would use the name of Heka to muster the powers of healing and there was an abundance of folk remedies. The calendar was divided into lucky days and unlucky ones, and people would use this, along with astrology, to try to predict which times might be propitious. Spells were readily available to everyone, sold by magical practitioners in the marketplace. We have records of spells to attract love, spells for good luck, for fertility, and for specific purposes, such as avoiding food poisoning, dodging a hangover or avoiding choking on a fishbone.

Curses were also inscribed on the walls of tombs and monuments, to prevent people from ransacking or damaging them (this is the origin of the legend of the 'Mummy's Curse'). There are records of spells to protect items such as books from theft, to 'remove anger from the heart of a god', and to protect a person against attacks from wild animals.

Like the Greeks and Romans, the Egyptians carried amulets and talismans in a variety of symbol-laden shapes, such as the *ankh*, a loop-headed cross that symbolizes eternal life; the Eye of Horus, which was used in healing; and the scarab, used for healing and protection.

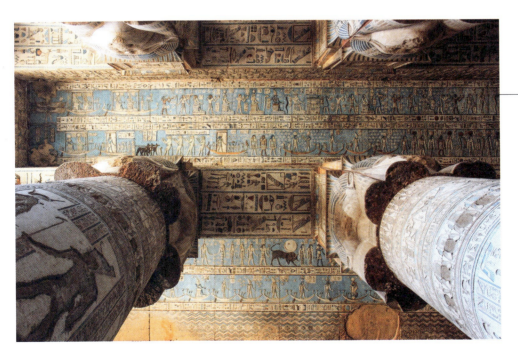

Ceiling calendar in the hypostyle hall of the temple of Hathor at Dendera, Egypt, 54 BCE.

54 BCE

ANCIENT GREEK MAGIC

The uncanny in ancient Greece

ORIGINS: Greece
DATES: *c.* 900 BCE–600 CE
PURPOSE: Invocations to the gods, ritual, attracting love or wealth, divination, cursing/binding

Magical practice in ancient Greece was widespread, although the attitude towards it differed from that in contemporary Egypt: it was often seen as sinister or disreputable. In his *Apologia* (158–159 CE), Apuleius called it 'vulgar' and suggested that its practitioners made outrageous claims.

It was divided into two rough categories: theurgy (θεουργία), or 'high magic', and goetia (γοητεία), or 'low magic'. Theurgy involved making invocations to the gods for a higher purpose, whereas goetia was for the benefit of the self or another individual – for example, to find treasure or bring love. We will meet goetia again later in this book, as the term is used to describe grimoire-based European sorcery.

LEFT *Frontispiece from the Bohn's Classical Library edition of* The Works of Apuleius, *1866.*

OPPOSITE *Illustration from* The Metamorphoses *by Apuleius, which is the only ancient Roman novel to survive in full. The novel follows the adventures of the protagonist, Lucius, who is curious about magical practices. Compain-Bastien edition, 1787.*

ORIGINS OF WESTERN OCCULTISM

Goetia (low magic)

Poppets (*kolossoi*) are a good example of ancient Greek low magic, and were very popular magical items. Their primary purpose was to bind one's enemies – which might include ghosts, spirits and even deities – to one's will. It was recognized that gods and ghosts could not be killed, and thus needed instead to be restrained. The Athenians bound the goddess of victory to stop her from leaving their city. Ghosts were bound after death, to stop them roaming the Earth. Personal items belonging to the spell's target, such as hair or nails, were embedded into the *kolossos*; then the little figure was tied up, and its parts mutilated and twisted. It was pierced with nails or thorns, or even animal teeth. The name of the person or entity to be bound was written on the body, and some were attached to other amulets to increase their efficacy.

Poppets were also used to defend a person against a *goês* (sorcerer), who could send *eidôlon* or *phasma* (phantoms) to do their bidding, or against other threats, such as lawsuits. *Kolossoi* might also be used in law to bind those making an oath. This process was usually accompanied by various incantations and/or rituals in order to further enhance the binding. Some poppets were rebound every year by priests in order to ensure that the binding remained intact: the god Ares, for instance, was unbound and rebound in chains or iron fetters by civic leaders on an annual basis to keep soldiers safe on the battlefield.

Curse tablets, *katadesmoi* (κατάδεσμοι, literally 'bindings down'), were also used from the 6th century BCE onwards. These were made from lead and inscribed with the name of the person being cursed, along with the curse itself. The tablet might be nailed shut and thrown down a well, or buried in a graveyard, or simply in the earth. Curses were placed in disputes over love or money, in legal cases and for vengeance. Entire families and their descendants might be cursed. Cursing was not confined to tablets, but could be spoken as well.

Where there are curses, there will be protective magic, too, and the use of amulets and talismans was common throughout this period. Amulets carved from precious stones were popular, and were often inscribed with portions of spell craft from Babylonian, Egyptian and even Judaic magical literature – an inevitable consequence of the melting pot that was the classical Mediterranean world.

Some commentators regard *erôs*-based love spells, cast for purposes of lust, as resembling curses because they use the kind of techniques that we find in cursing (such as poppets), whereas *philia*-based magic, for a calmer, romantic love, uses the techniques that we find in healing, such as potions, amulets and knotted cords.

Magic curse against enemies in a trial, written on a lead figurine, put in a lead box and found in the enclosure of Aristion. On display in the Kerameikos Archaeological Museum (Athens). Dating from 420–410 BCE.

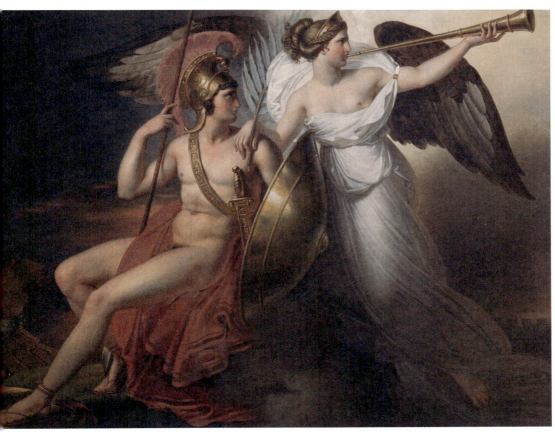

ABOVE *Painting by Anne-Louis Girodet-Trioson, Allegory of Victory, 1814.*

LEFT *Silver tablet (lamella) with an incantation against pain; Greek, 3rd century BCE.*

375–350 BCE

Theurgy (high magic)

Requesting the favour of the gods was a core feature of Greek magic and religious worship. The Olympian pantheon was led by Zeus and his wife Hera, with other gods and goddesses representing different aspects of human existence, such as love (Aphrodite), war (Ares) and wisdom (Athena), as well as natural features of the cosmos, such as the sun (Apollo), the moon (Diana) and the underworld (Hades). The gods were presumed to take an interest in human affairs, and sometimes singled particular humans out for their favour – and their retribution. Some of the earliest references to magic appear in Homer's *Odyssey* (7th–8th century BCE). In his wanderings, Odysseus meets the sorceress Circe, who has divine origins. She uses a wand to turn his sailors into swine, but the god Hermes tells Odysseus how to resist her powers through the use of a magical herb, Moly. Thus, with the aid of a deity, Odysseus outwits the witch who seeks to keep him and his men captive. In this ancient tale, we see some elements that are familiar to us today: the villainy of black magic that subverts the natural order of things; the use of magical tools and herbs; and the intervention of a more powerful, benign being.

Some Greek philosophers were credited with magical powers, such as Pythagoras, who as well as his famous theorem was known for his powers of precognition and prediction, and his reputed ability to be in two places at once. Empedocles, too, was rumoured to possess the power to heal the sick, raise the dead and control the weather. Plato mentioned magic, but did not have a high regard for it. Yet although magic was seen as somewhat disreputable by the ancient Greeks, its practice remained popular among common folk, and the number of texts that mention spells and ritual is considerable. We even have evidence of a magician's tools, from the city of Pergamon – a triangle and dish inscribed with magical symbols and images of the goddess of the underworld, Hekate, some black stones with the names of entities inscribed, and also a bronze nail and rings, dating from around the 3rd century BCE.

LEFT *Bronze magic plate from the ancient Greek city Pergamon, featuring three deities – Melinoe, Phoebe and Nikta. These three goddesses are sometimes conflated with Hekate, 3rd century BCE.*

OPPOSITE *Psyche, on her quest to the underworld, by Paul Alfred de Curzon, 1859.*

3rd century BCE

PAPYRUS OF MAGICAL CHARMS

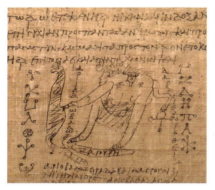

CHARM TO RESTRAIN ANGER,
TO SECURE FAVOUR AND FOR GAINING
VICTORY IN THE COURTS

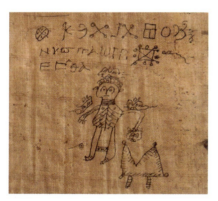

A CHARM TO BREAK ALL CHARMS

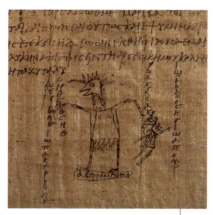

PUDENDA KEY SPELL

UVALL/VUAL/VOVAL

ABOVE *The demon Uvall.*

LEFT *Oslo university papyrus: a long roll of papyrus filled with magical spells and charms. The figures and signs were copied onto silver foil (lamella) with a bronze pen and worn under a garment. The title of the spell top left suggests: 'Charm to restrain anger, to secure favour and an excellent charm for gaining victory in the courts. It works even against kings, no charm is greater.' The middle charm is used as protection to break other charms being used against them. Bottom left: A faithfulness spell, 'she will love you alone and by no one else will she be laid,' it assures, 350 BCE.*

THE GREEK MAGICAL PAPYRI

Papyri found in Greco-Roman Egypt

ORIGINS: Greco-Roman Egypt
DATES: *c.* 200 BCE–700 CE
PURPOSE: Instructions for spells, hymns, rituals

Of great relevance to the history of the occult are the Greek Magical Papyri (known as the PGM, from *Papyri Graecae Magicae*). Dating from the 2nd century BCE to the 7th century CE, they contain a wealth of spells, hymns and rituals.

Copies began to appear on the antiquities market in the early 19th century, although some aspects of Egyptian magic seem to have made their way into earlier British texts (in the *Lesser Key of Solomon*, a 17th-century grimoire, the section known as the *Ars Goetia* mentions a demon Vual/Uvall who speaks Egyptian and who sometimes takes the form of a dromedary). The PGM were compiled between 200 BCE and 700 CE and written in both the ancient Egyptian hieroglyphic and hieratic (cursive) scripts, in Coptic and in Greek. The French Egyptologist Jean-François Champollion first deciphered hieroglyphs in the early 19th century, following the discovery of the Rosetta Stone, and thanks to his work we are able to learn much about ancient Egyptian magical practices. The PGM themselves were collated by the German scholar Karl Preisendanz and published in two volumes in 1928 and 1931. In the 1980s they were translated into English.

Some of the papyri are scholarly in origin, probably written by Egyptian priests under the Roman occupation, whereas others are the personal texts of travelling magicians.

Commentators disagree on their origins, however, and to some extent on their purpose. Some of the papyri clearly relate to cursing: they contain material similar to the Greek *katadesmoi* or curse tablets and references to magical figurines. There are also love charms, and rituals for conjuring demons. Papyri devoted to healing can be placed in two categories: those which are based on evidence and observation, and those detailing the incantations, spells and amulets used to drive away the entities that were held to cause diseases. Other papyri relate to religious rituals, such as the Mithras Liturgy, which gave directions for the ascent of the soul to achieve divine revelation. The papyri contain references to Greek deities as well as Judaic, Christian and Babylonian magical influences, a reflection of the syncretism that was a common feature of religious experience at this time.

Of course, the Greek Magical Papyri represent only a small fraction of the materials that would have been collated in Egypt over the course of its long history; there is much that we still do not know.

350 BCE

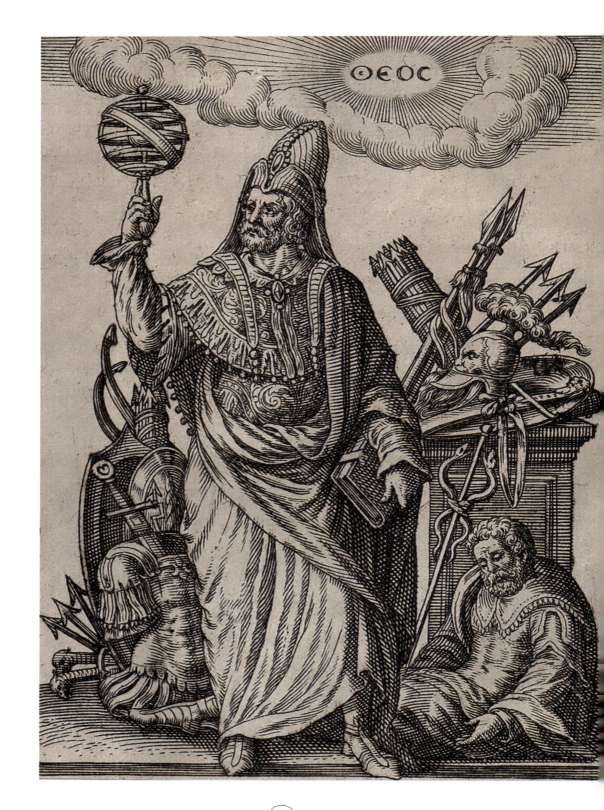

HERMETIC MAGIC
The study and practice of magic and occult philosophy

ORIGINS: Ancient Greece
DATES: *c.* 100–300 CE; early Middle Ages; Renaissance revival; present-day revival
PURPOSE: Ritual, astrology, developing the higher self

1471 CE

In the Middle Ages, Latin and Arabic translations of ancient classical texts known as the *Corpus Hermeticum*, or *Hermetica*, began to appear. These texts, attributed to Hermes Trismegistus ('Thrice Great Hermes') – a syncretization of the Greek god Hermes and the Egyptian god Thoth – began to appear in Hellenistic Egypt around the 2nd and 3rd centuries CE, and contained details of magic, astronomy, alchemy and medicine.

One of these texts tells that Alexander the Great found an emerald tablet in a tomb belonging to Hermes Trismegistus. This tablet outlined the principles of alchemy and other aspects of natural philosophy, and it is one of the foundation stones of what is known as Hermetic magic. This form of magic, in turn, is one of the main drivers of occult thought in the West today.

BELOW *Hermes Trismegistus (ascribed to)* De Potestate et Sapientia Dei. *Translation from the Greek by Marsilio Ficino (1433–1499). Treviso: Gerardus de Lisa, de Flandria, 18 December 1471.*

OPPOSITE *Mercurius Trismegistus, copper engraving by Johann Theodor de Bry for the* Tractatus posthumus de divinatione & magicis præstigiis *by Jean-Jacques Boissard, Oppenheim, National Library of Spain, 1615.*

37

THE TABLET STATES:

'What is below is like what is above, and what is above is like what is below, to accomplish the miracles of one thing. And as all things were derived from one by the meditation of one, so all things are born from this one thing by adaptation. The Sun is its father, the Moon is its mother, the Wind has carried it in its belly, its nurse is the Earth.'

1609 CE

The *Emerald Tablet*

The *Emerald Tablet*, or *Smaragdine Tablet*, is a short, cryptic text that was translated from Arabic into Latin in the 12th and 13th centuries CE, but probably dates from the 8th or 9th century CE. The *Hermetica* maintains that our spiritual task is the purification of the soul and dwells on the connection between mind and spirit. The ideas contained within it were adopted into Islamic thought in 640 CE when the Arabs took over Egypt, and the *Emerald Tablet* may have appeared in a 9th-century work called the *Kitâb sirr al-Halîka* (Book of the Secret of Creation). The *Emerald Tablet* continued to be disseminated in Latin until the 20th-century English historian E.J. Holmyard found an early Arabic version attributed to the alchemist Jābir.

The first sentence has proved highly influential in Western occultism. It implies that the movement and power of the stars affect what happens on Earth, and it harks to the doctrine of correspondences – the concept that different things can be categorized and linked together (for example, that emerald is the stone of Venus, whose day is Friday, and whose colour is green).

The *Tablet* is not uncontroversial, especially its origins. The German Jesuit Athanasius Kircher criticized it strongly in his work *Oedipus Aegyptiacus*, published in three volumes in the 1650s. He questioned its attributed authorship by Hermes Trismegistus, claiming instead that it was forged by a medieval alchemist. Nonetheless, some of the central concepts of the *Tablet* have proved enduring within Hermeticism.

OPPOSITE *Tabula Smaragdina (Emerald Tablet of Hermes Trismegistus). From Amphitheatrum Sapientiae Aeternae by Heinrich Khunrath, Private Collection, 1609.*

LEFT *Alchemical illustration by Matthias Merian from Atalanta Fugiens by Michael Maier, published by Johan Theodor de Bry in Oppenheim, 1617. Depicts a passage from the Emerald Tablet: 'the Wind has carried it in its belly, its nurse is the Earth.'*

Renaissance Hermeticism

In the 15th century, Count Giovanni Pico della Mirandola translated the *Corpus Hermeticum* and syncretized Jewish Kabbalah with a Pagan-Christian Hermetic amalgam. From this point on, Hermeticism becomes linked with Christianity, Renaissance Neo-Classicism and Humanism, natural magic, and Kabbalah. According to della Mirandola, following classical thought, there are two forms of magic: goetia, which relies on contact with demonic forces and which is essentially black magic; and theurgy, which is goetia's opposite and relies on contact with divine forces such as archangels and gods. Hermeticism also includes the idea of reincarnation and astrology and has retained links with alchemy. Other influential writers of the day, such as the Swiss Renaissance philosopher and theologian Paracelsus (1493–1541), drew upon the *Corpus* to devise a system of medicine.

From the 17th century onwards, Hermetic principles became increasingly important to magical practice and in particular to 'high' magic, becoming linked in particular to Rosicrucianism and Freemasonry. One of Hermeticism's basic precepts is that there is a *prisca theologia*, an

ABOVE *Sorcery and witch craze, by Hans Schäufelein, 16th century.*

RIGHT *Nag Hammadi Codex 2, page 32: the end of the Apocryphon of John and the beginning of the Gospel of Thomas, 4th century* CE.

HERMETIC PRAYER OF THANKSGIVING:

'We give thanks to You! Every soul and heart is lifted up to You, undisturbed name, honoured with the name "God" and praised with the name "Father", for to everyone and everything (comes) the fatherly kindness and affection and love, and any teaching there may be that is sweet and plain, giving us mind, speech,

ancient philosophy, given to humans by God, and that our task is to discover its nature. All religions and philosophies have this ancient knowledge at their base, although it may have become concealed or disguised, and thus our esoteric work must be to uncover it. Interest in Hermeticism was given a boost in 1945 when the Nag Hammadi manuscripts were discovered in Upper Egypt. Written in Coptic and dating from the 4th century CE, these leather-bound papyri contained a series of Hermetic texts, as well as part of Plato's *Republic* and the *Gospel of St Thomas*. Hermeticists, however, are particularly interested in the text named *The Discourse on the Eighth and Ninth*, which contains an initiation rite and which, like a number of Hermetic texts, is written in the form of a dialogue. The Nag Hammadi texts also include the Hermetic Prayer of Thanksgiving (see below).

Hermeticists believe that we are all part of a great living mind: that the universe is the consciousness of God. Hermeticism seeks the secret knowledge that explains all things, an epistemological Holy Grail.

'(and) knowledge: mind, so that we may understand You, speech, so that we may expound You, knowledge, so that we may know You. We rejoice, having been illuminated by Your knowledge. We rejoice because You have shown us Yourself. We rejoice because while we were in (the) body, You have made us divine through Your knowledge.'

400 CE

ORIGINS OF WESTERN OCCULTISM

MAGIC IN THE ROMAN EMPIRE

Magical philosophies in ancient Rome

ORIGINS: Rome
DATES: 27 BCE to 476 CE
PURPOSE: Ritual, cursing/binding, protection, initiation, summoning demons

The ancient Romans took much of their culture from the earlier Greeks, including the Roman version of the Greek pantheon. Zeus became Jupiter; Athena became Minerva; Ares became Mars. Several of the Roman gods are familiar to us today as the names of the planets, though the Greek sun god Apollo kept his name.

The Roman empire expanded over time to include the territories of Assyria, Egypt and Britain, and the Romans brought their gods with them, often deliberately syncretizing them with local deities. Thus the Celtic deity of Bath, Sulis, became Sulis-Minerva, assuming aspects of the Roman goddess of wisdom. This policy was consciously adopted to damp down dissent: local tribes were, in essence, allowed to keep their own gods under Roman rule, although the Romans also built temples to their own gods, such as the temples to Mars and Mithras in Britain. This would have affected magical practice in those occupied nations (we know there were rites to Mithras in Britain, for example). Judaic magic also appeared throughout the Roman empire, as Jewish regions became assimilated under the rule of Rome and their beliefs became incorporated into Roman practices.

OPPOSITE TOP *Illustration of the altar of the Twelve Gods, found in Gabii, Italy, published in* Magasin Pittoresque, *Paris, 1841.*

OPPOSITE BELOW *Medallion with relief of Mithras and a fresco of Apollo Kitharoidos Palatino in Roman times, 2nd century CE.*

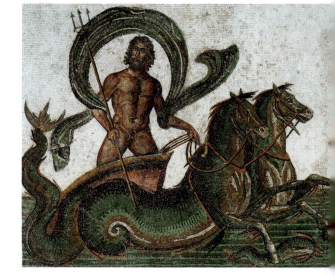

RIGHT *Buildings were decorated with images of the gods. Neptune, god of the sea, carrying a trident, stands in his chariot drawn by two hippocamps, 3rd century CE.*

42

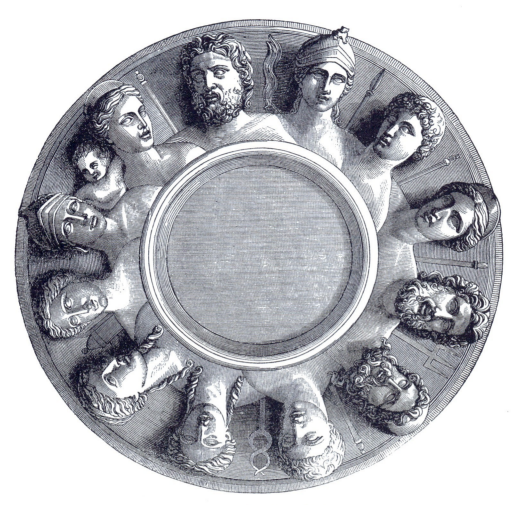

THE ROMAN PANTHEON OF GODS

44 BCE–14 CE

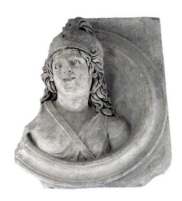

MITHRAS RELIEF

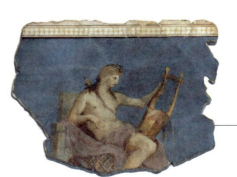

APOLLO KITHAROIDOS FRESCO

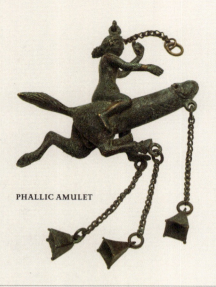

PHALLIC AMULET

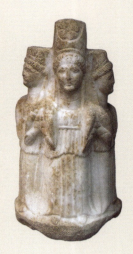

HEKATE

LUNULA

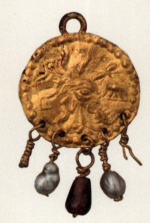

EVIL EYE

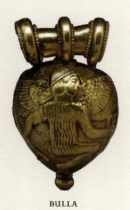

BULLA

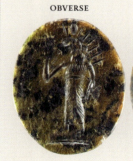

OBVERSE

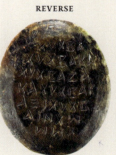

REVERSE

SERPENTINE INTAGLIO

A common craft

The Latin for 'magician' is *magus*, derived from the Greek *magos* and a word still in currency today. Like the Greeks, the Romans did not regard magic as respectable. We even find magical practitioners taken to task in the Roman legal system, in legislation such as *Tabulae XII*, which outlines the penalties for property damaged by agricultural or climate magic. Some of their magical practice was undoubtedly negative: curse tablets (*defixiones* in Latin) are found throughout the Roman empire and are similar to the Greek versions. Many of these have turned up in the waters of the Roman baths in Bath, dedicated to Sulis-Minerva and asking for justice or retribution in recompense for crimes such as theft of clothing. Others called upon the assistance of underworld gods, such as Persephone, Hekate and Typhon, and were placed in water or buried so as to be easily accessible by these chthonic deities. Binding spells were also used, along with poisons. As in Greek society, bound or mutilated figurines (poppets) were created in an effort to control people, then stuck with needles or pins.

Enchantments and spells were cast, and amulets were popular, carried around the neck, head or arm. Roman boys would carry a *bulla*, an amulet rather like a locket, sometimes covered in gold foil and depicting images of legendary figures, which was given to them nine days after their birth. When the boy came of age and adopted his *toga virilis*, or clothes of manhood, the *bulla* would be placed in the care of his household gods. Girls would wear an analogous amulet called a *lunula* and they, too, would put these aside once they reached adulthood. Phallic amulets were also widely worn as protection against evil, some combined with the ancient symbol of the *manus fica*, or 'fig', an obscene gesture made by placing the thumb between two fingers that is supposed to represent female genitalia – this gesture is still in use throughout the Mediterranean.

Some amulets are elaborate and beautiful, such as the example shown opposite centre right, which features attached gemstones and shows an eye being attacked by animals such as a scorpion and an elephant. This is a protective symbol against the evil eye, and similar depictions are found in the form of mosaics protecting the house against evil influences. Amulets are also found in tombs, placed there to protect the spirit of the dead person when they enter the afterlife.

2nd–3rd century CE

LEFT Twelve Tables *by Silvestre David Mirys (1742–1810); engraved by Claude-Nicolas Malapeau (1755–1803).*

OPPOSITE (TOP TO BOTTOM, LEFT TO RIGHT) *Greco-Roman bronze phallic pendant, 100 BCE–400 CE; Roman Hekate, Kütahya archaeological museum; Roman lunula, 1st century; Roman evil eye medallion, c. 2nd century CE; Bulla with Daedalus and Icarus, the Walters Art Museum, 5th century BCE; Serpentine intaglio inscribed with a lion-headed god on the facing side – the reverse features an incantation, c. 2nd–3rd century CE.*

ABOVE The City of Godd, *Miniature*, Conde Museum, Chantilly, France, 15th century.

ABOVE *The opening lines of Virgil's Eclogues in the* Vergilius Romanus, *5th century CE.*

Magic words

Some amulets carry spells or protective texts, which were also inscribed upon papyri or on metal sheets. Incantations (*incantamenta*) were an integral part of magic; those who knew the spells could ask the gods for help in healing or in matters of love, as well as in exorcisms and attempts to control the weather. The *incantamenta* differ from hymns, being efforts to control the world rather than simply to praise or worship the gods. Roman texts also record initiation rituals, methods of what is now known as trance mediumship, and means of summoning familiar spirits (*paredroi daimones*) who would then aid the magician. Methods of telling the future were also much in demand, as were astrological predictions. Augurs would study the shape of clouds or the flight of birds to distinguish omens and messages from the gods contained within. Thunder was lucky if it occurred on the left of the augur, but unlucky if it occurred on the right, for example.

We know much of this due to the existence of magicians' handbooks, such as Apuleius's *Apologia* (*Pro Se De Magia*), which gave detailed instructions regarding tools and methodology. In Pliny's *Natural History* we find an extensive description of the *magicae vanitates* (30.1–18), although Pliny was not in favour of magic himself. Mention of magical practices also appear extensively in Roman literature, such as the account of a werewolf in Virgil's eighth eclogue (64–110) (opposite).

But here we must be careful, as writers might not have been magical practitioners themselves, and may therefore have copied old ideas about the occult with little practical understanding of them.

Ein Augur, *etching by Bernhard Rode, c. 1768 CE.*

VIRGIL'S EIGHTH ECLOGUE (64–110)

'I've seen Moeris often with these herbs
Become a wolf, lurking in the woods; often
I've seen him call up souls of the buried dead
Or lead the standing crops from field to field.'

CELTIC MAGIC
Supernatural beliefs in Celtic Europe

ORIGINS: Northern Europe
DATES: *c.* 1200 BCE–300 CE
PURPOSE: Ritual, divination, worship

The cultures that are termed 'Celtic' spanned thousands of years and a considerable geographical region encompassing northern Europe, parts of Spain, and Britain and Ireland. Their tribal cultures varied considerably from one another, including the use of different languages, and they should not be seen as one united group: the pan-European culture of La Tène would have been significantly different from the Votadini or the Brigantes in what is now Northumberland, for example.

Because the Celts had an oral rather than a written tradition, we do not know a great deal about what they believed, how they practised magic or the deities they worshipped. What we know of Celtic magical practice, and the priesthood known as the Druids or *druidae* (from the Irish *draoithe* or the Welsh *dryw*, said to mean 'tree knower'), comes from Roman writers such as Tacitus, Pomponius Mela and Hippolytas, whose accounts we must treat with caution. Some contemporary commentators on the Druids, for instance, had never met one or even visited Britain, and their reports must be read with this reservation in mind.

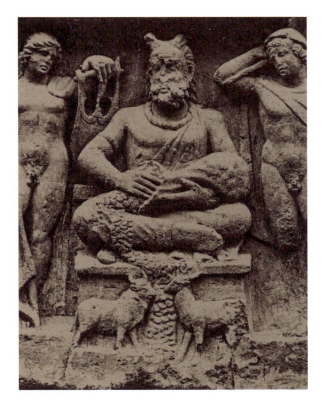

OPPOSITE *An image of a Chief Druid from a set of eight extra-illustrated volumes of* A tour in Wales *by Thomas Pennant (1726–1798).*

RIGHT *Gallo-Roman relief of the Celtic horned god Cernunnos (artist unknown).*

The Druids

The Roman historian Tacitus (c. 56–120 CE) tells us that the Druids were law-makers as well as priests, and that their training was extensive and intensive, lasting for twenty years. This included divination, the memorization of sacred verses and cursing. He also reports that some Druids could read and write, but did so in Greek and would not commit details of their spiritual practices to paper, perhaps to protect these secrets from the invaders or to retain their power in an illiterate culture. Roman writers also tell us that the Celts practised human sacrifice, burning a number of people in gigantic wicker figures (this is the premise of the 1973 pulp occult film *The Wicker Man*). Tacitus adds that the Druids on the island of Anglesey used human entrails for the purposes of divination. The poet Lucan, in his epic *Pharsalia* (c. 61–65 CE), states that the Gauls propitiated their god Taranis by burning people, placated the god Teutates by drowning them and hanged sacrifices for the god Esus, though the Greek writer Strabo, writing perhaps a century earlier, reported that the Romans put an end to these sacrificial customs; then again, Strabo had never visited Britain. Tacitus also gives an account of a battle on the island of Anglesey, known to the Romans as Mona. This was said to be the home of Druidic training, and thus the heart of the Celtic resistance to their occupiers. In this battle, Tacitus reports, the Celts were finally defeated by the Romans, although there were later rebellions against the invaders, such as the revolt headed by Boudicca.

In Christianized Irish medieval stories, the Druids are presented as magicians who are opposed to the coming of Christianity. In the *Táin Bó Cúailnge* (The Cattle Raid of Cooley), the hero Cuchulain must fight six Druids, three of whom are men and three women. This is one of few references to female Druids, although Tacitus mentions that women as well as men fought against the Romans on Anglesey. We do not know exactly what the Druids looked like. Although later images depict Druids as old bearded men wearing white robes, we do not know if this was originally the case. Irish accounts comment that the Druids wore bird-feather cloaks – a Druid named Mogh Ruith is described as having a 'speckled bird head-dress' – and were often tonsured, but in a different way to Christian priests.

In addition to being law-givers, the Druids seem to have been political advisers, astronomers and healers. Diogenes Laertius, in his 2nd-century work *Vitae*, says that they were interested in philosophy and that the Celts believed in reincarnation, although they buried grave goods for people journeying into the afterlife. Beliefs about the afterlife may have varied, however. Diodorus Siculus, writing in 36 BCE, claimed that Celtic tribes were divided into Druids, who were philosophers and theologians; *bardoi* (bards), who sang and recited poetry; and *o'vateis* or *ovates*, who were experts in the natural world and in divination. Words were held to have great power, and an expert bard was said to have the ability to raise blisters on the skin of someone who was the subject of their satire. It is likely that the Druids also studied the properties of herbs and plants for the purposes of healing, but again, we know little about their actual practices.

An image of a wicker man from a set of eight extra-illustrated volumes of A tour in Wales *by Thomas Pennant, published between 1778 and 1781.*

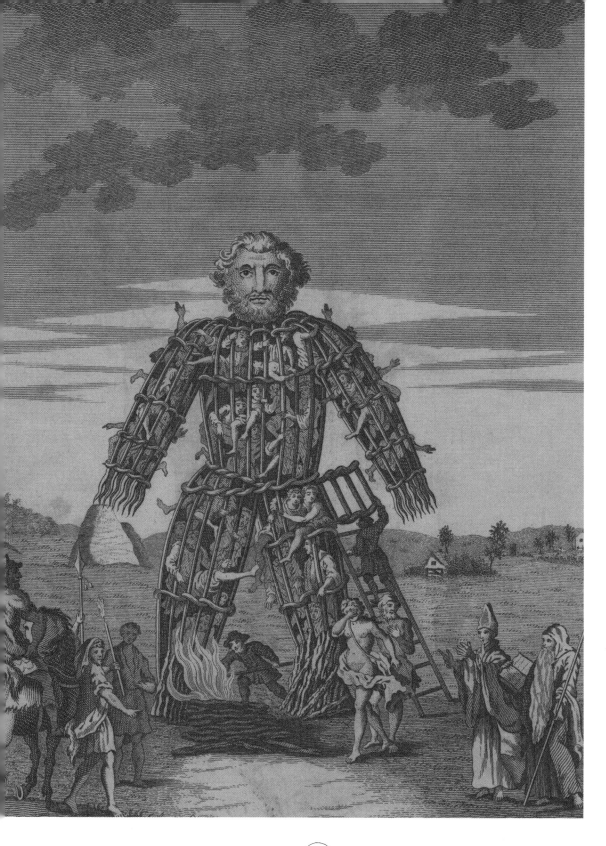

Gods and goddesses

As with Celtic religious practices, we also know relatively little about Celtic deities. The Gauls claimed that they were descended from a single god, Dis. There are also the deities called the Matres, or Matronae, who appear on votive offerings across northern Europe and Gaul. These are female figures with representations of sacrificial offerings, such as pigs, fruit and incense. In Britain and Ireland, deities seem to have been local and tribal, such as the god Nodens to whom there is a temple on the banks of the River Severn. Celtic cultural icons have passed into contemporary occultism, for many of the figures treated as deities by modern Pagans, including the revivalist Druid orders, are Celtic heroes or heroines, such as Rhiannon and Gwydion, who appear in the medieval Welsh work *The Mabinogion*. Some are old Irish deities, such as the war goddess The Morrigan, the father god The Dagda, and Bride, a goddess of healing, smithcraft, poetry and flame, as well as milking and brewing.

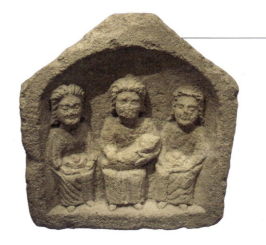

1st–4th century CE

THE CROSS OF ST BRIGID

OPPOSITE *St Bride carried by angels, by John Duncan, 1913.*

ABOVE RIGHT *Roman relief of three goddesses, Corinium Museum, Cirencester, 1st–4th century CE.*

RIGHT *Traditionally, St Brigid's Cross is fashioned from rushes.*

ANGLO-SAXON OCCULTISM

Magical practice in Anglo-Saxon Britain

ORIGINS: Northern Europe/Britain
DATES: *c.* 4th century–804 CE (on the continent); *c.* 410–1066 CE (Britain)
PURPOSE: Ritual, divination, worship

The Anglo-Saxons practised a variety of forms of witchcraft. Words relating to magic include *lybcraeft* (magic), *lybblac* (witchcraft), *begalan* (to enchant) and *morp weorc* (to kill someone by poison, witchcraft or both). In addition, *scinn-lac* (magical action) and *scinn craeft* (magical skill) are referenced, along with *wiccecraeft* and *wiccedom* (also meaning witchery) and *bealocraeft* (sorcery and evil art).

There are also words referring to ghosts and phantoms: our own word 'ghost', in fact, derives from the Saxon *gast*. In Europe, the Saxons were held to have practised human sacrifice; the Roman historian, Tacitus, writing on the region that is now Germany in the late 1st century, relates stories of human sacrifices to 'Mercury' (Woden/Odin) and animal sacrifices to other gods during the Roman period.

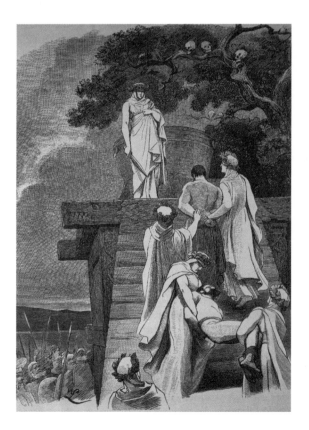

Cimbrian seeresses performing human sacrifice, from Germania, *by Johannes Scherr, 1891.*

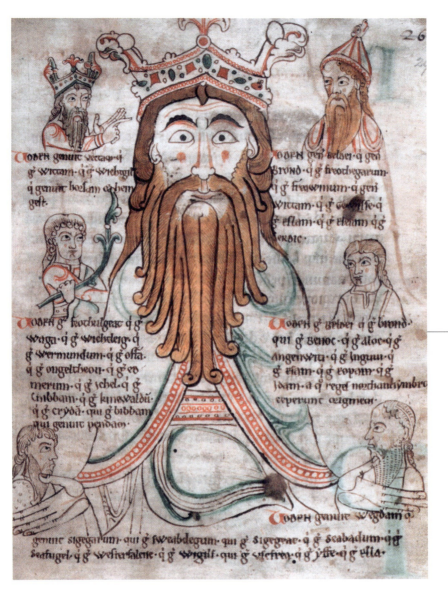

1099–1128 CE

ABOVE *Woden (Odin), depicted as ancestor of the Anglo-Saxon Kings from De primo Saxonum adventu. The British Library Board Cotton Caligula A.viii f. 29r. 1099–1128 CE.*

LEFT *Bracteate gold pendant, Germanic, early Anglo-Saxon, Undley Common, Lakenheath, British Museum, 6th century CE.*

Old English magic

The Saxons believed in portents and omens: dreaming of a ring suggested that the dreamer would become freed from cares, for example. They noted unusual weather conditions, such as alarming lightning flashes over Northumbria, held to be a presentiment of woe. Harald II regarded Halley's Comet as a portent of doom, shortly before the Norman invasion of 1066 CE.

We have records of some of the charms used by the Saxons, such as in the *Lacnunga* (Remedies), a 10th-century text that contains a variety of charms in Old English and Latin, including the famous Nine Herbs Charm:

'A worm came crawling, it killed nothing.
For Woden took nine glory-twigs,
he smote the adder that it flew apart into nine parts.
There the Apple accomplished it against poison
that she [the loathsome serpent] would never dwell
in the house.'

Another example is the Merseburg Charm, which was discovered in 1841 as part of a 9th- or 10th-century religious manuscript written in Old High German. The 'charm' consists of two spells, one of which refers to the gods themselves and is a healing incantation:

'Phol [Balder] and Wodan were riding to the woods,
and the foot of Balder's foal was sprained
So Sinthgunt, Sunna's sister, conjured it.
and Frija, Volla's sister, conjured it.
and Wodan conjured it, as well he could...'

Some of these spells appear in later grimoires, such as the Black Books that appeared throughout Scandinavia.

The 9th-century Old Saxon Baptismal Vow mentions Thunor, Woden (Odin) and Seaxneat as the three gods who must be renounced before a person is baptized as a Christian. There are other deities who have become more obscure, such as Rig, Ran, Tuisto, Mannus and Irpa.

Much Anglo-Saxon magic is related to healing. Bald's Leechbook, or the *Medicinale Anglicanum*, dates from the 10th century and is based on ancient Greek and Roman remedies. Its name comes from the Old English word for 'physician', *læca*, and it contains remedies for a variety of conditions, such as nosebleeds, cataracts and headaches. The Leechbook also references the supernatural causes of disease: mental illness and other conditions were often held to have an otherworldly cause, and the book contains methods of countering the ill will of elves (*ælfcynne*), night goblins (*nihtgehgan*) and devils (*deofol*).

Wið færstice, also found in the *Lacnunga*, is a charm against a sudden stabbing pain (possibly rheumatism), which the Saxons believed resulted from being 'elf shot' – stabbed with the tiny invisible arrows from an elfin bow (see right).

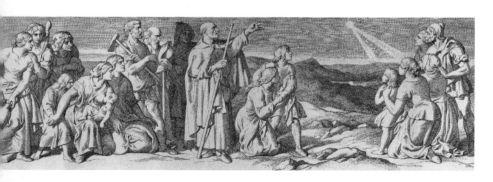

LEFT *Halley's comet appears in England, portentous of disaster, and is apostrophized by the Monk of Malmesbury.*

OPPOSITE *The first page of* Wið færstice *in the* Lacnunga, *10th or 11th century.*

WIÐ FÆRSTICE

'If you were shot/pained in the skin or were shot/
pained in the flesh, or were shot/pained in the blood,
or were shot/pained in the limb (?joint), may your
life never be harmed.
If it was the shot/pain of ese [gods] or it was the shot/
pain of ælfe [elves]
or it was the shot/pain of hægtessan [witches],
now I want to (?will) help you.
This for you as a remedy for the shot/pain of ese;
this for you as a remedy for the shot/pain of ælfe,
this for you as a remedy for the shot/pain
of hægtessan; I will help you.'

Opposition to magic

In the first half of the 10th century, the Saxon king, Athelstan, passed several edicts which came to be known as the Code of Athelstan. Included in the code were edicts against magic, which was seen as dangerous as it could be used to do harm, such as secretly killing people. Penalties included prison and a fine payable to the wronged party (see a section of the text, right).

KING ATHELSTAN'S LEGAL CODE

'...we have ordained respecting witch-crafts, and lybacs [sorcery], and morthdaeds [murder/mortal sin]: if any one should be thereby killed, and he could not deny it, that he be liable in his life. But if he will deny it, and at threefold ordeal shall be guilty; that he be 120 days in prison: and after that let kindred take him out, and give to the king 120 shillings, and pay the wer [blood price] to his kindred, and enter into borh [a system of surety] for him, that he evermore desist from the like.'

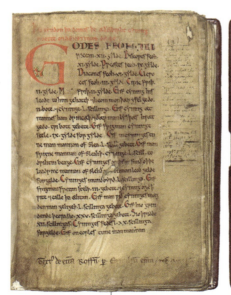

LEFT TOP *King Athelstan, unknown artist, line engraving, National Portrait Gallery, late 18th–early 19th century.*

LEFT *Athelstan's Grately Code, c. 926–930 CE.*

ORIGINS OF WESTERN OCCULTISM

KING EDGAR'S CANON LAW EDICT

'If any wicca [witch], wiglaer [wizard], false swearer, morthwyrtha [worshipper of the dead], or any foul contaminated, manifest horcwenan [whore] be anywhere in the land, man shall drive them out. We teach that every priest shall extinguish heathendom and forbid wilweorthunga [fountain worship], licwiglunga [incantations of the dead], hwata [omens], galdra [magic], man worship and the abominations that men exercise in various sorts of witchcraft, and in frithspottum [peace-enclosures] with elms and other trees, and with stones, and with many phantoms.'

c. 926–930 CE

King Edgar's canon law edict was passed only a few decades later (see left).

An edict passed by King Cnut (Canute) in 1020 CE prohibits the worship of 'heathen idols', such as wells, stones, trees in the forest, or the sun and the moon, suggesting that such worship was commonplace. The edict also mentions sacrifices and divination, implying that these practices too were sufficiently widespread to need legislation against them.

In spite of these edicts, Saxon charms and magic continued on in Britain even as it was Christianized, becoming incorporated into Christian superstition. Sometimes the pendulum even swung fully back, as with the Pagan Northumberland kingdom of Eric Bloodaxe in the 10th century. The German and Scandinavian peoples were somewhat later converts to Christianity.

ABOVE *King Edgar the Peaceful of England. Copperplate engraving by Verico from Giulio Ferrario's* Costumes Ancient and Modern of the Peoples of the World, *Florence, 1847.*

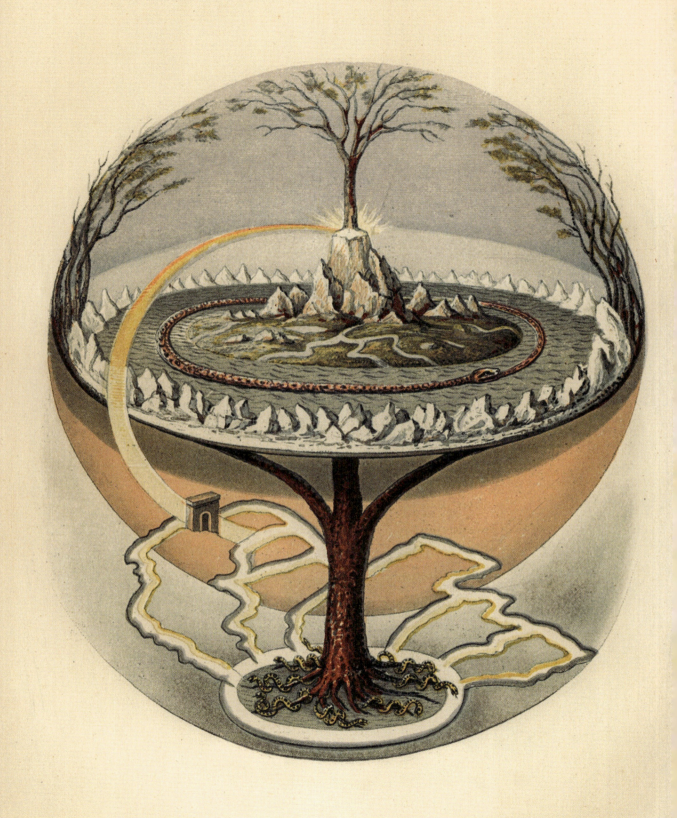

NORSE OCCULTISM

Supernatural beliefs in northern Europe

ORIGINS: Germany, Scandinavia, Britain
DATES: *c.* 800–1100 CE (on the continent); 793–1066 CE (Britain)
PURPOSE: Divination, prophecy, power, healing

13th century CE

In the 790s, Viking raids on Britain became increasingly frequent, and eventually many Norsemen settled in the north, in Shetland, York and Orkney, as well as in other European regions, such as Normandy. The sites of their temples still exist in some places, such as the one at Uppsala in Sweden dedicated to Thor, Odin and Freyr.

We have records of the Norsemen's beliefs in the sagas that they have left us, such as the *Prose Edda* by the Icelandic scholar and historian Snorri Sturluson (*c.* 1220 CE). We also have accounts by commentators like Adam of Bremen, an 11th-century German medieval scholar, who gives a description of the Uppsala temple and tells us that human sacrifices were made there. Another well-known account is that of the ritual murder of a slave girl in the Viking regions of the Volga so that her spirit could accompany that of her dead master, recorded by the 10th-century Islamic traveller Ibn Fadlan. These accounts need to be carefully examined before they can be taken at face value, but at the least they give us a picture of what others believed the Vikings to be.

RIGHT *Title page of a late manuscript of the* Prose Edda *written by Snorri Sturluson, 13th century.*

OPPOSITE *'Yggdrasil, the Mundane tree,' Baxter's Patent Oil Printing, from a plate included in the English translation of the* Prose Edda *by Oluf Olufsen Bagge, 1847.*

Norse gods and goddesses

The Vikings worshipped two main tribes of gods, the Aesir and the Vanir, and believed that at the centre of the universe was a huge ash tree called Yggdrasil that encompassed Asgard and Vanaheim, the realms of the gods, and Midgard, the human world. Other supernatural entities in the Norse pantheon include the Norns, three female figures in charge of fate; the Fylgjur, female guardian spirits; and Valkyries, the spirits who carry fallen warriors to the afterlife. The Norse gods have magical powers: they have totem animals (such as the flying boar who accompanies Freyr) and can shapeshift. The trickster god Loki, for example, shapeshifts into a salmon and a mare, and is said to be the mother of Odin's many-legged horse, Sleipnir. The Vikings also believed in Vaettir, nature spirits, such as wights and dwarves. Some of these became household spirits and persisted into the Christian era as brownies.

ABOVE RIGHT The Giant Suttungr and the Dwarfs, *by Louis Huard from the 1908 edition of Annie Keary's* The Heroes of Asgard, *1857.*

RIGHT *Runic stone at Tjängvide, Gotland, depicting the eight-footed horse of Odin from the book,* The Viking Age: the Early History, Manners, and Customs of the Ancestors of the English Speaking Nations *by Du Chaillu, (Paul Belloni), 1889.*

OPPOSITE *The Norse gods belong to two clans: Æsir and Vanir. Odin, Frigg, Thor, Loki, Balder, Hod, Heimdall and Tyr are representatives of Æsir and known as the main gods. The second clan, Vanir, contains the fertility gods, including Njord, Freyr and Freyja. Here we see some of the primary Norse deities.*

ODIN

IDUNA

THOR

LOKI

FREYR

FREYJA

Magical practices

Viking occult practices included *seidr* (*seiðr*), a form of trance mediumship or possession in which a woman channelled the words of a deity. *Seidr* techniques were used for divination, healing, bringing game or fish to the tribal lands, good luck and finding things that were lost. It was also used to try to control the weather. Some practitioners were known for cursing, and for giving false divinatory readings (paid for by the enemies of the reading's subject) to set people on a dangerous path. *Spádom* is another Norse practice of possession/trance mediumship and prophecy, conducted by *spækona*, women who undertake *spæwork*.

Seidr was practised by women known as *volva*, who travelled from place to place performing magic for hire. *Volva* are not the same as priestesses – *blótgyðiur* (sacrificial priestesses) or *hóvgyðiur* (temple priestesses) – who were based in a single sacred place. In the 13th-century *Saga of Erik the Red*, a *volva* in Greenland is depicted as wearing a cloak and a headpiece of wool and catskin. She carries a staff, decorated with bronze, and wears a glass-bead necklace. She wears calfskin shoes and catskin gloves: cats were sacred to the goddess Freyja, who was said to have brought *seidr* to the Aesir from her Vanir home. The *volva* is served with a dish made of the hearts of each kind of animal in the household. The women gather around her and sing songs dedicated to the gods with whom the *volva* wishes to speak. The saga tells us that the *volva* is able to predict the future and avert famine. *Volvas* were seen as dangerous and seductive. This is women's magic – men who practised it were seen as unmanly (*ergi*), although Odin himself is said to have been able to undertake *seidr*, perhaps as a deliberate act of transgression. In the *Ynglinga Saga*, Snorri Sturluson states that Odin was able to shapeshift into animals, so perhaps he was also capable of changing sex.

Freyja, the goddess primarily invoked in seidr, by John Bauer, 1905.

RIGHT *The Fyrkat seeress's cooking spit. The spit was already somewhat bent when it was buried. National Museum of Denmark, c. 980 CE.*

There is a *volva*'s grave at Fyrkat in Jutland; she was buried with a number of ceremonial items, including a copper sheet of runes and a staff, which has disintegrated. Henbane seeds, known for their sedative effects, have been found in the tomb, along with charms, including a little silver chair. This may be a representation of the ceremonial chair on which the *volva* would sit to give her prophetic pronouncements. Jewelry from Central Asia has also been found here, indicating the geographical trading reach of the Vikings. There are indications that the *volva* who was buried here was of higher status than the male priests whose remains have been found in the same area. In the Oseberg graves, which feature two women in a ship burial, the remains of animals have been discovered, along with cannabis seeds.

After the Vikings became Christianized, their magical practices were conducted under the names of their new god, and Christ. Some people seem to have adopted both, keeping their old gods while still paying allegiance to the new. A Viking coin found in York has an inscription to St Peter (Petri), but the final letter is in the form of Thor's hammer, a common Viking symbol. Another form of Norse magic, still practised today, is *Galdrastafir* ('incantation-staves'). This dates from the Christianization of Iceland and is a ceremonial combination of Norse magic, Christian theology and Kabbalism. It is practised by a *Galdrameisrari* ('Master of Galdr').

c. 980 CE

CENTRE *Silver chair amulet, perhaps representing the chair in which the seeress sat, found in the seeress's grave. National Museum of Denmark, c. 980 CE.*

ABOVE *These silver duck's foot-shaped pendants were also placed in the Fyrkat seeress's grave. National Museum of Denmark, c. 980 CE.*

KABBALISM

A form of Judaic mysticism adopted by magicians

ORIGINS: Judaism
DATES: *c.* 1200 CE–present day
PURPOSE: Development of the self,
understanding the universe, practical magic

Also known as the *Qabbala*, *Cabbala* or *Kabbalah* (literally 'received tradition'), Kabbalism originated in Judaism, but was later adopted into ceremonial magic. This system of thought first begins to appear in Provence and Catalonia in the 12th century, and it is based on a strand of Jewish philosophy which suggests that the letters of the Hebrew alphabet possess magical power: God creates the world by expressing his will through words.

Much Jewish magic, therefore, relies on the manipulation of letters and words, in an attempt to thereby affect reality itself, in line with our definition of magic as an expression of the magician's will. The clay figure of a *golem*, for instance, can be animated into life by a text placed into its mouth. There are innumerable manuscripts in Hebrew and Arabic which have never been translated, and the magical use of this system differs quite considerably from the Judaic form, so we must be careful not to confuse these different versions.

Jewish Kabbalists, Saxon University Library, Dresden, depicted in 1641.

HEBREW ALPHABET

ה	ד	ג	ב	א
HEI (H)	DALET (D)	GIMEL (G)	BEIT (B/V)	ALEF (SILENT)
י	ט	ח	ז	ו
YOD (Y)	TET (T)	CHEIT (CH)	ZAYIN (Z)	VAV (V/O/U)
ם	מ	ל	ך	כ
MEM (M)	MEM (M)	LAMED (L)	KHAF (KH)	KAF (K/KH)
פ	ע	ס	ן	נ
PEI (P/F)	AYIN (SILENT)	SAMEKH (S)	NUN (N)	NUN (N)
ר	ק	ץ	צ	ף
REISH (R)	QOF (Q)	TZADEI (TZ)	TZADEI (TZ)	FEI (F)
		ת	ש	
		TAZ (T/S)	SHIN (SH/S)	

Hebrew is written from right to left, rather than left to right, so the first letter is Alef. The alphabet pictured here is shown in Hebrew alphabetical order. Some letters have different forms when they are used at the end of a word, so appear more than once.

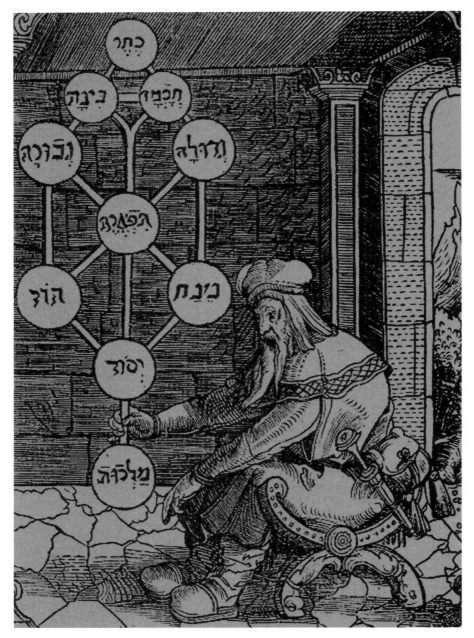

*Tree of Life woodcut title illustration by
Leonhard Beck from* Portae Lucis
by Joseph Gikatilla, 1293.

The Tree of Life

Kabbalism is based around a cosmological idea: that the universe we are capable of apprehending emanates from the mind of God, and is divided into ten zones, called sephiroth, in a diagram known as the Tree of Life. The higher one goes up the Tree, the closer one gets to God, and the more difficult it becomes for us to understand it: the human mind cannot cope with the vastness of these upper realms. The earthly world, our realm, is situated at the bottom of the Tree, and is known as the realm of Malkuth. The other spheres are linked to the planets and celestial bodies: starting with the moon (Yesod) and progressing through Mercury (Hod), Venus (Netzach), Jupiter (Chesed), Mars (Gevurah), the sun (Tiphareth), Saturn (Binah), Uranus (Chokmah) and Neptune (Kether). Finally, one reaches the Crown and a state of absolute compassion. (The outer planets of the solar system were not yet discovered when the Kabbalah was being developed: attributions of the outer planets were added at a later date.)

The Tree is also divided into three triangles – the upper sephiroth of Kether, Binah and Chokmah; the middle triangle of Geburah, Tiphareth and Chesed; and the bottom triangle of Hod, Netzach and Yesod, with Malkuth right at the base. The top triangle represents the Universal spirit; the middle triangle the soul; and the bottom triangle – pointing towards the material world – the personality.

1601 CE

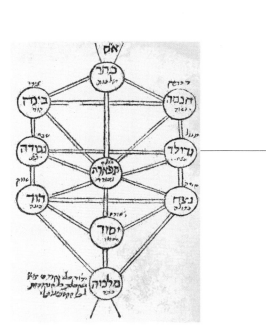

RIGHT TOP *The Sephiroth in relation to one another.* Assis rimonim *(essence of pomegranates) by Samuel Gallico, 1601.*

RIGHT *Sephirotic Christ. Plate found at the Book of John in an edition of a Syriac New Testament. Ed: Johann Albrecht Widmanstädt. Vienna: Michael Zimmermann, 1555.*

The European tradition

While Kabbalism has its origins in Jewish thought, the diagram of the Kabbalah and the precepts behind it were gradually absorbed into European occult philosophy. This process started in earnest during the Renaissance, continuing up to the dawn of the 20th century, when Kabbalism became firmly enmeshed in British and European occult practice. The French occultist Éliphas Lévi (1810–1875) incorporated elements of Judaic mysticism, including the Kabbalah, into his ceremonial magical practice. He correlated the cards of the Major Arcana in the Tarot with the paths of the Tree of Life described in Kabbalism, and his work was highly influential upon individual occult practitioners, such as Aleister Crowley (1875–1947), as well as occult groups, such as the Hermetic Order of the Golden Dawn. Crowley, for instance, expanded on the Tree of Life diagram, correlating Hod with quicksilver, opal and storax.

In the Victorian Rider-Waite-Smith Tarot deck, several of the Major Arcana feature pillars, because the Tree has a right- and a left-hand side – the three sephiroth downwards from Binah and Chokmah respectively. These are sometimes represented by two columns onto which the Tree is mapped: the pillars of Severity and Mercy, perhaps also representing male and female. It can however represent a human figure, with each sephiroth symbolizing a part of the body – rather like the Eastern concept of the *chakras*. There is a central pillar, too, of balance.

The Kabbalah can also be mapped onto astrology. The sephiroth Gevurah, for instance, is connected to the planet Mars, which rules Aries and Scorpio. Each sephiroth also has an associated angel; Sandalphon, the angel of Earth, is linked to Malkuth at the base of the Tree of Life. Thus the Kabbalah is a map of the magical universe. The planets have different qualities: each one rules a different day, and the hours throughout that day. This ties into Hermetic ideas – 'as above, so below'. If the Renaissance magician wanted to obtain wealth for his client, for instance, he could work with the powers of the planet Jupiter, which are tied in with wealth, and he would do so on a Thursday, which is the day ruled by Jupiter. He could look up the planetary hours on a table and do his ritual work on the hour ruled by Jupiter on that Thursday, to give the spell the maximum chance of success. The Kabbalistic sphere for Jupiter is represented by Chesed, which has various qualities and symbols attached to it (such as the colour violet and the semi-precious stone amethyst), which the magician might work with. If he was undertaking a love spell for a client, then the relevant sephiroth would be Netzach, which correlates to Venus. In this case, any magical work would be done on a Friday, the day that is ruled by Venus.

The Kabbalah can also be used as a 'mind map' to explore the psyche, a means of travelling upon the astral plane in a structured format or as a form of prayer.

OPPOSITE TOP LEFT *Alphonse Louis Constant (Éliphas Lévi), in Arthur Edward Waite's* The Secret Tradition in Freemasonry, *Rebman Publishing, London, 1911.*

OPPOSITE TOP RIGHT *General Plan Of Kabbalistic Doctrine, drawing by Éliphas Lévi, 1922.*

OPPOSITE BELOW LEFT *Kabbalistic Tree of Life, derived from the Hermetic Order of the Golden Dawn, c. 1920.*

OPPOSITE BELOW RIGHT *Occultist Aleister Crowley, c. 1954.*

1911 CE

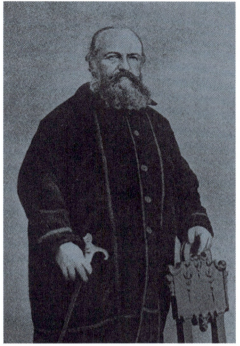

ÉLIPHAS LÉVI

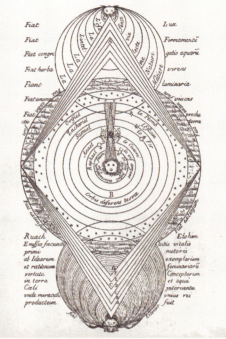

KABBALISTIC DOCTRINE

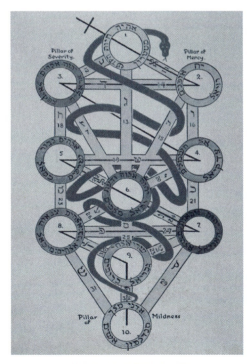

GOLDEN DAWN TREE OF LIFE

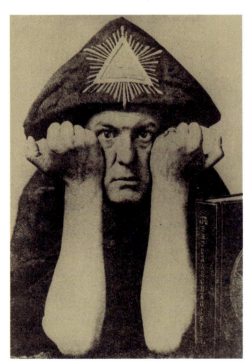

ALEISTER CROWLEY

ALCHEMY

The history of attempts to turn base metals into precious metals

ORIGINS: Middle East, Europe, China, India
DATES: Golden Age, *c.* 1300–1700 CE
PURPOSE: Transmutation of metals into gold, the quest for immortal life

Alchemy – the transmutation of lead or other metals into gold, the transformation of the spiritual self, or the attempt to discover the secret of everlasting life – is a very old and enduring belief. The word comes from the Greek *khēmeía* (χημεία), and Arabic *al-kīmiya*, the same etymological root as for the word 'chemistry', and indeed it may be regarded as a form of prototype chemical analysis that seeks to create substances from primordial matter.

The Greek *khem* has its roots in the ancient Egyptian word *kem*, meaning 'the black land' and referring to the dark, fertile soil that the River Nile brought with its yearly flood. Alchemy seems to have been a product of a merging of Greek and Egyptian thought, with its home in the city of Alexandria on the coast of the Nile Delta. There are references to it in the Greek Magical Papyri, such as the Stockholm papyrus and the Leyden papyrus X (250–300 CE), which contain instructions for fabricating gems, pearls and imitation gold and silver. Sadly we know comparatively little about its ancient Egyptian origins, due to the destruction by fire of the Great Library of Alexandria in 48 BCE. Many alchemical texts were also destroyed on the orders of Emperor Diocletian in 292 CE following a revolt in Alexandria. Nevertheless, the lore of alchemy remembered its Egyptian origins – in the Middle Ages, practitioners claimed that alchemy was started by the Egyptian god Thoth – and forms of alchemy spread throughout the Islamic world. It also developed in India and China, for example in Taoist monasteries. In this compendium we will be looking primarily at its Western form.

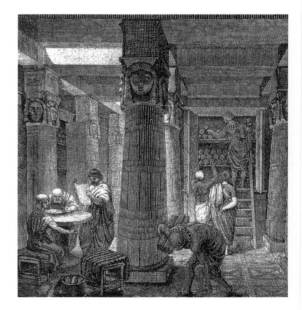

RIGHT The Library of Alexandria
by O. Von Corven, 19th century.

OPPOSITE The Alchemist
by William Fettes Douglas, 1855.

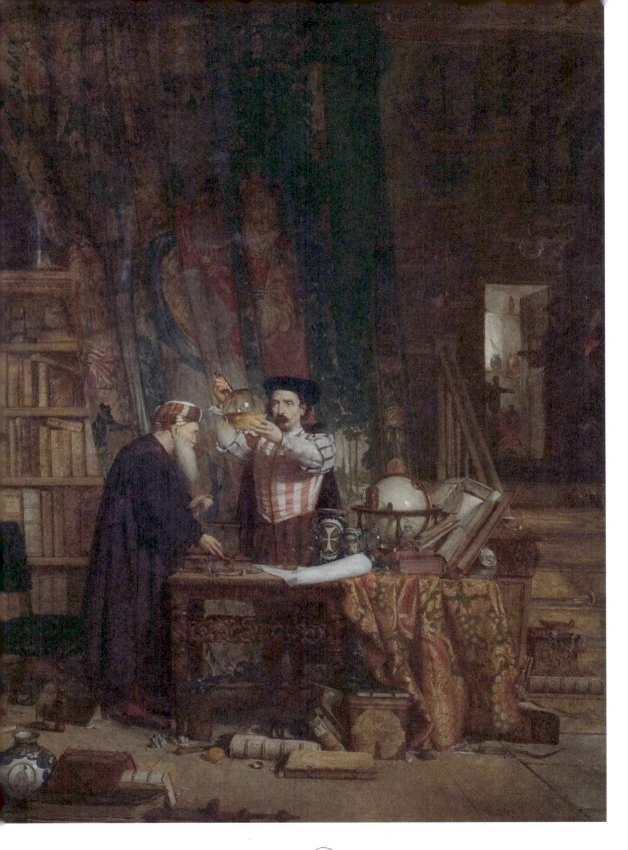

Alchemy in the medieval world

Alchemy was introduced to Europe from Arabia in the 8th century. It was widely practised in Spain, in cities such as Toledo, where Islamic influence was strong. One of the most well-known Islamic alchemists was Jā̄bir ibn Hayyā̄n, a 9th-century scholar whose aim was to create life within the laboratory, using methods based on Aristotelian theories. Jā̄bir was fascinated by the concept of the Philosopher's Stone, a mythical substance that can transform base metals such as mercury and sulphur into gold and is first mentioned in the *Cheirokmeta* of Zosimus of Panopolis, a Greco-Egyptian alchemist, around 300 CE. The roots of the Stone lie in the classical Greek theory of the elements, but it has proved an enduring idea: its promise of the generation of great wealth from very little has an obvious appeal. In Chinese alchemy, the Philosopher's Stone is said to grant eternal life; the First Emperor of China, Qin Shi Huang, initiated an imperial quest for the 'elixir of life'.

The work of Muslim scholars such as Avicenna (980–1037 CE) was highly regarded, and Arabic alchemical terms began to be imported into English. From the 12th century, alchemy started to be practised among British magicians, such as Robert of Chester (Abbot of Pamplona). Robert wrote *The Book of the Composition of Alchemy* in 1144 and his work was taken up by later commentators and practitioners, such as Roger Bacon and George Ripley. Chaucer satirized alchemy in *The Canterbury Tales*; the alchemist in the Yeoman's Tale is seen as shabby and unconvincing.

In the Renaissance, the Italian philosopher Ficino translated the *Corpus Hermeticum* into Latin: a compilation of teachings probably dating from between 100 and 300 CE, but again held to be the work of the Egyptian god Thoth.

The English physician Robert Fludd further popularized alchemical practice, travelling to Europe in 1598 and studying a form of medicine based on the work of the Swiss alchemist Paracelsus (1493–1541). This is founded on the doctrine of signatures: for instance, that if a plant resembles a body part, it is able to cure an illness in that part of the anatomy. It involves planetary magic – the idea that if you wish to achieve a particular result, you need to undertake magical work in the hour that belongs to that planet. For example, if you want to magically attract wealth, you would do your spell on a Thursday, which belongs to Jupiter, who rules wealth, in the hour of Jupiter.

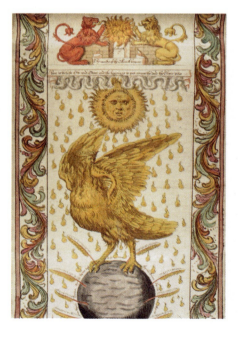

Image taken from the Rotulum Hieroglyphicum (Ripley Scroll), *a six-metre-long alchemical manuscript. G. Ripley, 16th century.*

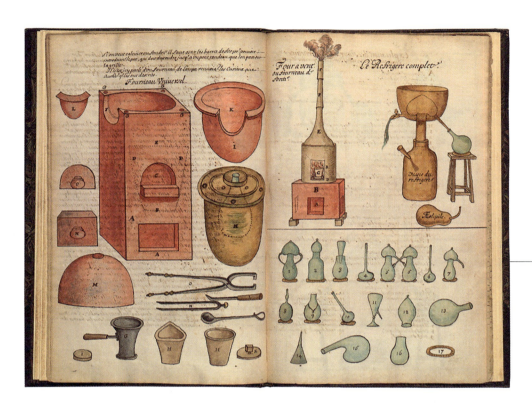

c. 1700 CE

ABOVE *Alchemical Equipment. From* Traité de Chymie *(Treatise on Chemistry), c. 1700.*

RIGHT *Miniature of physician Ibn Sina (Avicenna).*

FAR RIGHT *The English alchemist George Ripley, as illustrated in an edition of* The Ripley Scroll, *16th-century.*

75

The Emerald Tablet, title page for Daniel Mylius's book
The Medical-Chemical Work, *1618.*

Science or magic?

Alchemists used spells in addition to laboratory work; hence alchemy is regarded as a form of magic. Yet this was a period in which science and magic were not so starkly differentiated. The famous English scientist Isaac Newton, known as the 'father of physics', was an alchemist, and returned to his alchemical studies at the end of his life. Prototypical scientific concepts were applied to magic: phenomena such as gravity and magnetism were considered to be an example of invisible influences, and if this holds true in one case, it might hold true in others. Thus the planets could have an influence on human behaviour at the time of a person's birth, or correspondences might exist between different but visually similar things, such as plants and parts of the human anatomy.

Alchemical practice reached its height between 1650 and 1680. By this time, alchemists had divided into two camps: those who sought to understand the nature of chemical substances and their interactions, and those who took a more metaphysical approach that continued to strive for eternal life and the transmutation of metals. By the late 17th century, science and magic were also beginning to move apart. Alchemy, however, was not abandoned completely. There are people today who practise Spagyric medicine, an offshoot of alchemy that stems from the work of Paracelsus, and there are a few magical practitioners who run alchemical labs. Annual conferences on alchemy are also held. Although it is a niche interest among Western occultists, it is still held to be worthy of study.

ABOVE LEFT The Dissolution, or The Alchymist producing an Aetherial, *by James Gillray, 1796. This is a satirical reference to William Pitt, but it does illustrate the common understanding of alchemical principles at the time.*

LEFT *Sir Isaac Newton experimenting with a prism. Engraving after a picture by J.A. Houston, c. 1870. Courtesy of The Granger Collection, New York.*

Alchemical symbols

Alchemical symbols were used to denote different elements, such as sulphur, until the 18th century. Prior to this, these symbols were not standardized but varied between alchemical practitioners. Paracelsus, for instance, held that all material substances were composed of the *tria prima*, or three primes: sulphur, mercury and salt, but Western alchemy also includes the symbols for the four elements (air, fire, water and earth) and for the planetary metals (iron, for example, is connected to Mars). Some symbols also refer to alchemical compounds such as vinegar or nitric acid. Although it has a spiritual component, alchemy is a form of early chemistry. In 1789 Antoine Lavoisier (1743–1794) grouped elements into gases, non-metals, metals and earths and from this, subsequent chemists developed the modern periodic table.

BELOW *The philosopher's stone symbol. This sign symbolizes chemicals essential in alchemical procedures.*

ABOVE *Emblem representing the path to the philosopher's stone in alchemy. Etching by Defehrt, after L.-J. Goussier, after the frontispiece to a 17th-century book by Libavius, 1768.*

OPPOSITE *Gallery of the most common symbols used in alchemical texts.*

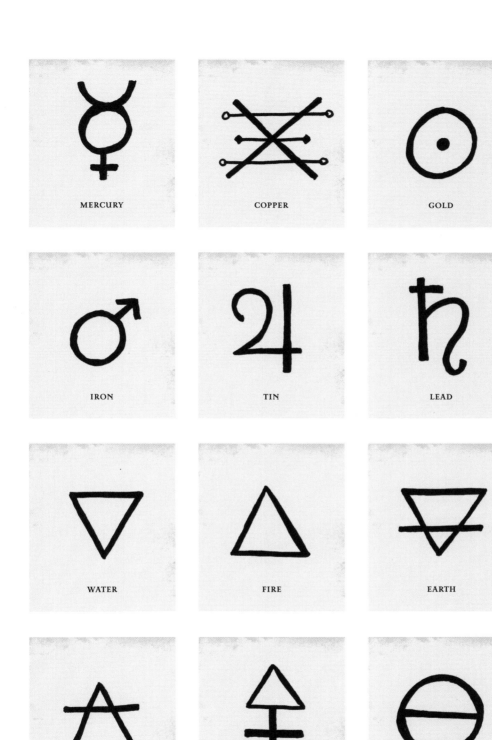

EARLY MODERN AND MEDIEVAL MAGIC AND WITCHCRAFT

The practices and persecution of witches through the ages

ORIGINS: Europe and USA
DATES: 1300–1782 CE
PURPOSE: Healing, finding lost objects, lifting curses

Magical practice was found throughout the ancient world, and witchcraft was an aspect of this. The Mesopotamians believed in witches and witchcraft – we have examples of spells to avert witchcraft – although the Egyptians did not. In Greek literature, both Circe and Medea are early examples of the witch-figure, and women in Thessaly were supposed to have particularly strong magical powers.

The Romans introduced the term *maleficum*, for a person who caused harm through magic, and seem to have held some form of witch trials, in which mainly women were prosecuted. The early modern concept of the witch has its roots in Roman times. We have seen that magical practice was found throughout the ancient world, and its use persisted after Europe was Christianized. Magic was widely practised throughout Europe in the medieval (500 CE–1400) and early modern era (about 1500–1800). It took many forms, including alchemy, divination, necromancy, demonology and astrology.

In Britain, cunning folk were available to assist clients with spells and remedies for healing, love, finding lost objects and treasure, and the removal of curses. In Germany, *Hexenmeister* or *Kräuterhexen* ('herb witches') performed the same role. In France, such people were known as *evins-guérisseurs* ('soothsayer-healers') and *leveurs de sorts* ('curse-lifters'), and in Holland as *toverdokters* ('magic-doctors') or *duivelbanners* ('devil-banners'). These are just a few examples: at this time, magical practitioners could be found in every country in Europe. Many of these people were not perceived as witches per se – in Britain, for instance, a witch was specifically a person who caused harm: *maleficum*. Gradually, however, the term *maleficum* began to be used for all forms of magic.

The Church was always hostile towards magic, but in its early days in Europe, did not specifically set out to target magical practitioners. Its attempts to control magical practice increased from 1300 onwards, partly due to a rise in ceremonial magic derived from newly translated Arabic and Greek texts, which posed a more direct threat to clerical authority than the practices of a peasant class.

The Burning of Louisa Mabree, Convicted Witch, Early French Aquatint. Artist unknown, c. 18th century.

In September 1398, the Faculty of Theology at the University of Paris issued a statement condemning magical practice as harmful, whatever its intent.

The Catholic church was concerned about heresy and losing its power over the population, but many clerics also had a genuine fear of the supernatural: the prospect that demons could actually be conjured and cause havoc. This growing fear lent traction to the witch trials.

The anti-witch movement

The stereotypical figure of the witch – a sexually unbridled woman who worshipped the Devil at a witch's sabbath, who could fly at night and who had animal familiars, such as cats – seems to have first arisen in the Pyrenees and Italy. Superstitions derived from local folklore and classical mythology, such as the fear of night-roving cannibal spirits and demons, fed into a growing alarm about witchcraft. A fear that witches murdered children was also a feature of this social panic. Heretics, too, such as the Templars, were accused of consorting with Satan. It is likely, however, that relatively few of those accused actually worshipped the Devil. Nor, except in some geographically distinct regions, were they members of any surviving Pagan religion.

BELOW *A coven of witches around a cauldron, after a 19th-century illustration in* Tales From Shakespeare Designed For The Use of Young Persons *by Charles Lamb, 1807 edition.*

OPPOSITE (TOP TO BOTTOM, LEFT TO RIGHT) *Green blown glass witches' cauldron for herbs and concoctions, c. 1910; a witches' doll pierced with iron nails and thorns that was placed inside a chimney; dried frog – witches were believed to control the weather by concocting brews from frogs, toads and snakes, often referred to as 'Toad Soup'; mole's feet – these played a role as evidence in several witch trials, 18th century; leather boots were concealed inside the chimney and used to trap witches – the smell of burning leather enticed witches into the chimney, 19th century; hollow glass float – in folklore, witches are attracted to the beauty of the ball, and are pulled inside and become trapped.*

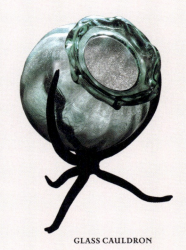
GLASS CAULDRON

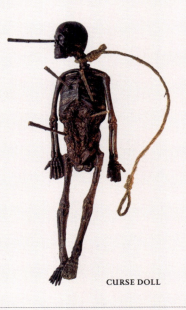
CURSE DOLL

1700 CE

DRIED FROG FOR POISONOUS CONCOCTIONS
AND CONTROLLING THE WEATHER

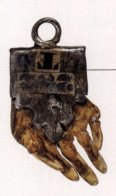
MOULDWARP (MOLE) FOOT AMULET
FOR TOOTHACHE OR CRAMP

CONCEALED BOOT FOR PROTECTING
ENTRY POINTS IN A HOUSE

WITCHES' BALL

The witch trials

Most of the witch trials were held roughly between 1400 and 1782, but we have records of mob trials and the lynching of suspected witches from the 1000s onwards. On the continent, the Inquisition (beginning in 12th-century France) was initially established to punish heresy, but as the Church became more concerned about the use of magic, it also became a primary driver of witch trials. Pope John XXII (1316–1334 CE) drew a link between witchcraft and heresy, and in 1484 Pope Innocent VIII issued a Papal bull against witchcraft, which was used by the German Inquisitor Heinrich Kramer as the basis for a treatise, written in 1486, on how to identify and deal with witches. Around the same time, in 1497, Dominicans Heinricus Institoris and Jacobus Sprenger published the *Malleus Maleficarum* (Hammer of Witches). This work, which remained influential for hundreds of years, sought to prove that magic was not only real but could be used for harmful purposes, particularly by women. Thus, Inquisitors had Papal authority and could act on flimsy evidence, such as rumour or stories told by children. New legislation was introduced: anti-witchcraft acts across various European countries made prosecutions easier. As well as the diktats of the Church itself, mass hysteria has also been blamed, along with ergot poisoning. It is, however, likely that there was not one single cause of these outbreaks of communal violence, but a range of underlying factors.

Witch trials were not confined to the old world. In the USA, the famous Salem trials took place in Massachusetts in the late 1690s, resulting in 200 prosecutions and over twenty deaths, either from hanging, torture to extract confession, or imprisonment. Overall, in Europe and America between 40,000 and 60,000 people were put to death for witchcraft.

Levels of persecution varied throughout Europe. Most persecutions for witchcraft took place in the Alpine areas and southern Germany. Some of these trials, throughout the 1500s and 1600s, involved hundreds of victims, such as those in Trier, Bamburg, Fulda and Würzburg. In Spain and France, the Church was less convinced of the reality of magic, thus prosecutions were fewer. In Britain, the justice system in England limited prosecutions, so the worst persecution occurred in Scotland rather than south of the Borders, with outbreaks in England, such as those generated in East Anglia by the self-styled Witchfinder General, Matthew Hopkins. In Scotland, those found guilty were garrotted then burned, but in England most were hanged. Burning was more commonplace in Europe, particularly in Germany.

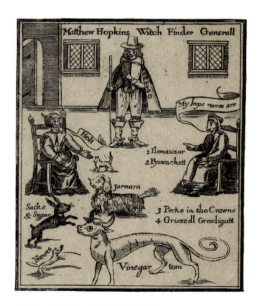

Matthew Hopkins, self-styled Witchfinder General. This is the frontispiece from The Discovery of Witches; *it depicts witches identifying their familiar spirits, 1647.*

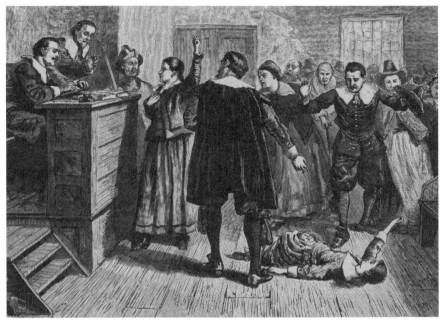

TOP *The trials at Salem, illustration from* Pioneers in the Settlement of America *by William A. Crafts, 1876.*

ABOVE LEFT *Witch pins, preserved among the files of the county court at Salem; the accused were charged with using them to torment their victims, c. 1865 to 1914.*

ABOVE RIGHT *The Rev. George Burroughs was accused of witchcraft on the evidence of feats of strength, tried, hanged and buried beneath the gallows at Salem. Illustration published in* Some Legends of the New England Coast, Part III, *1873.*

IN TRIER, AN EYEWITNESS REPORTED

'Inasmuch as it was popularly believed that the continued sterility of many years was caused by witches through the malice of the Devil, the whole country rose to exterminate the witches. This movement was promoted by many in office, who hoped for wealth from the persecution. And so, from court to court throughout the towns and villages of all the diocese, scurried special accusers, inquisitors, notaries, jurors, judges, constables, dragging to trial and torture human beings of both sexes and burning them in great numbers.'

Scandinavia experienced a less extreme form of the witch trials. Around 860 people were tried for witchcraft in Norway, and there was a spate of trials in Denmark in the 1620s. In Iceland, more men than women were accused of witchcraft.

These were some of the last outbreaks of witch hunting in the West: by the time the Salem trials took place, witch trials in Europe were already beginning to die down. In Europe, the last alleged witch to be killed was Anna Goeldi, who was executed in 1782 in Switzerland after she was accused of putting a spell on the daughter of the household in which she was a maidservant. Alice Molland, hanged in Exeter in 1684, was the last person to be executed for witchcraft in England, and Janet Horne was the last in Scotland, in 1722.

The role of heresy

Witch trials are regarded by some historians as an adjunct to heresy trials. There were many prosecutions for heresy as groups held to be heretical by the Catholic Church, such as Waldensians, Lollards, Cathars, Hussites and many more, gained ground throughout Europe during this period. Ironically, a great many of the people who were executed during this period were not witches. Many of those in post-Reformation Britain would have been secret heretics, such as Catholic recusants, or wealthy landowners such as Alice Nutter at Pendle, Lancashire, whose house was coveted by a local magistrate. Some of them would have believed in their own magical powers, but some would have been delusional or simply petty criminals. In some parts of Europe, such as Finland, a few were indeed genuine magical practitioners such as Sámi shamans. Overall, however, service magicians, such as cunning folk in Britain, were comparatively rarely accused. Many people would simply have been falsely accused, a result of unpopularity or victims of a sweeping moral panic: much of the pressure to prosecute accused witches seems to have come from local people, feeding into the anti-witchcraft legislation of the Church.

Gradually, however, the phenomenon of the witch trials lessened, as the Church and courts became more rigorous in assessing accusations, and victims became more likely to be subject to correction rather than execution.

OPPOSITE *Trier witch trials. Pamphlet, 1594.*

BELOW LEFT *Hexen process in Mora, 1670.*

BELOW RIGHT *German illustration of Anna Goeldi, Glarus, 1782.*

PART TWO
DIVINATION

EGYPTIAN ASTROLOGY

The study of the stars in ancient Egypt

ORIGINS: Egypt
DATES: *c.* 3100–332 BCE
PURPOSE: Foretelling the future

Astrology was of great importance in ancient Egypt. For people living in this period, light pollution would not have been the problem that it is today, and the constellations would have been prominent. Priests studied the movement of the stars to predict important events, such as the rise of the River Nile: the ascent of Sirius heralded the beginning of the annual floods.

Star charts were produced from the 9th Dynasty onwards (*c.* 2160–*c.* 2130 BCE). Whereas the Mesopotamians developed the zodiac signs as we know them and also developed the concept of natal astrology, for the Egyptians, astrology was based on asterisms (small star clusters rising above the horizon), and instead of a sign for each monthly period, their astrology applied to particular days of the month. The Egyptian bas-relief known as the Denderah Zodiac depicts the signs of the zodiac which are familiar to us, with Egyptian representations of some, such as Hapus for Aquarius.

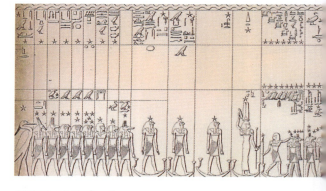

ABOVE *Inscription from the Cenotaph of Seti I portraying the 36 decans,– 1290–1279 BCE.*

The Egyptians also worked with the decans: these are divisions of each zodiac sign which affect the sign's characteristics. There are thirty-six of them, each of the twelve signs being divided into three decans. After Egypt was conquered by Alexander in 332 BCE, Babylonian astrology and Egyptian astrology began to merge, combining the decans with the signs of the zodiac itself. Two of the signs – the Scorpion and the Balance (Scorpio and Libra) – were introduced from the Babylonian system. The Book of Nut, named after the Egyptian goddess of the sky, gives details of the decans and the stars, and the 2nd-century CE Alexandrian astronomer Ptolemy set the basis for Western astrology in his *Almagest* and *Tetrabiblos*, which present astrology as a natural science and a legitimate subject of study. We also have horoscopes inscribed onto papyri and potsherds (*ostraka*) from 1st-century Egypt and there is evidence that Egyptian astrologers cast horoscopes for newborn children.

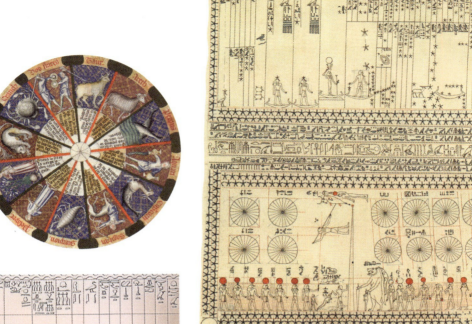
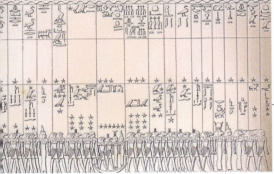

TOP LEFT *Wheel of the zodiac from the Breviari d'Amour, originally published in Catalonia, 14th century.*

TOP RIGHT *Top and bottom portions of the Celestial Diagram in the tomb of Senenmut, c. 1479–1458 BCE.*

RIGHT *Terracotta astrological disc, Egypt, 30th Dynasty, Ptolemaic Period (332–31 BCE).*

FAR RIGHT *The goddess Bastet on a throne decorated with the decans. Third Intermediate Period (c. 1070–664 BCE).*

DIVINATION

ASTRONOMICAL CEILING

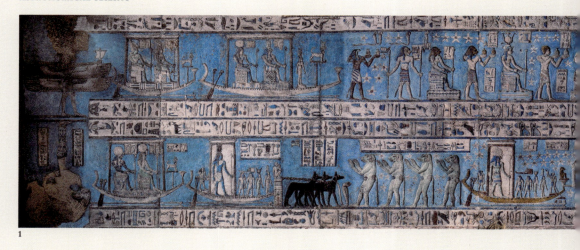

1

ASTROLOGICAL MAP

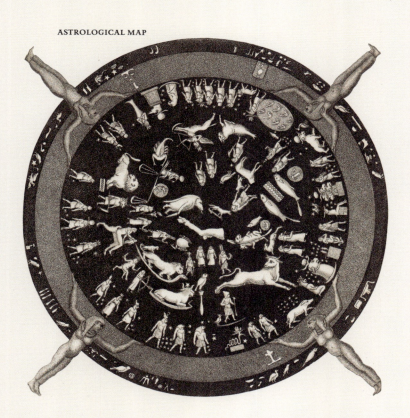

2

LEFT *Drawing of the zodiac relief from the ceiling of the temple of Hathor at Denderah, Egypt. The illustration is from the* Universal Dictionary of Arts, Sciences, and Literature *published in London, 1810–1829.*

TEMPLE PORTICO

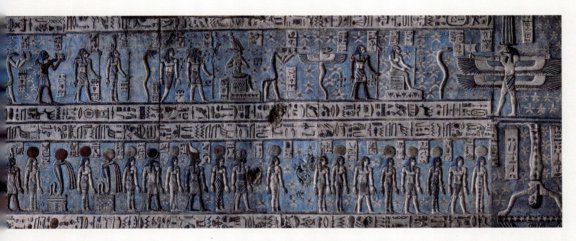

1 2

ABOVE *Astronomical ceiling at the Hathor Temple of Denderah, ceiling of the pronaos (portico), chapel dedicated to Osiris, 30 BCE–30 CE.*

TOP RIGHT *Illustration of the interior of the Portico of the Temple of Denderah, Egypt, 19th century.*

DIVINATION

LEFT *An illustration of the ancient Greek philosopher and scientist, Aristotle.*

BELOW *Illustration showing the position of the Sun, Moon and planets and the band of the ecliptic. System proposed by Claudius Ptolemy in the 2nd century CE, 1660.*

ABOVE *Portrait of Ptolemy by Justus van Gent and Pedro Berruguete, 1476.*

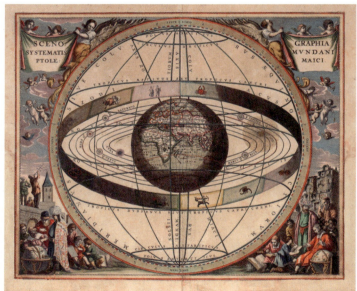

GREEK ASTROLOGY

Astrological theories in ancient Greece

ORIGINS: Greece
DATES: *c.* 900 BCE–600 CE
PURPOSE: Foretelling the future

Astrology was popular in classical Greece, being adopted from the Babylonians and taught in the philosophical schools of Plato, the Stoics and Aristotle. Some Hellenistic astrologers attributed the origins of astrology to Hermes Trismegistus, who is said to have developed the system of houses. (This legendary figure appears elsewhere in this book as he is cited by many later occult practitioners, particularly in Rosicrucianism and Hermetic practice.)

However, most authorities suggest that astrology became widespread in Greece around the 4th century BCE, and there are references to a Babylonian astrologer, Berossus, who reputedly set up a school of astrology on the island of Kos in 280 BCE. Much of later Greek astrology was influenced by the work of the 2nd-century CE Alexandrian astronomer Ptolemy, but the basis of the study was already firmly established prior to this. The Greeks took on the Ptolemaic idea of astrology as a natural science, but also saw it as a form of divination that could be influenced by the gods. In the 2nd and 3rd centuries CE, Greek astrology spread to India via translations in Sanskrit (initially by Yavaneshvara, writing in 149/150 CE, which became the *Yavanajataka* compiled by Sphujidhvaja around 269/270 CE).

Hellenistic astrology included elements of Egyptian astrology, such as the decans. Like Mesopotamian astrology, Hellenistic astrology focuses on the natal chart and the ascendant (a person's rising sign – the sign rising on the eastern horizon at the moment of birth). The earliest Greek papyri that mentions astrology dates to 29 BCE. It not only makes a prediction based on the natal day of the inquirer, but also the position of the five planets (Mars, Venus, Saturn, Mercury and Jupiter – all that were known at the time), plus the sun and moon. The word 'zodiac', which means 'a procession of animals' in Greek, is still used today: Hellenistic astrology entered the Islamic world, from which it was reintroduced into Europe.

100–170 CE

PALMISTRY

Divination carried out by studying the human hand

ORIGINS: Global
DATES: 5th–1st century BCE
PURPOSE: Divination, insights into the personality

Palmistry is the art of reading palms. It is divided into two main areas of study: cheiromancy, which studies the shape of the hand and the fingers, and chirology, which studies the palm itself. Both hands should be studied. The palmist examines a person's hands to gain insights into their personality or to foretell the future.

Palmistry appears in cultures across the world, including those of Sumer, Egypt, India and China. The Hindu sage Valmiki is said to have written a text several thousand years ago that gives details of palm reading, but the practice also developed in Greece. Aristotle (384–322 BCE) reputedly discovered a treatise on palmistry on an altar to Hermes and gave it to Alexander the Great. There are also references to the practice in the Bible (Job 37:7, 'He sealeth up the hand of every man, that all men may know his work').

Palmistry remained a popular form of divination throughout the Middle Ages, but the Church did not approve, including it in a list of banned practices in the 1500s. Yet interest persisted; in 1839 the French Captain Casimir Stanislas D'Arpentigny published a popular work titled *La Chirognomie*, and in 1889 Katharine St. Hill founded the Cheirological Society of Great Britain. A similar organization, the American Chirological Society, was established in the US by Edgar de Valcourt-Vermont in 1897. Throughout the late 19th and early 20th centuries, the practice became very popular. Palmists such as Cheiro, the pseudonym of Irishman William John Warner (1866–1936), gained global followings; Warner's celebrity clients included Oscar Wilde, Mata Hari and Mark Twain.

ABOVE *Sage Valmiki composing the Ramayana.*

OPPOSITE *Adaptations of Illustrations that originally appeared in* Perin's Science of Palmistry; A Complete and Authentic Treatise, *1902.*

PALMISTRY

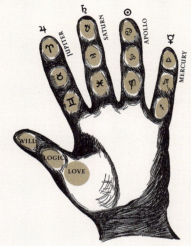

FINGERS

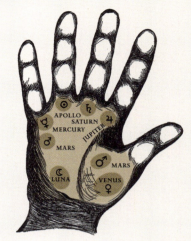

MOUNTS

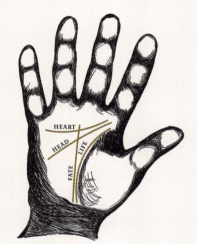

MAJOR LINES

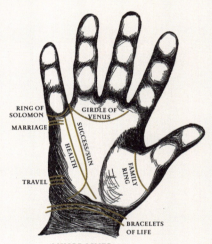

MINOR LINES

ELEMENT HANDS

FIRE HAND

EARTH HAND

AIR HAND

WATER HAND

LONG
SHORT

DIVINATION

FROM THE 'HÁVAMÁL'

'I know that I hung on a windy tree

nine long nights,

wounded with a spear, dedicated to Odin,

myself to myself,

on that tree of which no man knows from where its roots run.

No bread did they give me nor a drink from a horn,

downwards I peered;

I took up the runes,

screaming I took them,

then I fell back from there.'

RUNES

Divination through the use of runes

ORIGINS: Northern Europe
DATES: *c.* 150–1100 CE
PURPOSE: Originally writing, now prediction

The runes are a form of northern European divination devised by Germanic tribes. They date from around 150 BCE and were replaced by the Roman letters around 700 CE, although others may derive from early Italic alphabets.

The word 'rune' comes from a Germanic word meaning a 'mystery', 'secret' or a 'whisper'. Their original name is *fuþark* (futhark), deriving from the first six initial letters of the runes: *fehu* (cattle), *uruz* (aurochs), *thurisaz* (thorn), *ansuz* (ancestral god/Odin), *raidho* (wagon) and *kenaz* (torch). Runes take the form of a number of symbols which stand for different aspects of human existence. There are a number of variations on this system, including the Elder Futhark (150–800 CE), the Old English Futhark (400–1100 CE) and the Younger Futhark (800–1100 CE). The Elder Futhark is divided into three sets of eight, which are known as the *aettir* (each set is an *aett*). Some runes seem to be taken from the Roman alphabet, but others may come from early Italic alphabets.

The modern use of runes, however, may not bear a great relationship to their use in ancient times: originally, they seem to have been used primarily for lists of goods, inscriptions and graffiti rather than for divination, which is their principal use today. Modern rune sets can be purchased in which the runes are carved onto wooden tiles, stones or metal. In the part-saga known as the 'Hávamál', the Norse god Odin credits them with being able to restore the dead to life (see opposite).

OPPOSITE *Illustration of the Stranger at the Door from the 'Hávamál', illustrated by W. G. Collingwood, 1908.*

RIGHT *A set of Nordic Runes – the Elder Futhark.*

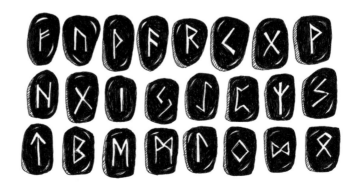

DIVINATION

RENAISSANCE ASTROLOGY

The study of the stars in Renaissance Europe

ORIGINS: Europe
DATES: c. 1300–1650
PURPOSE: Prediction, personality insights

1411–1485 CE

Astrology was widespread in Europe throughout the Renaissance and was used in all aspects of life, from politics and medicine to the planning of dynastic alliances. Renaissance astrology included the Behenian (fixed) stars, such as Arcturus, Vega and Capella.

The name derives from the Arabic *bahman*, or 'root', as there was supposed to be a relationship between these stars and the planets: each planet takes its power from the corresponding star. The name may also come from the herb *Centaurea behen*, or saw-leafed centaury, which was known as the 'beekeeper's herb' – the dome of stars, drawn from above, resembles bees in a hive.

Ancient roots

Most of our star names come from Arabic – any star beginning with the prefix 'al', for instance, has an Arabic name. When astrologers in medieval Europe began their work, they started to look closely at Persian, Arabian, Hebrew and other Eastern astrological systems and took a great deal from them, although some asserted that they were merely reclaiming astrology from Arabic influence. Astrologers also looked towards Greek authorities, such as Ptolemy. The Renaissance mage Cornelius Agrippa in his *Three Books of Occult Philosophy* (1531) explains how to make talismans of fixed stars, as does the grimoire *The Picatrix* (first written in Arabic as the *Ghāyat al-Ḥakīm* in the 11th century).

This undertaking relies on the theory of correspondences, which we find throughout Western occult philosophy: each planet is associated with a gem, herb, animal and so on.

OPPOSITE *June, an illustration from Très Riches Heures du duc de Berry, 15th century.*

THE PICATRIX

HOW TO MAKE TALISMANS OF FIXED STARS:

'Now, the manner of making these kinds of rings [& talismans!], is this, viz., when any star ascends fortunately, with the fortunate aspect or conjunction of the Moon, we must take a stone, and herb that is under that star, and fasten it under that star and make a ring of the metal that is suitable to this star, and in it fasten the stone, putting the herb or root under it; not omitting the inscription of images, names and characters, and also the proper suffumigations...'

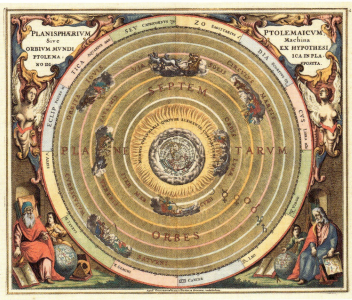

14th century CE

OPPOSITE *Fragment from an edition of* The Picatrix, *14th-century.*

TOP *Celestial map, manuscript of Zubdat al-Tawarik, 1583.*

ABOVE *Celestial map illustrating Claudius Ptolemy's model of the universe, 1660.*

DIVINATION

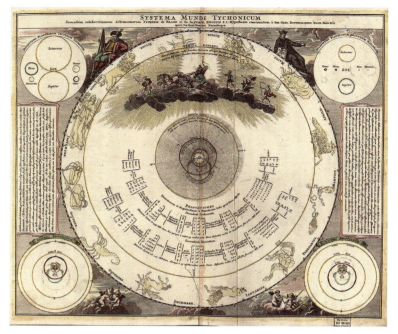

TYCHO BRAHE

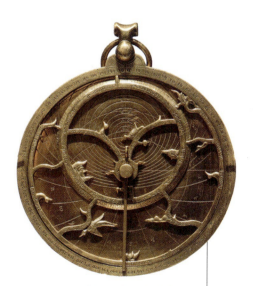

CHAUCER ASTROLABE

WILLIAM LILLY

Renaissance revivals

Chaucer mentions astrology in his *Canterbury Tales*, which begin with a mention of the alignment of the zodiac in spring: the sun 'hath in the Ram his halfe cours yronne'. He also wrote a *Treatise on the Astrolabe* in 1391 for his son. One of the first recorded British astrologers is Richard Trewythian, who kept notes of his astrological predictions between 1430 and 1458, along with details of how he arrived at his astrological conclusions. In 1433, for example, these predictions included the health of King Henry V: 'it seems that the king will be sick this year because Saturn is lord of the tenth house.' The development of natal charts for kings, queens and popes became popular, too. John Dee, the famous 16th-century magician, drew up the astrological charts for Queen Elizabeth I's coronation in 1559.

The Italian philosopher Marsilio Ficino published his *De vita libri tres* (Three Books on Life) between 1480 and 1489. The third book, *De vita coelitùs comparanda* (On Obtaining Life from the Heavens), describes how the movement of the planets affects all human life and includes a number of astrological charts and instructions on the making of astrological talismans and how to conduct magical ceremonies. Girolamo Cardano (1501–1576) was another well-known Italian astrologer, mathematician and scientist, who also made a study of algebra that is still referenced today. In 1543 he published his work on astrology *De supplemento almanach*, which is a commentary on Ptolemy's *Tetrabiblos* and contains a natal horoscope of Christ. This brought Cardano to the attention of the Inquisition and he was arrested and imprisoned, although he was freed after several months, probably through the intervention of powerful contacts.

The development of printing did much to circulate the precepts of astrology. In the mid-17th century, the English astrologer William Lilly issued an annual almanac entitled *Merlinus Anglicus* (The English Merlin) and its estimated annual circulation reached 30,000 copies. The total number of almanacs printed in England in this period exceeded the number of Bibles, and it's estimated that one third of all English households had astrological almanacs. Lilly was seeing around 2,000 clients per year, some of them very wealthy but also servants and those of more lowly birth. People wanted to know things about their health, their money, love and good fortune, and the future of their children. Lilly's speciality was horary astrology, which concerns itself with the time at which a particular question is asked, and which deals with current events and the prediction of world affairs.

Some European astronomers were also astrologers, such as Tycho Brahe (1546–1601) and Johannes Kepler (1571–1630). The two branches of study were initially much more closely related than they are today. Yet astrology had its critics; in 1496, the philosopher Count Giovanni Pico della Mirandola's work *Disputationes adversus astrologiam divinatricem* (Disputations against Divinatory Astrology) was posthumously published, drawing a distinction between astronomy and astrology. The ideas it contained gained traction and astrology began steadily to attract the negative attention of the Catholic Church, which regarded it as potentially evil, and in 1586 a papal bull was issued against the practice. As we can see from the success of Lilly's publications, however, the efforts of the Church were not successful in stamping astrology out and it remains a significant interest among many people today.

1326 CE

TOP LEFT Systema Mundi Tychonicum by Johannes Doppelmayr, 1740.

FAR LEFT So-called Chaucer Astrolabe, dated 1326.

LEFT Birth chart for astrologer William Lilly, 1602–1681.

TAROT

Divination through the use of Tarot cards

ORIGINS: Italy
DATES: *c.* 18th century
PURPOSE: Foretelling the future

The Tarot gradually began to gain recognition in Italy throughout the Renaissance, and may have been devised by the artist Bonifacio Bembo as a means of flattering the Visconti family of Milan. In this early stage of its history, the cards were a game, called *Tarocchi*. The true origins of the Tarot, however, remain unclear, although some would like to claim very ancient roots for this form of divinatory practice.

Origins of the Tarot

In the 1770s–1780s, the French scholar Antoine Court de Gebélin wrote a nine-volume esoteric work called *Le Monde Primitif* (The Primitive World). He had, so he said, visited a female friend, who had shown him a new card game that was becoming increasingly popular. It featured a set of decorated cards, called *Tarocchi* in Italian and *les tarots* in French. Court de Gebélin claimed that he had a revelation that this game was Egyptian in origin. He called it the *Book of Thoth*, after the ibis-headed Egyptian god of scribes and learning, asserting that Thoth himself had given the images of the Tarot cards to his disciples and they had sent them down through the centuries in the form of a game. This is analogous to claims that Hermetic texts derive from Hermes Trismegistus: ancient sages are often invoked in the occult to lend legitimacy to practices and claims.

Some commentators have suggested that Court de Gebélin and a later admirer of his, the Comte de Mellet, who linked the Tarot images to the letters of the Hebrew alphabet, were Freemasons, and that Court de Gebélin's story about being introduced to the Tarot by a lady friend was a disguise for the Masonic images. His is only one among many claims that have been made about the origins of the Tarot – that they come from ancient Atlantis, or are the creation of Cathar-inspired papermaking guilds, or represent Chaldean phases of the moon. There are almost as many origin stories for the Tarot as there are cards in a deck.

OPPOSITE *Tarot trump card designs from the Court de Gébelin essay, 'Du Jeu des Tarots,' 1781.*

ABOVE *The Tarocchi Players. Fresco from the Casa Borromeo, Milan, 15th century.*

Modern forms of the Tarot

The Tarot has gone through many forms and changes across the centuries. One of the most common decks today, which dates from 1910, is known as the Rider-Waite-Smith, Rider being the publisher, Arthur Waite the interpreter and Pamela Coleman Smith the illustrator. Both Waite and Coleman Smith were members of the late 19th-century occult society of the Hermetic Order of the Golden Dawn, and it was this society that popularized the Tarot at the turn of the century. Members of the Golden Dawn, such as Aleister Crowley and Arthur Waite himself, drew up their own decks.

Crowley's tarot is, like the Court de Gebélin's, named the *Book of Thoth*, and is beautifully illustrated in a Deco/Nouveau style by Lady Frieda Harris. Waite attracted some criticism for changing the look of the cards (the Sun, for instance, shows a child on a white horse riding from a garden, rather than the traditional image of two children within a garden), but if Crowley didn't like the message of a card, he simply made up another one. Thus Temperance, a calm, angelic figure in the Rider-Waite-Smith deck, is transformed into Lust in Crowley's deck, with the Whore of Babylon riding upon a beast.

In its most popular current forms, the Tarot is divided into the Major Arcana, consisting of twenty-two cards, and the Minor Arcana, made up of a further fifty-six cards. The Major Arcana, beginning with the Fool, represent the journey of the soul through the human world, then down into death and subsequently to resurrection and spiritual understanding. The Minor Arcana are based on four suits of fourteen cards each, representing the elements: pentacles for earth; cups for water; wands for fire; and swords for air. The cards of each suit depict all the various situations that a person might encounter throughout their life – falling in love, loss, wealth, difficulties in communication, being betrayed and so forth. As in ordinary playing-card decks, there are also court cards: pages, knights, queens and kings, usually held to represent people in the life of the inquirer.

A Tarot reader will use one of a series of popular spreads (the way in which the cards are laid out) for their client, typically a Celtic Cross spread, which depicts several situations: the querent at the time of the spread; whatever is blocking them; the root of the situation; their perspective upon it; the recent past and future, and then the next six months; their relationship; their hopes and fears; and the outcome. This is supposed to represent a snapshot of time and the future is not fixed, but is open to change. Some cards have a sinister reputation, such as the card that depicts Death – but in the Tarot, this simply means change.

We have seen that the Tarot can be linked with the Kabbalah, and in addition there are astrological links between the Major Arcana and astrology. It is also connected to the ordinary playing-card deck and this, too, can be used as a predictive system if you know its elemental correspondences, although it is more limited in scope as there is no equivalent to the Major Arcana, only to the Minor. Today, there are a variety of oracle decks that resemble the Tarot but are based on other spiritual systems and use different correspondences. Some Tarot readers also use the Chinese system known as the *I Ching*, which is entirely different and is often read via the use of yarrow sticks rather than cards.

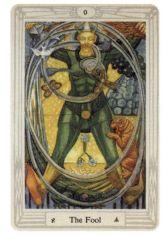
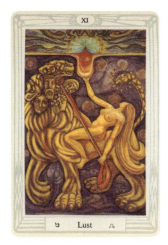
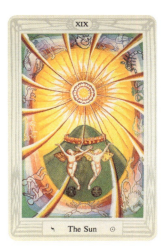

1701 CE

TOP LEFT *The Fool*, Visconti-Sforza Tarot *by Bonifacio Bembo, Milan, Italy, c. 1480–1500.*

TOP RIGHT, RIGHT AND FAR RIGHT The Book of Thoth *Tarot (the Fool, Lust and the Sun) by Frieda Harris, 1944.*

BELOW LEFT *Fortune teller on the streets of Japan, photo by Elstner Hilton, between 1914 and 1918.*

BELOW RIGHT *Diagram of I Ching hexagrams owned by Gottfried Wilhelm Leibniz, 1701.*

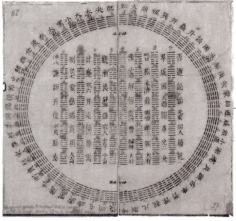

Cards of the Tarot

The twenty-two cards of the Major Arcana of the Rider-Waite-Smith Tarot deck, illustrated by Pixie Colman Smith, 1909.

THE FOOL

THE MAGICIAN

THE LOVERS

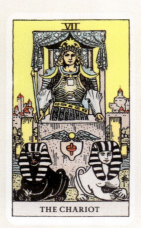
THE CHARIOT

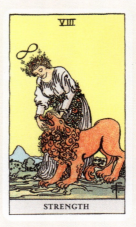
STRENGTH

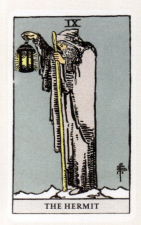
THE HERMIT

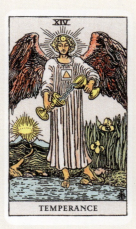
TEMPERANCE

THE DEVIL

THE TOWER

THE STAR

THE HIGH PRIESTESS

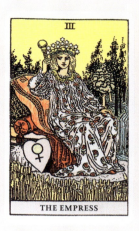
THE EMPRESS

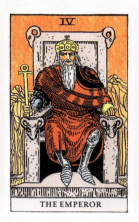
THE EMPEROR

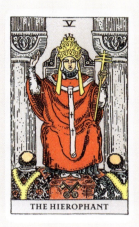
THE HIEROPHANT

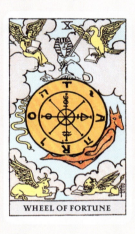
WHEEL OF FORTUNE

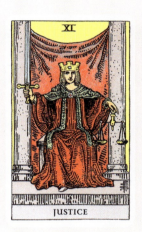
JUSTICE

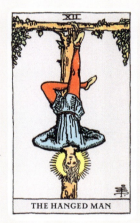
THE HANGED MAN

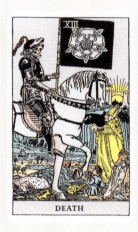
DEATH

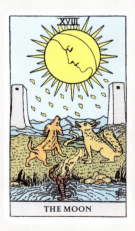
THE MOON

THE SUN

JUDGEMENT

THE WORLD

LEFT Feiluan xin yu.
Representation of fuji (planchette spirit-writing method) or 'descending of the phoenix', 1884–1889.

BELOW *Ouija board illustration.*

BOTTOM *Ouija board from the Kennard Novelty Company, c. 1890.*

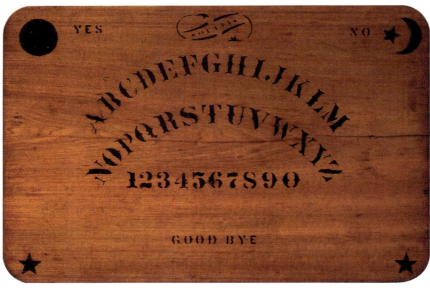

OUIJA BOARDS

Contacting the dead by means of a spirit board

ORIGINS: China, USA
DATES: 1890–present day
PURPOSE: Communicating with spirits and the dead

Ouija boards, sometimes called spirit boards or talking boards, have one of the most sinister reputations of all the tools of the occult. The name derives either from the French and German words for 'yes' (*oui* and *ja* respectively), or was coined in 1890 by the American medium Helen Peters Nosworthy, sister-in-law of Elijah Bond, who with his business partner, Charles Kennard, claimed to have invented the board.

Ouija boards are marked with the letters of the alphabet and numbers, and are accompanied by a small glass or a heart-shaped piece of wood named a planchette. The idea is that the visiting spirit – either a dead person or an astral being – moves the planchette or the glass around the letters to spell out a message.

Planchette writing dates from 12th-century China, where it appears during the Song Dynasty, but it became popular in the USA in the latter half of the 19th century, after the Civil War, when people were desperate to communicate with those killed in the conflict. The board was first patented by Maryland lawyer Elijah Bond in 1890. Now, 'Ouija' is trademarked by Hasbro, and the boards were marketed as a parlour game throughout the 20th century. The use of Ouija boards is often targeted today by the Christian Church as Satanic, but they are not usually employed to summon the Devil, and are more often used in mediumship and seances to contact the dead. Many occultists, however, urge caution in the use of the Ouija board.

Many writers and poets have claimed to have gained inspiration through the use of Ouija boards, including the Irish Romantic poet W. B. Yeats. In 1982, American poet James Merrill published the results of his long-term experimentation with the Ouija board and spirit guides in his award-winning work *The Changing Light at Sandover*. Sceptics, on the other hand, claim that, like dowsing and the use of pendulums, the moving of the planchette is simply a consequence of micro-movements of the medium's hands (the ideomotor response).

DOWSING DATES BACK HUNDREDS OF YEARS

A poem about dowsing from the 17th century.

'Some Sorcerers do boast they have a Rod,
Gather'd with Vowes and Sacrifice,
And (borne about) will strangely nod
To hidden Treasure where it lies;
Mankind is (sure) that Rod divine,
For to the Wealthiest (ever) they incline.'

Samuel Sheppard, 'Virgula Divina', 1651

DOWSING

Divination to find water or other substances with rods

ORIGINS: Europe
DATES: Unknown to present day
PURPOSE: Divining the flow of underground water, locating metals and other substances

Dowsing, sometimes referred to as 'water witching' or radiesthesia, is the art of finding precious metals, water, treasure or even dead bodies beneath the earth using dowsing rods or a forked stick.

Hazel is traditionally used, although American dowsers use witch-hazel, and rowan and willow can also be employed; some dowsers also use a pendulum, keys or wire coat hangers. Holding the ends of the 'fork' in both hands, the dowser finds a place to start walking and waits for the wands or stick to begin twitching – an indication of water or metal below the earth.

As an occult practice, dowsing was held to break the First Commandment of the medieval Church, 'You shall have no other gods before Me'. Nevertheless, it was commonly used throughout mining districts in the UK and Europe, particularly in Germany. In 1961 the American Society of Dowsers was set up in Vermont, and dowsing is still used today in the oil and water industries, although many remain sceptical regarding its efficacy. Dowsing is supposed to work by picking up vibrations that are emanated from the substance that is being sought, but sceptics believe that the twitching of the dowsing instruments results from micro-movements of the dowser's hands, known as the ideomotor effect. Double-blind empirical trials have suggested that dowsing is in fact ineffective, but this does not appear to have hampered its popularity.

ABOVE The Dowser by Pietro Bellotti, 17th century.

OPPOSITE A French engraving of four scenes, depicting: trial by water, people using divination rods, and different types of rods.

PENDULUMS

Divination through the use of the pendulum

ORIGINS: Global
DATES: Unknown to present day
PURPOSE: Answering questions, divination

Pendulums have been used for the purposes of divination for many years. They consist of a weight, such as a crystal, metal weight or gem, which can be round or pointed, hung at the end of a string or chain. In the context of divination (as opposed to their use in engineering) they are used to answer questions.

The querent asks the pendulum to indicate a yes/no answer via the type of its motion (circular or from side to side). Pendulums are used to find lost objects, answer questions relating to health and allergies, and sometimes to dispel negativity in the local environment.

It is unclear when pendulums first began to be used for divination, although some authorities believe that the Pythian Oracle in Delphi may have used one, which would date their use to at least 400 BCE, and they are also found in ancient China as a means of determining the presence of evil spirits. Pope John XXII banned their use in the 14th century, suggesting that their employment was already well known as an aspect of witchcraft.

The French chemist Michel Eugène Chevreul investigated their use in 1833, reaching the conclusion that their motion is due to tiny, involuntary movements of the hand; whether or not this is the case, diviners still find pendulums useful today. In the early 20th century, the French priest Abbé Mermet was hired by the Vatican to use an ebonite pendulum to find missing treasure in a reversal of the previous policy. He also worked in South Africa and many other regions of the world in search of minerals and watercourses (pendulums can also be used for the purposes of dowsing). His book *Principles and Practice of Radiesthesia: Textbook for Practitioners and Students* is still available and so are copies of his pendulum, usually produced in bronze.

OPPOSITE TOP *A selection of divining pendulums.*

OPPOSITE *Father Alexis Mermet, priest and dowser, surrounded by fellow diviners in Haute-Isle, France, 1933.*

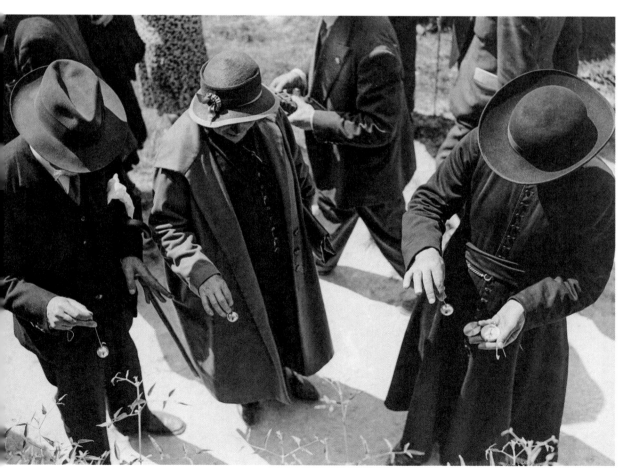

DIVINATION

SCRYING

Divination through the use of a scrying mirror or black liquid

ORIGINS: Classical world, Renaissance
DATES: Unknown to present day
PURPOSE: Foretelling the future, communicating with spirits and the dead

Scrying, also known in the past as 'peeping', is a form of divination that is used for predicting the future and other forms of far-seeing. The College of Psychic Studies tells us that it is a method of accessing the unconscious mind.

Typically, the scryer stares into an opaque, transparent or darkly reflective surface such as a black mirror, a bowl of ink or a crystal ball, although some scryers are able to work simply by closing their eyes. The scryer then enters a trance that enables them to witness future events, but also sometimes the past, or events happening elsewhere at the same time. Divination in ancient China was carried out through the study of oracle bones – such as tortoiseshell or the shoulder bone of an ox. These were heated and the cracks were interpreted (*c.* 1400 to 1200 BCE, Shang Dynasty). There are also mentions of scrying in ancient Egypt and Greece.

The French mystic Nostradamus used either a magic mirror or a bowl of water placed on a tripod in order to undertake scrying: he would stare at the water until he saw a 'slight flame' and would then note what he perceived, which he then collated into his famous work *Les Prophéties* (1555). His prophecies have remained a source of fascination ever since, fuelling claims that they predicted the death of John F. Kennedy as well as the events of 9/11.

The English magician John Dee (1527–1608) used a black mirror, made from Mexican obsidian, to see the future and to contact spirits or angels (it is now in the British Museum). Horace Walpole wrote of Dee's associate Kelly, quoting Samuel Butler's poem 'Hudibras', (see below).

Amateur scrying also appears in folklore. Young women wishing to see the face of their future husband would look into a bowl or a mirror on Hallowe'en.

> 'Kelly did all his feats upon
> The Devil's Looking Glass, a stone;
> Where playing with him at Bo-peep,
> He solv'd all problems ne'er so deep.'
>
> HORACE WALPOLE, QUOTING
> SAMUEL BUTLER'S POEM 'HUDIBRAS'

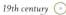
19th century

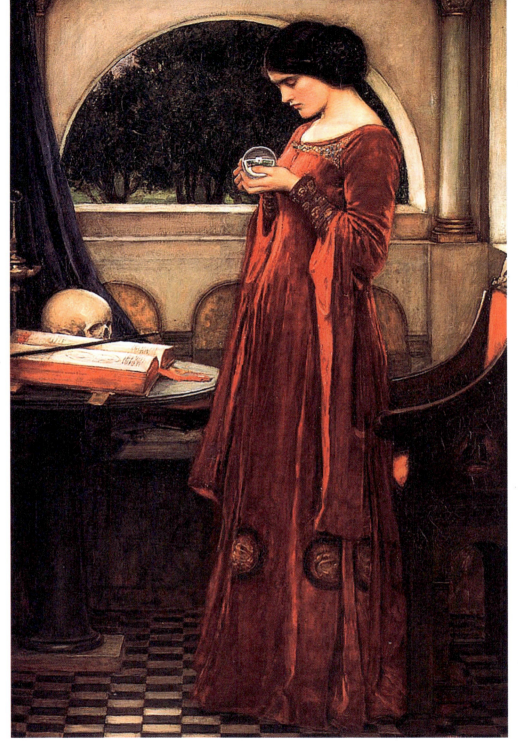

OPPOSITE *Magic mirror with an image of the Amitābha Buddha, Japan, 19th century.*

ABOVE *The Crystal Ball by John William Waterhouse, 1902.*

PART THREE
RITUALS AND RITES

EGYPTIAN RITUALS

Magical ceremonies in ancient Egypt

ORIGINS: Egypt
DATES: 1550–1650 BCE
PURPOSE: General magical practice, safeguarding the souls of the dead

Many Egyptian rituals were performed to ensure the safe passage of the dead through the Duat (underworld). One such ritual was known as the 'Opening of the Mouth' ceremony. The mouth of the dead person was physically opened during the mummification process and the Opening of the Mouth ritual was performed after mummification, so that the soul of the deceased could breathe in the Duat.

The ceremony was also conducted on inanimate images, such as statues, to make those images a suitable conduit for the divine force which it represented. Offerings would then be made regularly to that force, which could be a god, a king or a deceased individual, by presenting the statue with clothes, food and drink, or ointments and scented oils (otherworldly entities were believed to have similar physical requirements to living human beings). Some offerings were specific to a particular deity: mirrors were offered to the goddess Hathor, who was the patron deity of love, for example. Such offerings were made daily, and were intended to maintain the balance and continuation of the cosmos by propitiating the divine spirits manifested within the statues.

OPPOSITE LEFT *Mirror with Hathor emblem handle, New Kingdom, Egypt, c. 1479–1425 BCE.*

OPPOSITE RIGHT *Mummy mask cartonnage, Egypt, Manchester Museum, 305 BCE.*

RIGHT *Nakhtamun's Funeral Procession, Tomb of Nakhtamun, c. 1279–1213 BCE.*

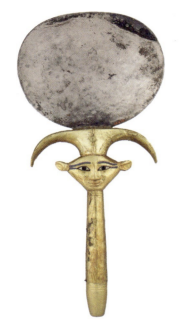
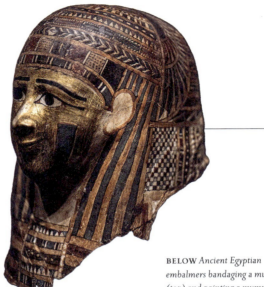

BELOW *Ancient Egyptian embalmers bandaging a mummy (top) and painting a mummy (bottom). Illustration from* The Holy Bible containing the Old and New Testaments, *1896.*

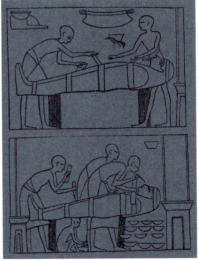

305 BCE

CANOPIC JARS

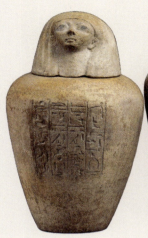

ISIS
PROTECTS THE
LIVER

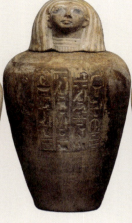

NEPHTHYS
PROTECTS THE
LUNGS

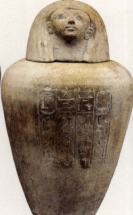

NEITH
PROTECTS THE
STOMACH

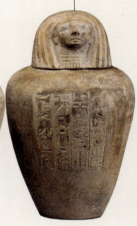

SELKET
PROTECTS THE
INTESTINES

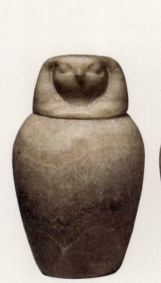

KEBEHSENUEF
(FALCON-HEADED)
PROTECTS THE
INTESTINES

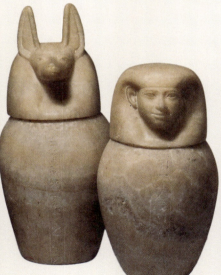

DUAMUTEF
(JACKAL-HEADED)
PROTECTS THE
STOMACH

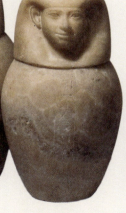

IMSETY
(HUMAN-HEADED)
PROTECTS THE
LIVER

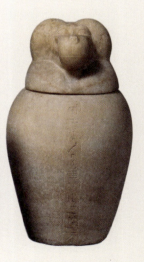

HAPY
(BABOON-HEADED)
PROTECTS THE
LUNGS

Egyptian ritual practices

These rituals took place within temples, in tombs, in houses and also in the streets: statues of gods were paraded in a community during some festivals to enable people to experience the power of the deity directly. We have a description of an Opening of the Mouth ritual from papyri dating from *c.* 945–800 BCE, in the 22nd Dynasty, relating to the worship of the god Amun-Ra and the goddess Mut at Karnak in Thebes. Incense would be burned before the daily ritual, which was held in a sealed shrine and which was not open to the public. Rulers would sometimes participate. A liturgy would be read and a sistrum would be shaken in order to drive away any evil influences. The shrine would then be opened and the priest, having purified himself, would greet the deity by kissing the ground in front of the image and then raising his arms in worship. Hymns were sung and the priest would make the appropriate offerings to the deity. The statue would be draped with cloth and might be offered cosmetics, such as eye make-up. Once this was done, the priest would leave the shrine, having made offerings of incense, natron (a cleansing salt mixture) and water. In the Papyrus Berlin 3055 (22nd Dynasty), which relates to the worship of Amun-Ra, a great deal of detail is provided relating to preparations for the ritual, giving formulae for lighting the fires, breaking the seals on the shrine, and even for the manner in which the priest must place his hands on sacred items in order to perform the purification.

Sacrifices

Egyptian rituals sometimes involved offerings of animals – for instance, hippopotami and crocodiles appear as offerings in one of Egypt's very oldest temples, at Hierakonpolis (*c.* 3500 BCE). However, practices may have changed over time, as the Greek author Herodotus, writing in the 5th century BCE, relates that the Egyptians were prohibited from sacrificing animals except bullocks, pigs and bulls.

OPPOSITE *Canopic jars were used to hold organs which the spirit was believed to need in the afterlife. The jars were protected by the four funerary goddesses: Nephthys, Isis, Neith and Selket (top), c. 1504–1447 BCE. Later canopic jars included depictions of the Four Sons of Horus: Kebehsenuef, Duamutef, Imsety and Hapy (bottom), c. 664–525 BCE.*

RIGHT *An illustration of the Opening of the Mouth ritual from the Book of the Dead papyri of Hunefer, 1275 BCE.*

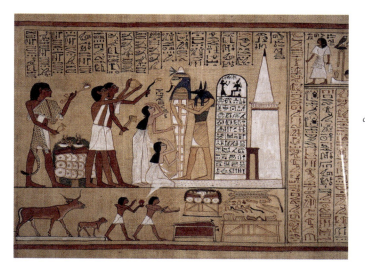

c. 1504–1447 BCE

A TEXT ATTRIBUTED TO KING OSORKON

'Then [Osorkon] struck them [the captives] down for him, causing them to be carried like goats on the night of the Feast of the Evening Sacrifice in which braziers are lit ... like braziers at the going forth of Sothis. Every man was burned with fire at the place of his crime.'

STAMPING ON A POT EXECRATION RITUAL
One text calls for the object to be treated in the following way:

'spit on him four times ...
trample on him with the left foot ...
smite him with a spear ...
slaughter him with a knife ...
place him on the fire ...
spit on him in the fire many times.'

OPPOSITE *Animal mummies*,
c. 2000–30 BCE.

He also tells us that in some regions goats were sacred, and at least one bull, the Apis bull dedicated to the god Ptah, was held to be sacred and could not be sacrificed. Instances of human sacrifice (slaves and prisoners of war) are also known; this is stated in a text attributed to the 22nd Dynasty King Osorkon found at Karnak, on the Bubastite Portal in the temple complex of Amun-ra (see left, top).

Execration rituals

Execration rituals, conducted in order to destroy the pharaoh's enemies – which might include enemies outside Egypt, rebels within it, or even supernatural forces – were carried out from the Old Kingdom up until the Roman occupation. Details about such rituals appear in the Papyrus Bremner-Rhind, P. Louvre 3129, P. British Museum 10252 and P. Salt 825, and we also have remnants of execration artefacts, such as smashed red pots and texts referring to specific individuals or lists of enemies and giving instructions for performing the rite – essentially a form of sympathetic magic in which the object represented the target. Bound figurines also relate to these rites, and it is probable that animal sacrifices were associated with them, too. The items linked with execration rituals were desecrated in a variety of ways, such as stamping on a pot, and thus stamping out the enemy (left).

Today, Egypt is an Islamic nation, but there may be echoes of earlier practices: both Copts (Egyptian Christians) and Muslims in some agricultural areas carry out a little rite in which cotton wool wrapped around a bottle, or placed on a cardboard dolly, is scattered with seven types of grain and then buried. Perhaps this is a faint trace of a rite dedicated to the god Osiris, king of the netherworld, who was slain and brought back to life again. The Copts also visit tombs a prescribed number of days after the death to make libations of water and offerings of flowers and food.

ANIMAL SACRIFICIAL MUMMIES

CAT

DOG BONES

FISH

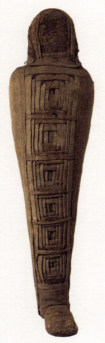

FALCON

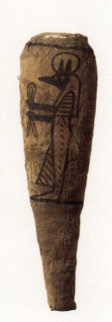

IBIS

CROCODILE

c. 400 BCE–100 CE

GREEK RITUALS

Magical customs in ancient Greece

ORIGINS: Greece
DATES: *c.* 1600–1100 BCE
PURPOSE: General magical practice, worshipping the gods

Greek rituals centred around the worship of the gods and often had as their focus animal sacrifice, which took place in front of an altar in the temple precinct (*temenos*). Libations would be made (for example, of wine) and purification would be undertaken: 'Never omit to wash your hands before you pour to Zeus and to the other Gods the morning offering of sparkling wine; they will not hear your prayers but spit them back' (Hesiod, *Works and Days*, *c.* 700 BCE).

Some of the most famous rites in the ancient world are those of the Eleusis 'mysteries'. Worshipped throughout Greece, the earth goddess Demeter and her daughter Persephone were the focus of one of the most famous mystery traditions. In legend, Persephone is abducted into the underworld by Hades, the god of the dead. Her mother goes in search of her daughter, eventually finding her, but in the time that this takes, Demeter's life-giving powers have been withdrawn from the world and winter has come. She is told that she can only rescue her daughter if Persephone has neither eaten nor drunk – and it turns out that the girl has indeed eaten six pomegranate seeds. So Persephone is allowed to return to her mother for only six months of the year, and for the other six must return to Hades and rule as the queen of the underworld.

Immediately after Persephone's abduction, Demeter is said to have spent time in Eleusis, at the palace of the king, looking after his infant son in disguise. When her hosts discovered her identity, she asked them to build her a temple there. The disappearance and rescue of Demeter's daughter was the central focus of the Eleusinian mysteries, which were conducted by various ranks of priests and priestesses. The rites may have derived from Mycenaean practices and were initially reserved for married women, but the rites changed over their long history (overall, they probably ran for around 2,000 years) and were later opened up to men, unmarried women and slaves. From 300 BCE onwards, initiations increased in number. Only the initiated could participate in the mysteries themselves, which seem to have featured some form of re-enactment of Persephone's abduction in a triple cycle – the descent, search and ascent – and to have been based around the annual return of life to the Earth in the spring.

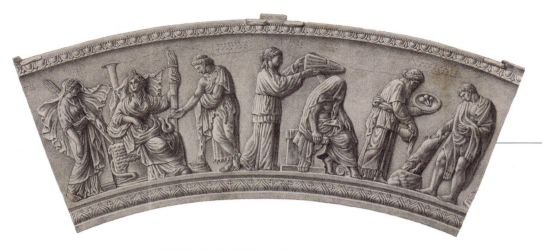

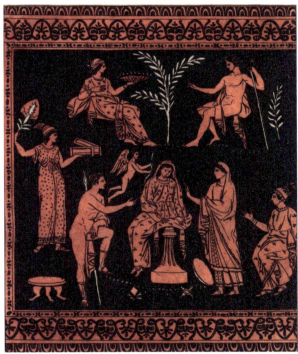

ABOVE A drawing of the relief around the side of the Lovatelli urn, showing Herakles' initiation into the Eleusinian mysteries, 1879.

BELOW Fragment of the Great Eleusinian Relief. Demeter, the goddess of agricultural abundance, stands at the left, on the right is Persephone, her daughter and the wife of Hades. The boy is thought to be Triptolemos, who was sent by Demeter to teach men how to cultivate grain. Roman, c. 27 BCE–14 CE.

ABOVE The Eleusinian Mysteries. The goddess Ceres sits on the Puteal on the Callirhoe well surrounded by dancing virgins. Hand-coloured copperplate engraving by Fumagalli from Giulio Ferrario's *Costumes Ancient and Modern of the Peoples of the World*, Florence, 1826.

43 BCE–18 CE

EXPELLING PHARMAKOI

'It was the custom at Athens to lead
two pharmakoi ... This cleansing served to
ward off plagues of disease, and it took its
beginning from Androgeus the Cretan, because
the Athenians were afflicted with a plague of
disease when he died unjustly in Athens, and

Scapegoating ritual

In another ritual, a person – or two people – called the *pharmakos* (φαρμακός) would be expelled permanently from society at festivals or in times of emergency (such as famine or war). The 4th-century Greek grammarian Helladius tells us about the origins of this ritual in Athens (see opposite).

This was a so-called expiatory ritual, in which the scapegoating of an individual was held to propitiate a god on behalf of the whole community, and the person selected as the scapegoat would be held to be expendable: a criminal, a slave, a beggar or someone who was severely disabled. The individual may also have been someone who was already condemned to death. Opinion varies on whether the *pharmakos* was actually killed, for instance by being thrown from a cliff into the sea, or whether they were simply beaten or sent away. The Greek poet Hipponax, writing in the 6th century BCE, describes an episode of this kind at a Thargelia (a summer festival for the god Apollo and his sister Artemis), during which an exceptionally ugly man was feasted, then whipped and driven from the town. There are suggestions that in an emergency situation the *pharmakoi* would be killed, but as a general rule they would only be driven out of the community, taking the ill luck of the community with them. A contemporary rendition of the scapegoat persists in modern Greece: a bonfire is lit on May Eve, and after local women have jumped over it three times, a straw effigy is thrown upon it and held to take with it the problems of the community as it burns.

OPPOSITE *Greek mythological figures.*

BELOW *The second long side of the Agia Triada Sarcophagus showing a procession of Young Men With Offerings, Archaeological Museum of Heraklion, 1370–1320 BCE.*

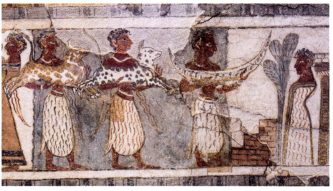

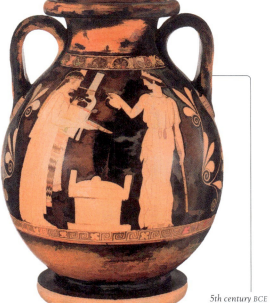

5th century BCE

ABOVE *Classical, Greek, Attic, terracotta vase, depicting Apollo and Artemis pouring a libation at an altar, mid-5th century BCE.*

The Thesmophoria

Another example of ancient Greek ritual is the Thesmophoria (Θεσμοφόρια). This women-only rite, rather like the rituals of Eleusis, celebrated the mysteries of the fertility goddess Demeter and her daughter Persephone/Kore, who in a myth relating to the turning of the seasons is abducted into the underworld by the god of the dead, Hades, and must remain there for six months of the year. The wives of male citizens were allowed to organize and participate in this festival, which was not open to men (usually, in Greek society, the reverse was the case). It was celebrated widely across Greece and may be very old; there have been suggestions that it dated back to the 11th century BCE.

The Thesmophoria rites, which took place over three days, were conducted in the month of Pyanepsion (Πυανεψιών), roughly correlating to late October, at the start of the autumnal planting season, and were designed to protect the growing crops over the winter (they were thus fertility rituals, unlike the Eleusis mysteries, which focused more on a communal religious experience). The focus of the rites was the return of Persephone from Hades. Piglets would be sacrificed and buried in a pit, a *megara*, along with snakes and phalluses made out of dough, and women would disinter the remains of the previous year's sacrifices and place them upon an altar. On the final day of the festival, the participants would call upon Demeter's nursemaid, Kalligeneia, asking her to watch over their own fertility. Aristophanes' play *Women at the Thesmophoria* (411 BCE) is a satire on events at this festival, with men infiltrating the festival in women's clothing. The rites also feature in Lucian's *Dialogues of the Courtesans* (43 BCE).

Thesmophoria by Francis Davis Millet, 1894–1897.

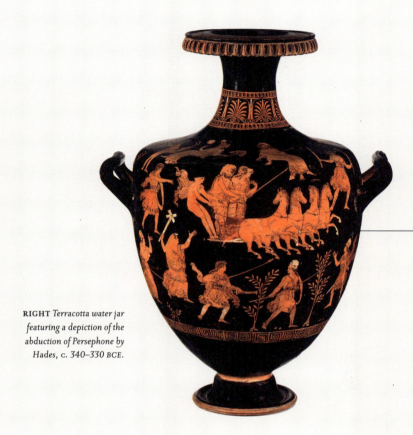

RIGHT *Terracotta water jar featuring a depiction of the abduction of Persephone by Hades, c. 340–330 BCE.*

c. 340–330 BCE

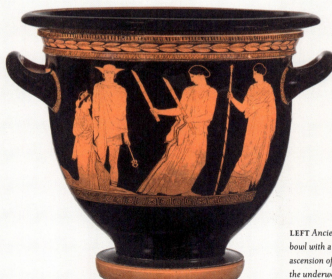

LEFT *Ancient Greek terracotta bowl with a depiction of the ascension of Persephone from the underworld, c. 450 BCE.*

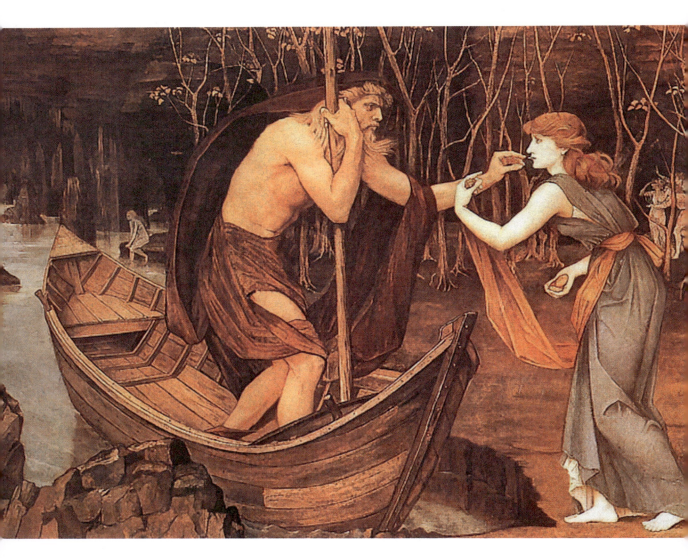

Charon and Psyche *by John Roddam Spencer Stanhope, 1883.*

Death rituals

The Greeks also developed extensive rites based around funeral customs. In the Mycenaean period (*c.* 1600–1050 BCE), high-status individuals were placed in chamber tombs and laid to rest along with lavish grave goods. One of the most spectacular such finds, the so-called Mask of Agamemnon, was found at Mycenae by Heinrich Schliemann in the 1870s.

Death was considered to be a polluting force, and thus priests were not allowed to tend the dying. This was the task of the women of the household, who would lay out the body (the period of *prothesis*) and place a coin in the mouth of the deceased to pay Charon, the ferryman who took souls to the underworld. They would also assume the role of chief mourners in the *prothesis*, during which dirges were sung and the women would tear their clothing. A close relative of the deceased would then make offerings to the gods of the underworld, such as *choe*, a libation consisting of honey, wine, oil or water and poured from a vessel onto the ground, into the grave, or into a hole in the earth, as Homer describes in the *Odyssey* (10.515–520): 'Thither, Hero, do thou draw nigh, as I bid thee, and dig a pit of a cubit's length this way and that, and within it pour a libation to all the dead, first with milk and honey, thereafter with sweet wine, and thirdly with water, and sprinkle thereon white barley meal.'

BELOW *Gold mask of Agamemnon, 1550–1500 BCE.*

1550–1500 BCE

RIGHT *Depiction of a Greek funeral, 6th century BCE.*

ROMAN RITUALS

Ritual practices in ancient Rome

ORIGINS: Italy
DATES: 2nd–4th century CE
PURPOSE: General magical practice, worshipping the gods

Like the Greeks, the Romans offered libations and animal sacrifices in their rituals, which might be dedicated to the main gods of the Roman pantheon or to the smaller household deities. Rituals were carried out for the *lar familiaris*, or household spirit, and also for the *lares* who protected the fields, either at crossroads (*compita*), in the countryside or at shrines on the streets of cities and towns.

The *lares* of the households were celebrated particularly on the Kalends, Nones and Ides (the first, seventh and middle days of each month, respectively), but daily offerings of incense and wine would be made to them before the dessert course (*secunda mensa*) of the main meal.

In addition to these everyday rituals, the state sponsored regular rituals that were performed in order to retain the goodwill of the gods. Sacrifices usually took place out of doors and would be performed by a professional known as a *victimarius*. Goats and a dog were ritually slain at the Lupercalia, which was held in February at the Lupercal, where the she-wolf was said to have suckled Romulus and Remus, the founders of Rome. During sacrifices, Roman senators were said to compete to see who would end up with the most bloodied clothing, as it was believed that this could stave off death. The emperor Marcus Aurelius himself is shown, veiled as a priest, about to offer the sacrifice of a bull in a *bas*-relief on his triumphal arch on the Capitoline Hill. Bulls, pigs and sheep were ritually slain in sacrifices known as *suovetaurilia*. Animals were also sacrificed by consuls to protect troops about to go into battle.

Not all rituals involved animal sacrifice: the goddess of love, Venus, was given offerings of myrtle and wine, for instance. One of the oldest recorded rituals is the Night Watch of Venus, carried out between the 2nd and 5th centuries CE, which culminates in a gift of roses.

ABOVE Venus Verticordia *by Dante Gabriel Rossetti, 1864–1868.*

LEFT *Romans performing the suovetaurilia ritual, whereby a pig (sus), a sheep (ovis) and a bull (taurus) are sacrificed to a deity, often Mars, to bless and purify land.*

FIELD REMEDY CHARM FOR THE PROTECTION OF LAND

The charm begins:

'On the night of the new moon, take four sods of turf from four corners of the land and mark how they previously stood. Then, take oil … and honey and barm and the milk of every animal on that land, and a piece of wood from every kind of tree which is grown on the land, save sacred oak and beech, and a piece of every named plant, except burr, and then put Þunor-hallowed water sourced from the land onto them, and let it drip thrice into each piece of turf.'

SAXON RITUALS

Rites of magic in Saxon Europe

ORIGINS: Britain
DATES: 10th–11th century CE
PURPOSE: General magical practice, protecting the land

A number of Saxon rituals began as invocations to the Anglo-Saxon gods, such as Woden (Odin) and Loki, then migrated into the Christian religion, calling instead on the Father, Son and Holy Spirit. One example is the *Æcerbot* (field remedy) charm, which is a ritual for the protection of land that has been cursed or blighted by wights or other malignant spirits (opposite).

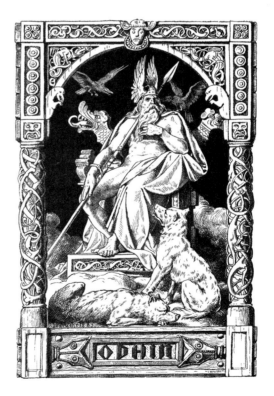

The *Þunor*-hallowed water in the original version of this charm is water that has been made sacred to the god Thunor, but in the Christianized version, holy water is to be used. The remainder of the rite would take place over the next few hours and involved taking the turf to an altar (*wēofod*) or, later, a church, where the four pieces would be blessed before being replaced. The land itself would thus be blessed.

The Saxons appear to have had wayside shrines and may also have held rites in woodland or on high places. There is some evidence that they venerated sacred trees, converting them into carved pillars when they died. They also performed animal sacrifices – preferring oxen, for instance, as part of funeral rites – and there is some evidence of human sacrifice.

RIGHT *Odhin by Johannes Gehrts, 1901.*

OPPOSITE *Peasants ploughing. A miniature from the Cotton MS Tiberius, 9th or 10th century CE.*

RENAISSANCE RITUALS

Magical rituals in Renaissance Europe

ORIGINS: Europe
DATES: 1450–1650 CE
PURPOSE: General magical practice

By the Renaissance (c. 1450–1650), magical practice was firmly entrenched in Europe, despite opposition by the Church. Grimoire-based magic was undertaken for a variety of personal aims and gains: locating hidden treasure, attracting love or wealth, or summoning demons to do one's bidding (see page 202). People used magic for all manner of purposes: in the 16th century, Lord Neville sought to learn to play the lute through magical means, while the 17th-century English antiquary Elias Ashmole used astrological talismans to get rid of vermin in his house.

Magic during the Renaissance can be roughly divided into 'low' magic, such as witchcraft, which might seek to harm someone's cattle or perform a love spell, and 'high' magic, which is generally Hermetic and Neoplatonist in origin; grimoires fall into both categories. Practitioners such as the Italian scholar Marsilio Ficino (1433–1499) gave detailed instructions on how to perform ritual magic, including making incantations and carving talismans. For instance, Ficino recommended that 'one sculpts Mercury in marble, in the hour of Mercury, when Mercury is rising, in the form of a man who bears arrows' to ward off a fever (*De vita libri tres*, Three Books on Life, 1480–1489). The German polymath Heinrich Cornelius Agrippa von Nettesheim (see page 164) gives instructions for the magician to understand demons and angelic powers, such as categories of demons and their rank, although this was frowned upon by Church authorities. For example, in Bologna in 1473, the vicar, under orders from Pope Sixtus IV, began to investigate claims that the local clergy had been instructing parishioners that summoning demons was not, after all, heretical. It was not uncommon for members of the clergy to be accused of witchcraft, and many of them seem to have actually practised it. The Dominican Inquisitor Giovanni Cagnazzo, influenced by the anti-witchcraft treatise *Malleus Maleficarum* that was published in 1486, led the attack on the practices in Bologna, although he targeted a female necromancer (a person who attempts to raise or to communicate with the dead) rather than his fellow churchmen.

OPPOSITE LEFT TOP *An apothecary preparing the drug theriac, under the supervision of a physician. Woodcut, Germany, 1500–1599.*

OPPOSITE LEFT *The image illustrates a natal horoscope for Leonhard Reymann. The central image shows the World, surrounded by personifications of the seven planets known to pre-modern astrology. This is surrounded by the twelve signs/constellations of the zodiac, and the outer ring represents the twelve houses, 1515.*

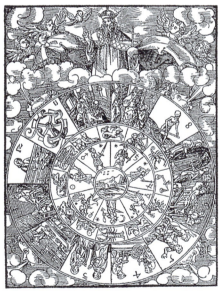

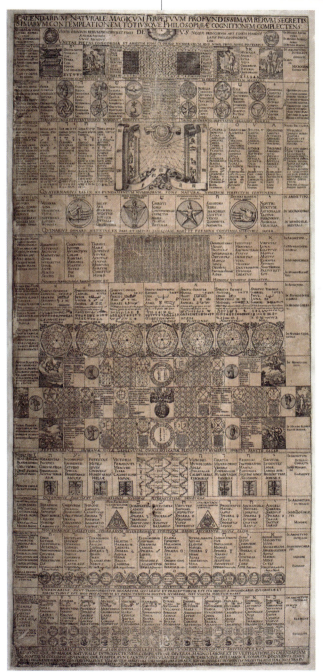

c. 1619–1620

RIGHT The Calendarium Naturale Magicum Perpetuum, *grimoire and esoteric print of calendar engravings, c. 1619–1620.*

THE BLACK MASS

Ritual magic practised by followers of Satan

ORIGINS: France
DATES: 1672 CE–today
PURPOSE: Worshipping Satan

The Black Mass is an oft-cited example of occult practice, but these days it is relatively rare. A Satanic parody of the Catholic Mass said to involve drinking blood instead of wine, it has often been sensationalized and confused with other rituals, such as the Thelemic Gnostic Mass, which, although technically a blood rite, does not involve the worship of Satan.

Among the earliest examples of the Black Mass are those arranged by the French king Louis XIV's mistress, Madame de Montespan. She is said to have hired a fortune teller and abortionist, Catherine Monvoisin (also known as La Voisin), to organize Black Masses for her between 1667 and 1673 in order to enable Montespan to retain the affections of the king. This culminated in a plot to commit regicide when Louis took another mistress, and La Voisin was arrested and burned at the stake. In this form of the Black Mass, based on instructions in *The Grimoire of Pope Honorius*, a woman (in at least one ceremony, Montespan herself) took the role of the altar, and a baby – either killed during the ritual or already dead – was desanguinated into a chalice placed upon her body. The aim of this was to summon the Devil, whom the practitioner of the Mass would then petition.

The Black Mass features in French literature, such as in the works of the Marquis de Sade, in Joris-Karl Huysmans's *Là-bas* (*Down There*, 1891), in which the protagonist, Durtal, explores the French occult underworld, and in Jules Michelet's *La Sorcière* (1862), which aimed to give a historical analysis of sorcery. H. T. F. Rhodes's *The Satanic Mass* (1954) also brought the practice to wider public attention, but neither Michelet's nor Rhodes's accounts are particularly accurate.

OPPOSITE *Catherine Deshayes, La Voisin, 17th-century print.*

RIGHT The Guibourg Mass *by Henry de Malvost. From the book* Le Satanisme et la magie *by Jules Bois, Paris, 1903.*

THELEMA

An occult philosophy and set of esoteric practices adopted by Aleister Crowley

ORIGINS: Britain
DATES: 1904–today
PURPOSE: Development of the higher self

Aleister Crowley (1875–1947) was one of the most significant British occultists of the late 19th and early 20th centuries. The magical system that he devised, Thelema, and the organization that he took over, the Ordo Templi Orientis (OTO) (see page 226), still exert significant influence over occult practice today.

In turn, Crowley, a former member of the Hermetic Order of the Golden Dawn (see pages 146 and 220), was influenced by Egyptian magic (see page 22), Kabbalism (see page 66), Indian practices, Hermeticism (see page 36) and Theosophy (see page 224). He began working magically with a channelled entity called Aiwass, whom he described as having 'a body of "fine matter", or astral matter, transparent as a veil of gauze or a cloud of incense-smoke. He seemed to be a tall, dark man in his thirties, well-knit, active and strong, with the face of a savage king, and eyes veiled lest their gaze should destroy what they saw' (*The Equinox of the Gods*, 1936). Crowley's writings contain many rituals, many of them based around sex magic, of which Crowley was a devoted proponent, and with a strong Egyptian influence. In his book *Liber Resh vel Helios* (1911), he published a number of ritual incantations to be conducted at different times of the day: at sunrise Ra is to be praised, at noon one praises Hathor, followed by Tum at sunset and Khephra at midnight. Those aspiring to join the OTO are invited to undertake the Minerval ritual as a first step. This does not commit one to joining the organization, but is an initiatory ritual in which the candidate is blindfolded and led on an allegorical journey through a number of ritual stages, culminating in a meeting with a ritualist representing the Islamic warrior Saladin. It also involves a reading of sections of Crowley's *Book of the Law* (*Liber al vel Legis*, 1904), which is the primary text of Thelema and core to many of its practices – Crowley claimed that Aiwass dictated it.

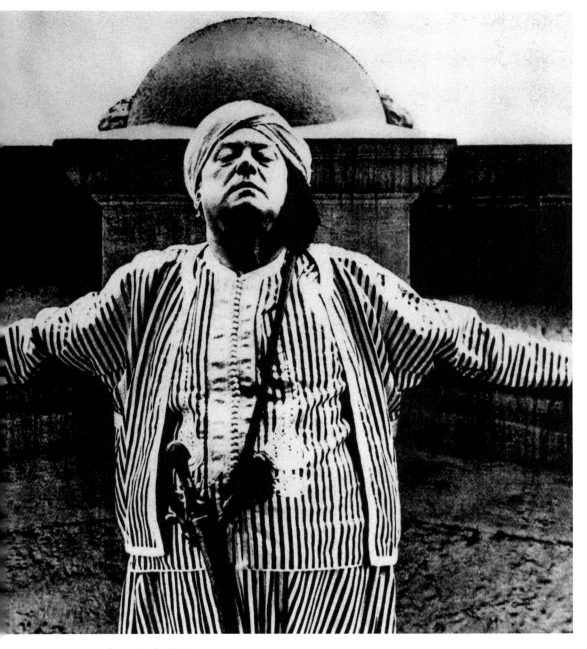

ABOVE *Aleister Crowley, 1934.*

OPPOSITE The Equinox – *a periodical that served as the official organ of the AA, a magical order founded by Aleister Crowley. Founded in 1909 and last published in 1998.*

RITUALS AND RITES

BELOW *The Key of Solomon (Clavicula Salomonis), early 18th century.*

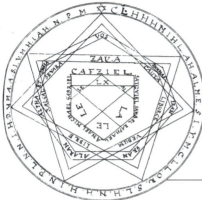

LEFT *'As Above, So Below', frontispiece from Transcendental Magic, its doctrine and ritual, by Éliphas Lévi, 1896.*

RIGHT *In the Lesser Banishing Ritual of the Pentagram, the practitioner draws a pentagram with an athame or wand and then calls to the four archangels.*

LEFT *Synaxis of the Archangel Michael. An Eastern Orthodox Church icon of the Seven Archangels, 19th century.*

RITUALS OF THE GOLDEN DAWN

early 18th century

Magical organization based on Egyptian and Celtic religion

ORIGINS: Britain
DATES: 1887–today
PURPOSE: General magical practice

The powerhouse behind much of modern occultism is the Hermetic Order of the Golden Dawn. Formed in London in 1888 by Dr William Woodman, Samuel MacGregor Mathers and William Westcott, the order opened temples in Bradford, Weston-Super-Mare, Edinburgh and Paris.

The Golden Dawn was built around the Kabbalah, divination, astronomy, alchemy, ancient Egyptian magic and Christian mysticism. One of its leading lights, actress Florence Farr, allegedly used scrying to communicate with a long-dead Egyptian priestess. Farr's Egyptian magic group, the Sphere, which operated within the Golden Dawn, had links with Egyptologists working in the British Museum. Members were also expected to familiarize themselves with astrology and the Tarot, and with the Hebrew alphabet. In addition, they had to memorize complex rituals as well as making their own robes and magical instruments. The magical tools of W. B. Yeats, a famous member of the group, can be seen in the National Library of Ireland in Dublin.

The Lesser Banishing Ritual of the Pentagram (LBRP), developed by occultist Éliphas Lévi, derives from the *Key of Solomon* (see pages 180 and 182). The LBRP is a ritual of purification often conducted at the beginning and/or end of magical rites to clear the space in which the practitioner is working of any negative influences. The practitioner begins with the Kabbalistic Cross, in which the right hand is drawn down from the forehead intoning the word *Ateh* ('thou art'), to the pelvis intoning *Malkuth* ('the kingdom'), to the left shoulder intoning *ve-Geburah* ('the power'), to the right shoulder intoning *ve-Gedulah* ('and the glory'), followed by clasping the hands in front of the chest and intoning *le-Olahm* ('amen'). This is the first part of the Lord's Prayer, in Hebrew.

The practitioner then 'draws' a series of pentagrams in each of the four directions with his/her hand, an athame or a wand, and intoning four of the Hebrew names of God. Then the practitioner asks the four archangels for their protection: 'Raphael before me [east], Gabriel behind me [west], Michael to my right hand [south], and Uriel to my left hand [north].' Finally, the practitioner utters the phrase 'For about me flames the pentagram, and upon me shines the six-rayed star.' The LBRP is still used today, and is one of occultism's many legacies from the Golden Dawn.

Rite to Isis and Osiris

Rituals were also conducted for initiations into the different grades, and at particular times of the year, such as the equinoxes. We also have an account of a rite to the Egyptian gods Isis and Osiris by French journalist André Gaucher, published in *L'Echo du Merveilleux* in December 1900. The rite, which was created by Golden Dawn members Samuel and Moina Mathers, was carried out by a priest and priestess, who knelt before a statue of the goddess in a room filled with roses, camellias and wisteria to light benzoin incense before scattering flower petals and grains of wheat. Participants became overcome with emotion and fell to the floor (see opposite).

It is possible that this was a recreation of the Khoiak festival in which ancient Egyptians lamented the death and celebrated the rebirth of the god Osiris. Samuel and Moina Mathers founded a number of Egyptian temples in Paris at this time.

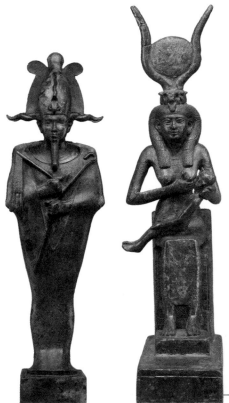

ABOVE *Moina Mathers in her performance in the* Rites of Isis *in Paris, 1899.*

RIGHT *Statues of Isis and Osiris, 1070–343 BCE.*

OPPOSITE *Frontispiece to* The Temple of Nature *by Erasmus Darwin, 1803.*

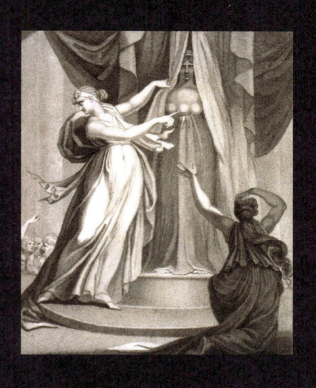

A RITE TO THE EGYPTIAN GODS ISIS AND OSIRIS

Gaucher wrote:

'...under the eyes of the god, the worshippers
fall in ecstasy or catalepsy. Around me sighs,
convulsive cries. Their bodies roll on the ground,
in the darkness, in the anguish of dreadful nervous
spasms. Others stand, straight, rigid, with
bloodless faces, haggard eyes. The vision descends
into a nightmare. A scarlet torch illuminates the
back of the sanctuary with an infernal glimmer,
I believe that, at the rear, I see the gigantic statue
in a terrible grin. Horror!'

RITUALS AND RITES

HAITIAN VOODOO MASKS

NIGERIAN YORUBA DIVINATION TAPPER

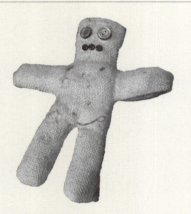

NEW ORLEANS VOODOO DOLL

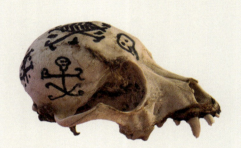

BARON SAMADI VEVE

VEVE OF ERZULIE DANTOR

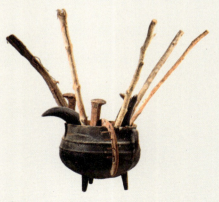

SANTERÍA NGANGA

VOODOO

An occult religion of the Americas, deriving from Africa

c. 18th century

ORIGINS: North America and the Caribbean
DATES: 20th century
PURPOSE: General magical practice

Voodoo (Vodou/Vodun) is a religion of the African diaspora and appears in various forms throughout the USA and the Caribbean. It shares many features with other African diasporic spiritual practices in which the worship of African deities brought to the New World by captured slaves merged with Catholic practice, such as Candomblé in Brazil and Santería in Cuba. It also contains elements of grimoire magic, deriving mainly from the *Petit Albert* grimoire that circulated among French colonies.

In voodoo rituals, termed services, spirits are summoned to possess the person leading the ceremony, for example a Houngan (male practitioner) or Mambo (female practitioner) in Haitian Voodoo. These spirits are held to come from Guinea, the otherworld, and include such figures as Baron Samedi and his wife Maman Brigitte, who represent the first man and woman buried in a cemetery; Erzulie, representing love and beauty; Agwe, who is linked to the sea; and Papa Legba, who guards the crossroads. There are various types of Voodoo, so the spirits found in a Haitian ritual may vary from those found in practices from the Southern states of the USA and elsewhere.

Many Voodoo ceremonies are held in private, although they are often welcoming to outsiders. One of the most public forms of ritual is the New Orleans Jazz Funeral, which combines Catholic elements with West African ones. These 'second lines' funerals are community events that take the form of a procession from the funeral home to the cemetery, accompanied by a brass band. The procession begins with a dirge and ends with dancing and song when the body is laid to rest, or 'cut loose'. Anthropologists contend that the roots of these events lie in the funerary practices of Senegal and Gambia, and of the Yoruba of Nigeria.

OPPOSITE (TOP TO BOTTOM, LEFT TO RIGHT)
Haitian voodoo masks; ivory Yorùbá Divination Tapper (Iroke Ifá), poss. 18th century; Voodoo doll, New Orleans museum; the skull of a dog with Veve design; Veve of Erzulie Dantor; Santeria cast-iron spell pot.

SATANISM

The worship of Satan

ORIGINS: Europe
DATES: 1860s–today
PURPOSE: Worshipping Satan

Satanism is one of the most controversial aspects of the occult, although those outside occult practice perhaps regard it as characteristic of occult thought. The early Church in Europe denounced Satan as a force for evil, depicting him with horns and hooves in the manner of the Greek god Pan.

People practising black magic were often held to have made a pact with Satan or with other demons, such as Beelzebub. In fact, theological Satanism is relatively rare: sociologists of religion report that there are only a few hundred practising Satanists in the UK today, for example. Much of modern Satanism is a political as well as a religious movement, using sinister images such as the composite deity Baphomet to advertise the concepts of progressive activism. Satanists regard themselves as their own 'gods,' and use Satan as a symbol of personal freedom and individualism.

Satanism in a modern context was initiated by Polish author Stanisław Przybyszewski (1868–1927). A Bohemian follower of Nietzsche, Przybyszewski was one of the first people to define himself as a Satanist, although occultists such as Éliphas Lévi (see page 70) also wrote extensively about entities such as Lucifer. German occultist Eugen Grosche, the author of *Satanische Magie* (Satanic Magic), founded the magical order of the Fraternitas Saturni in 1928. In 1966, Anton LaVey, perhaps the best known American Satanist, established the Church of Satan, and in 1972 he published *The Satanic Rituals*, drawing on Templar, Yezidi and Masonic rituals and symbols (see pages 212 and 216). This includes the Ceremony of the Stifling Air, a re-enactment of death and rebirth in which the candidate lies in a coffin and is 're-awakened' by a naked woman, who seeks to revive him through the power of lust. The candidate must then dedicate himself to Satan. LaVey states that this is not a Black Mass (see page 142), but does contain an element of deliberate blasphemy. The instructions for the ritual suggest the use of strobe lights and Moog synthesizers: Satanic rituals place an emphasis on atmosphere.

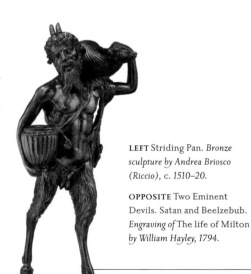

LEFT Striding Pan. *Bronze sculpture by Andrea Briosco (Riccio), c. 1510–20.*

OPPOSITE Two Eminent Devils. Satan and Beelzebub. *Engraving of* The life of Milton *by William Hayley, 1794.*

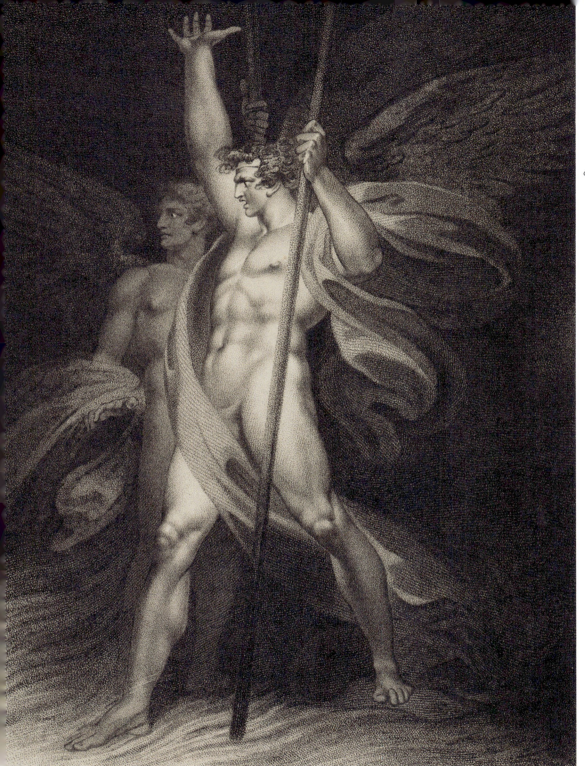

c. 1510–20 CE

RITUALS AND RITES

WICCAN WHEEL OF THE YEAR

SKETCH OF BREUIL'S HORNED GOD

THE HORNED GOD/BAPHOMET

WICCAN RITUALS
The practice of contemporary witchcraft

ORIGINS: Britain
DATES: 1950s–today
PURPOSE: General magical practice, worship

Wicca has been described by historian Ronald Hutton as the only religion that Britain has given the world. It is probably the most popular and widespread of the Pagan paths today and explicitly endorses the use of magic.

It dates roughly from the 1950s, when it was compiled in the New Forest by retired tea-planter Gerald Gardner along with a number of his coven members, such as Doreen Valiente, who was responsible for much of the poetry and wording used in Wiccan rituals (see page 228). Its roots lie in Freemasonry (see page 216), the Golden Dawn (see pages 146 and 220), Theosophy (see page 224), amateur dramatics, and an early version of the Boy Scouts movement called the Kibbo Kift, which drew on Native American beliefs and rituals as well as an outdoors activities ethos.

The branch of Wicca founded by Gardner is known as Gardnerian Wicca, followed by Alexandrian Wicca, which was developed by Alex Sanders in the 1960s. There are other forms, such as a women-only version known as Dianic Wicca and a version constructed by writer Robert Cochrane.

Wiccan groups are called covens and traditionally consist of thirteen participants, including a High Priest and High Priestess, both of whom will have passed through the Wiccan grading system of three degrees. The first degree is symbolized by a pentagram, the second by an inverted pentagram (not a Satanic symbol but an indication that the spirit has been temporarily subsumed by work with the four elements), and the third by a pentagram capped with a triangle. The central deities of Wicca are the horned god and the goddess of the moon, often named as Diana, although Wiccans may worship a wide variety of gods and goddesses, usually Celtic (see page 48), Norse (see page 60) or Saxon (see page 54), and sometimes Egyptian (see page 22).

Wicca has many rituals, including initiation rites for each degree, and the celebration of the Wiccan Wheel of the Year, which begins at Samhain (Hallowe'en) and progresses through the Winter Solstice (21 December), Imbolc (1 February), the Spring Equinox (around 21 March), Beltane (1 May), the Summer Solstice (21 June), Lughnasadh (1 August) and the Autumn Equinox (around 21 September).

OPPOSITE TOP *The Wiccan wheel of the year, mid-20th century.*

OPPOSITE BELOW LEFT *The Sorcerer, a sketch by Henri Breuil, 1920s.*

OPPOSITE BELOW RIGHT *The Sabbatic Goat from* Dogme et Rituel de la Haute Magie *by Éliphas Lévi, 1856.*

Drawing Down the Moon

One of the best-known Wiccan rituals is the rite known as Drawing Down the Moon. This is conducted by a coven in circle at the full moon, and is a ritual focused on trance mediumship. The High Priestess invokes the power of the moon in order to draw the goddess into herself and speak to the participants of the ritual (see opposite).

The concept may come from Greek accounts of witches in Thessaly (as related in Claudian's *First Book Against Rufinus*, 395–97), who were said to be able to 'pull down' the moon and control its power, and such a ceremony is also referenced in Charles Leland's influential work *Aradia o il Vangelo delle Streghe Italiane* (Aradia or the Gospel of Italian Witches, 1899), in which Leland claimed to have been given first-hand information on Pagan witchcraft in Tuscany by a young woman named Maddalena. She told Leland that her family had been practising witchcraft since Etruscan times, but it is debatable whether this was actually the case, and Maddalena's existence has been called into question: some historians believe that Leland made the whole book up, based on his research into European and Italian folklore. While there are doubts about Leland's claims and their historical authenticity, many of the rites, spells and ideas outlined in *Aradia* have been adopted by contemporary Wicca. The book contains love spells, instructions for making amulets and incantations to Pagan deities.

ABOVE LEFT *Anton Raphael Mengs,* Diana als Personifikation der Nacht, *c. 1765.*

TOP RIGHT *Charles Godfrey Leland, between 1855 and 1865.*

ABOVE RIGHT *Maddalena of Florence, Leland's folk custom informant. Image first published in Elizabeth Robins Pennell's* Charles Godfrey Leland: a Biography, *1906.*

INVOKING THE POWER OF THE MOON

Part of the ritual which is recited as follows:

'Of the Mother darksome and divine
Mine the scourge, and mine the kiss;
The five-point star of love and bliss-
Here I charge you, in this sign.
All ye assembled in my sight,
Bow before my spirit bright
Aphrodite, Arionhod.
Lover of the Horned God,
Mighty Queen of Witchery and night,
Morgan, Etoine, Nisene,
Diana, Bridgid, Melusine,
Am I named of old by men,
Artemis and Cerridwen,
Hell's dark mistress, Heaven's queen.
Ye who would ask of me a rune,
Or who would ask of me a boon,
Meet in some secret glade,
Dance in my round in green wood shade,
By the light of the Full Moon.

In a place, wild and lone
Dance about mine altar stone;
Work my holy mystery.
Ye who are feign to sorcery,
I bring ye secrets yet unknown.
No more shall ye know slavery,
Who give true worship unto me.
Ye who tread my round on Sabbat night,
Come ye all naked to the rite,
In token that ye be really free.
I teach ye the mystery of rebirth,
Work ye my mysteries in mirth.
Heart joined to heart and lip to lip,
Five are the points of fellowship,
That bring ye ecstasy on earth,
For I am the circle of rebirth.'

PART FOUR
CHARMS AND TALISMANS

THE ORIGINS OF CHARMS, AMULETS AND TALISMANS

Charms, amulets and talismans all bear a relationship to one another; they are images or symbols made from a variety of substances such as wood, metal, paper or plastic. They are common to every culture across the world and, along with astrological predictions, are one of the most widely adopted aspects of the occult in everyday life.

They range from complex astrological talismans constructed according to strict magical criteria to bracelet charms worn by children. Some might not have been produced by human hand at all, but may be a stone, a plant or the body part of an animal. They are worn upon the body – in a pocket or handbag, as a necklace or bracelet – or kept in the home, perhaps hung up in some significant place. The words 'charm' and 'amulet' are often used synonymously.

Charms

Charms are worn for luck but may be worn for protection as well, such as a St Christopher medal to protect you if you are travelling. Traditional charms include hagstones or adder stones, which are stones with a natural hole through them – some of these were believed to result from a nest of serpents, but they are a naturally occurring rock formation. The Roman author Pliny the Elder (23/24–79 CE) relates that they were sacred to the Druids.

Charms such as black cats, leprechauns, shamrocks, four-leafed clovers and horseshoes are familiar to most people in the UK, while the symbol of the protective eye is well known across many Mediterranean countries and in India, where it is called a Nazar battu. Many modern charms are Christian in origin: saints' medals are commonly worn in Catholic nations along with images of the Virgin, and most Christians wear a cross or a crucifix. Jews may wear a six-pointed Star of David and Pagans often wear the five-pointed star of the pentagram or pentacle (a star in a circle).

In older times, people in the UK often carried a rabbit's foot as a charm for good fortune, and heather is still sold by Romany people as a lucky charm. In Japan, *omamori* are sold as lucky charms at both Shinto and Buddhist temples. These are made of wood or paper, placed inside a small embroidered bag and may have specific meanings, for instance the *Gakugyō-jōju* for passing exams. Coins and lucky knots are also found throughout the Chinese-influenced world. Charms in the form of little elephants may be found in India and other parts of Asia as symbols of good luck and prosperity, and the elephant-headed god Ganesha is a popular image. In the Middle East, you will see the *hamsa*, a hand with an eye in the centre of its palm, also held to promote good fortune.

Amulets

Amulets (from the Latin *amuletum*, defined by Pliny in his *Natural History* as 'an object that protects a person from trouble') are worn primarily for protection, such as a medal of St Jude, which was commonly carried by Catholic policemen in New York, or the bloodstones carried by Crusaders. They also had the potential for healing; the English diarist Samuel Pepys (1633–1703) relates how his stomach trouble was cured as soon as he purchased a new hare's foot from a vendor.

ST JUDE MEDAL

RABBIT'S FOOT

Talismans

Talismans (from the ancient Greek *telesma*, τέλεσμα) are intended to focus on particular benefits, such as the attainment of wealth. They are often inscribed with incantations, such as the TAROT/ROTA talisman, or religious texts, such as verses from the Qu'ran, and are thus often text based. Islamic charms may feature the name of Allah, which is said to be able to ward off evil, or of the Prophet Muhammed. In Japan, *ofuda*, made of paper, metal or cloth and inscribed with the names of deities, can be found in both Shinto and Buddhist temples. In India, metal talismans known as *nauratan* could be strung together to form a necklace. Thus there are many varieties of talisman: they may take the form of a single item, whereas an amulet can be a collection of items (such as a bag filled with herbs and semi-precious stones), and talismans are usually human made, whereas charms and amulets can be natural items. However, the definitions of amulets, talismans and charms are not fixed and the distinctions between them are not hard and fast.

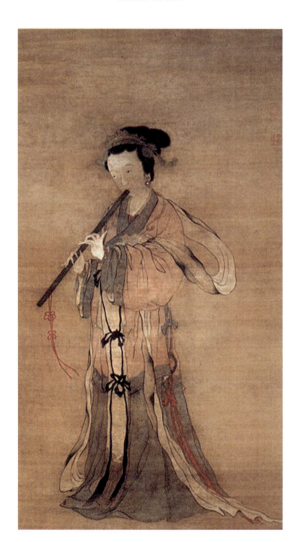

TOP *Saint Thaddaeus, also known as Jude the Apostle, 17th century.*

MIDDLE *Lucky rabbit's foot.*

RIGHT *Tan Ying, Ming Dynasty illustration depicting a figure playing a flute adorned with lucky knots, 1520.*

CHARMS AND TALISMANS

MILAGROS EXAMPLE

GOOD LUCK CLOVER CHARM

RINTINTIN AND NÉNETTE ET RADADOU

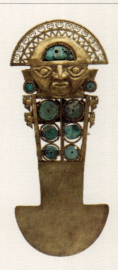

CEREMONIAL KNIFE (TUMI)

HAMSA

WRITTEN O-FUDA, JAPANESE

Popular charms and talismans today

Today, people wear or use a variety of charms and talismans. We have cited the Middle Eastern *hamsa*, shamrocks and four-leafed clovers, and Japanese ofudas. There are legends behind all of these symbols: one holds, for example, that Eve took a four-leafed clover with her in exile to remind her of the Garden of Eden.

The five fingers of the *hamsa* symbol found throughout the Middle East represents, respectively, the five books of the Torah if you are Jewish, and the five pillars of Islam if you are Muslim. The three-legged Golden Toad (*jin chan*) in China, who sits on a pile of coins and holds a coin in its mouth, can be attributed to Taoist legend and attracts wealth (and is therefore often seen in business premises).

In Mexico, religious charms called *milagros* (miracles) are often seen; these are made of a variety of materials, such as silver or tin, and take a range of forms – they may represent body parts, for example, or animals. They are carried as charms, but may also be used as votive offerings to saints. In Peru, we find *tumis*, ceremonial knives, which are the national symbol of the country and which are hung on the wall for good luck.

Modern French charms include the little figures known as Nénette and Rintintin. Made of yarn and linked by a thread (and sometimes with a baby, named Petit London), these date to the First World War and were given to soldiers as lucky charms or worn pinned to clothing. As with many charms, they are only lucky if they are given as a gift, not purchased.

A charm may also be a simple stone, such as a piece of obsidian to protect from negativity, or a crystal, such as rose quartz to attract love.

1753 CE

RIGHT *St Patrick is said in legend to have used the shamrock to explain the Holy Trinity of Christianity: the three leaves representing the Father, the Son and the Holy Spirit. Engraving of St Patrick by E. Finden, 1815.*

OPPOSITE *Examples of charms and talismans from around the world.*

THE THEORY OF CORRESPONDENCES

The magical theory behind occult beliefs

ORIGINS: Germany
DATES: 1400s–1500s
PURPOSE: Magical understanding

The German occultist Heinrich Cornelius Agrippa von Nettesheim (1486–1535) exerted a substantial influence on subsequent occult practice via his *De occulta philosophia libri tres* (*Three Books of Occult Philosophy*), which cover the elemental, astrological and celestial worlds.

As well as being an occultist, Agrippa was a theologian, soldier, physician, alchemist and legal commentator, beginning his career as a mercenary. He led a contentious life, being arrested several times and coming to the attention of the Inquisition on more than one occasion, yet being knighted by the Holy Roman Emperor Maximilian I. His published works compiled accounts of many earlier magical practices as well as his own philosophy.

Agrippa's first *Book of Occult Philosophy*, published in 1533, borrowed many ideas from Neoplatonism, and many of the concepts that it covers are derived from the works of Pliny and other classical writers. It is concerned with the connections between the things of the natural world – for example, animals, plants, precious and semi-precious stones – and the planets and stars, angels and demons. Each planet has at least one herb, semi-precious stone, hour of the day, day of the week and animal associated with it, although lists of correspondences can be idiosyncratic to individual magicians. Agrippa argued that the universe is animated by a *spiritus mundi* ('spirit of the world') that connects everything to everything else: the elementary world is governed by natural magic, including medicine; the celestial realm is governed by the rules of astrology; and the intellectual world is governed by angelic magic.

Etching of Heinrich Cornelius Agrippa von Nettesheim, 1727.

1531 CE

TOP Frontispiece of the Historia Mundi Naturalis, *by Plinio il Vecchio (Plinius Secundus Gaius), 1582.*

ABOVE *Aristotelian cosmology with astrological and zodiacal symbols, 1564.*

ABOVE *Theban alphabet (Honorian alphabet or the Runes of Honorius) and Celestial Alphabet (Scriptura Malachim or Angelic Script). Engraving from Agrippa's Three Books of Occult Philosophy, 1531.*

The Pentagram and the Body

The Pythagoreans (6th century BCE) attributed the points of the five-pointed star of the pentagram loosely to the elements: earth, fire, air, water and 'idea', or spirit. Agrippa further maps the symbol onto the human body – the head at the top and the feet at the two points of the base – and thus attributed correspondences between parts of the human body and other natural phenomena, such as the elements. In Agrippa's theories, like is related to like. Celestial powers filter down to the natural world; thus, if you want to undertake a love spell, you should take heed of the following instructions:

'From the operations of Venus they made an Image, which was available for favor, and benevolence, at the very hour it ascending into Pisces, the form of which was the Image of a woman having the head of a bird, and feet of an Eagle, holding a dart in her hand. They made another Image of Venus for to get the love of women, in the Lapis Lazulus [lapis lazuli], at the hour of Venus, Venus ascending in Taurus, the figure of which was a naked maide with her haire spread abroad, having a looking glass in her hand, and a chain tyed about her neck, and nigh her a handsome young man holding her with his left hand by the chain, but with his right hand making up her hair, and they both look lovingly on one another, and about them is a little winged boy holding a sword or a dart. They made another Image of Venus, the first face of Taurus or Libra or Pisces ascending with Venus, the figure of which was a little maide with her hair spread abroad, cloathed in long and white garments, holding a Laurell Apple, or flowers in her right hand, in her left a Combe. Its reported to make men pleasant, jocand, strong, chearfull [cheerful] and to give beauty.'

The magician must learn these correspondences, as magical work should be undertaken in the hour/day/astrological period which is ruled by the relevant planet. In the case of the love spell above, this would typically be undertaken on a Friday, Venus' day, for example.

ABOVE *Image of a human body in a pentagram from Heinrich Cornelius Agrippa's* Three Books of Occult Philosophy, *1531.*

OPPOSITE *Roman fresco of Venus and Mars from the Casa di Marte e Venere (VII 9, 47) in Pompeii, c. 450 BCE–79 CE.*

Worldly correspondences

Astrological influences are important, but lower level correspondences in the natural world must also be taken into consideration (see right).

Carved talismans could be used for healing; according to Agrippa these should be made of semi-precious stones. He attributes selenite and quartz to the moon; amethyst and topaz to Jupiter, and beryl and carnelian to Venus. Combined with herbs, these talismans can be 'imprinted' with the powers of the planets if the correct ritual is undertaken at the corresponding planetary hour.

Agrippa also recommends the use of 'magic squares', in which numbers are arranged in a particular order. This practice dates from Arabic magic in which numbers or letters were held to have magical power. For example, Agrippa writes the spell:

4	14	15	1
9	7	6	12
5	11	10	8
16	2	3	13

'if this magic square is stamped on a silver plate at a time when Jupiter rules, it provides profit and wealth, grace and love, peace and concord with men, and placates enemies, confirms honours and dignities and counsels. And if it is inscribed on coral, it destroys evil spells.'

Agrippa took this spell from the work of earlier magicians, such as the 14th-century *Book of Angels* by Francesc Eiximenis, which gave further instructions on the use of herbs to lend additional power to the square and suggests that it is placed in a dovecote or a beehive in order to ensure the success of the flock or swarm.

HOUND'S-TONGUE

'They say also that a stone bitten by a mad dog has the power to cause discord, if it is put in a drink, and that one who puts a dog's tongue in his shoe, under his big toe, will not be barked at by dogs, especially if it is added to the herb of the same name, cynoglossa [hound's-tongue] And a membrane from the afterbirth of a dog has the same effect, and dogs will shun one who has a dog's heart.'

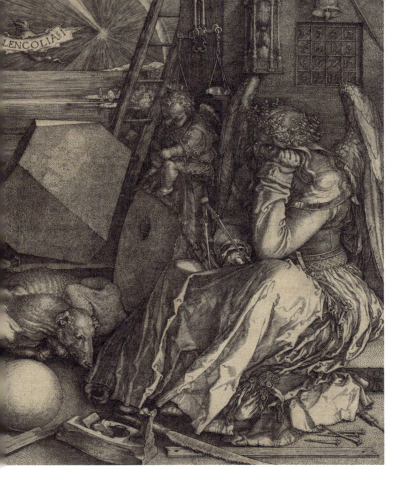

1592 CE

OPPOSITE LEFT *Illustration of hound's-tongue.*

LEFT *On the face of the building in this engraving is a 4 x 4 magic square – the first printed in Europe.* Melencolia by Albrecht Dürer, 1514.

BELOW LEFT *Asian magic square, Hindi Manuscript 317, folio 2b, Wellcome Collection.*

BELOW RIGHT *Cheng Dawei (Chinese mathematician) magic square, 1592.*

EGYPTIAN AMULETS AND CHARMS

Amulets of ancient Egypt

ORIGINS: Egypt
DATES: c. 3100–332 BCE
PURPOSE: Protection

We have examples of a great many ancient Egyptian amulets, charms and talismans, dating from across Egypt's long history, although there were some trends and fashions: amulets in the shape of animals seem to have been popular in the Old Kingdom period (2700–2200 BCE), for instance. These would have been carried or worn by the living.

Archaeologists have also found amulets in the bandaging of mummies, suggesting that they were also believed to protect the dead. Many of these amulets took the form of a heart, and while the heart was not removed in mummification, an amulet was placed on the mummy's chest to prevent the heart testifying against its owner in the Weighing of the Heart ceremony, in which the heart was weighed against the feather of Maat. The Egyptian belief was that everyone's heart was weighed by the gods on a pair of scales as the soul passed through the Duat (netherworld).

Amulets have been found in the shape of lions (for valour), flies (for persistence) and hares (their meaning is uncertain but they may have been valued for their fecundity), cobras (the symbol of the royal house of Egypt), vultures (to ward against danger) and scarabs (symbolizing the sun, since the scarab-faced god Khepri was held to roll the sun across the sky just as the actual scarab beetles roll balls of dung across the desert). Other forms include representations of lotus flowers, which open and close with the sun, and cowrie shells, used for fertility as they resemble female genitalia. More esoteric, abstract amulets include the *ankh*, symbol of life; the *djed* pillar, representing the backbone of Osiris, for strength; and the *wadj* sceptre, which takes the form of a papyrus scroll and was often placed in the throat of a mummy, perhaps for the preservation of the body. Some amulets were carved from gemstones and many were made from faience (a mixture of quartz, salts and lime that turns blue in the firing). Gold and silver were also used.

OPPOSITE (TOP TO BOTTOM, LEFT TO RIGHT) *Ankh, c. 1400–1390 BCE; Cobra, 1070–332 BCE; vulture pectoral, c. 1479–1425 BCE; cowroid inscribed with an ankh, c. 1492–1473 BCE; wadj amulet, 664–332 BCE; djed pillar, c. 664–332 BCE.*

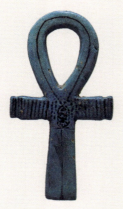
ANKH

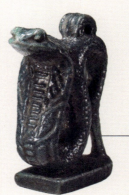
COBRA

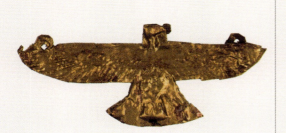
VULTURE

COWROID

WADJ SCEPTRE

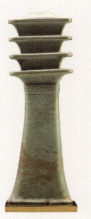
DJED PILLAR

1070–332 BCE

CHARMS AND TALISMANS

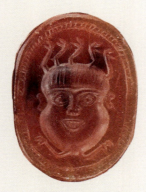

CARNELIAN SCARAB

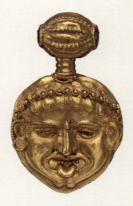

GOLD GORGON PENDANT

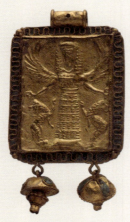

DAEDALIC PENDANT

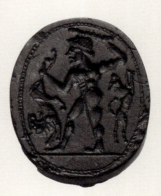

JASPER SCARAB

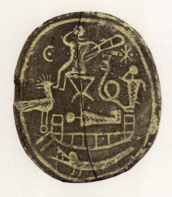

PALINDROME AMULET (OBVERSE)

PALINDROME AMULET (REVERSE)

GREEK AMULETS

Amulets found across ancient Greece

ORIGINS: Greece
DATES: c. 900 BCE–600 CE
PURPOSE: Protection, achieving an intention

The Greeks commonly wore apotropaic (protective) amulets for protection against the Evil Eye, witchcraft, accident, attack and robbery, to give just a few examples. They also wore talismans to produce a particular result, such as attracting love or wealth.

Magical formulae could be inscribed upon papyrus, such as the word *abracadabra* to ward off disease, or magical injunctions placed on a house to ward off sickness or bad luck:

ὁ τοῦ Διὸς παῖς καλλίνικος Ἡρακλῆς ἐνθάδε κατοικεῖ· μηδὲν εἰσίτω κακόν.

(The son of Zeus, resplendent in victory, Heracles, lives here. Let no evil enter!)

Texts include Hebrew and Egyptian incantations.

Amulets could take many forms. Some were carved from semi-precious stones; body parts from executed criminals could be carried, to fend off bad luck. Scarabs were used, as in Egypt, but also a hand performing an obscene gesture, or male and female genitalia. Phallic amulets, made of bone or bronze, were sacred to the god Dionysus and would have been worn for fertility, potency and power. Pliny the Elder (23/24–79 CE) in his *Natural History* terms these phallic amulets *medicus invidiae* or 'doctors against the Evil Eye', since some individuals were thought to be able to exert a baleful influence on others through the power of their gaze alone.

Girls may also have worn an amulet in the shape of the crescent moon, known as the *selenis*. Even gods, such as Zeus and Hera, were depicted wearing amulets; in this instance, the *gorgoneion* or Gorgon's face – a powerful protector, as the Gorgons had the power to turn the beholder to stone. Amulets could be worn in the form of pendants or rings, and they also appear in mosaics in order to protect the home.

c. 500 CE

OPPOSITE (TOP TO BOTTOM, LEFT TO RIGHT) *Engraved Carnelian Scarab with head of a Gorgon, c. 500 BCE; gold pendant in the form of a gorgoneion (Gorgon's face), Greek, Cypriot, c. 450 BCE; gold and glass Daedalic Pendant with Potnia Theron (Mistress of the Animals), 650–600 BCE; jasper scarab, c. 6th century BCE; Cypriot palindrome amulet. The facing side of the amulet features depictions of the gods, on the reverse side is a palindromic inscription, c. 500 BCE.*

ROMAN AMULETS

Protective amulets from ancient Rome

ORIGINS: Italy
DATES: 27 BCE–476 CE
PURPOSE: Protection, achieving an intention

The phallus, winged or otherwise, was a very common Roman amulet. These are called *fascinare*, which means 'to cast a spell' (the origin of our word 'fascinate'). They were made out of precious metals, glass, amber or bone and were placed around the necks of babies to protect them from the Evil Eye. They also featured in *tintinnabula* – wind chimes with a central erect phallus surrounded by bells. Some feature in triple form.

Like the Greeks, the Romans used magical incantations as amulets. One 3rd–4th century CE example, now in the British Museum, was cut from a rectangular gold sheet (*lamella*) and inscribed with a mix of letters and geometrical figures (*charaktêres*) that form an appeal to 'holy names' (*voces magicae*) on behalf of a pregnant woman named Fabia. The amulet was made for Fabia by her mother and would probably have been worn in a special case around her neck to ensure her safety during childbirth. Women might also wear a *lunula*, an apotropaic amulet in the shape of the crescent moon and analogous to the Greek *selenis* (see page 173). Boys would wear a *bulla* around the neck like a locket for protection against evil forces.

Coins were also used as 'touch pieces': Emperor Vespasian (r. 69–79 CE) gave these out at ceremonies to those who were ill. They have a protective function and were also held to bring good luck.

Charms have been found in the ruins of Pompeii – preserved under the volcanic ash – made of amethyst, amber, bone, bronze and glass. These include beads (for example, a glass bead bearing the head of the god Dionysus and tiny carvings made to resemble a human skull) and Egyptian scarabs. Amulets were also carved in the form of a god or goddess, for example the goddess Fortuna, who has given her name to our word 'fortune,' meaning luck.

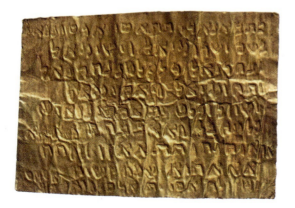

Gold lamella Orphica with prayer for recovery, Greek, 3rd century CE.

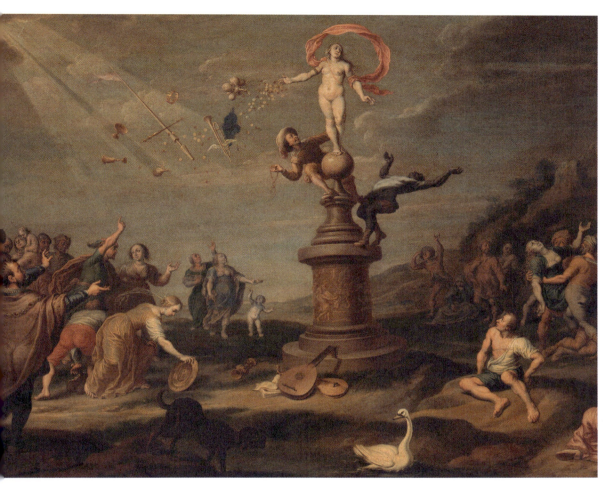

81–96 CE

TOP Fortuna Distributing her Largesse, *attributed to Cornelis de Baellieur, between 1617 and 1671.*

ABOVE LEFT *Roman bronze phallic amulet, 1st century* CE.

ABOVE RIGHT *Domitian gold aureus, 81–96* CE.

CHARMS AND TALISMANS

MARMION

'When Whitby's nuns exalting told,
Of thousand snakes, each one
Was changed into a coil of stone,
When Holy Hilda pray'd:
Themselves, without their holy ground,
Their stony folds had often found.'

by Sir Walter Scott (1808)

SAXON SNAKE STONES

Naturally occurring fossils used as amulets for healing

ORIGINS: Britain
DATES: 410–1066 CE
PURPOSE: Warding off disease

Ammonites are the fossilized remains of a species of prehistoric sea creatures classified as cephalopods. The Anglo-Saxons, unaware of their biological origins, called them 'snake stones' and carried them as amulets, probably to ward off disease.

A legend from the north of England tells us that the 7th-century Abbess of Whitby, St Hilda, came to the town when it was still known as Streonshalh and found it overrun with snakes, seen as creatures of the Devil. She chopped off the snakes' heads with a whip, then changed them into stone and cast them from the cliffs, where they still reappear. The Scottish writer Sir Walter Scott referenced this folk story in his poem *Marmion* (1808) (see opposite).

Some of the ammonites that were used as amulets had snakes' heads added to them, an example of which can be seen in Whitby Museum. Ammonites have been found in Saxon graves along with other fossils, such as 'snake's tongues' (in actuality, the teeth of ancient sharks), sea urchins (echinoids), sea lily stems (crinoids) and the marine animals known as belemnites.

9th century CE

The Saxons carried other charms, too, such as rings inscribed with runes, oak galls, pieces of white quartz and hagstones. Some folklorists believe that they also used objects from past societies as charms, including Roman beads or *bullae* (see page 174) and prehistoric flint arrow tips. Once the Pagan Saxons became Christianized, amethyst began to be used in amulets. Thin pieces of pressed gold known as *bracteates*, made into pendants, have also been found; these feature either Saxon deities or, post conversion, Christian symbols. Thor's hammer also appears as an amulet, along with other miniature weapons. But it seems likely that most amulets were worn by women and children, judging from the content of Anglo-Saxon graves. Some of these burials may have been those of cunning women.

ABOVE LEFT *Drawing of an ammonite.*

ABOVE RIGHT *The Bramham Moor ring – an Anglo-Saxon ring inscribed with runes, 9th century.*

OPPOSITE *Saint Hilda at Hartlepool by James Clark, 1925.*

CHARMS AND TALISMANS

GRIMOIRES

Magical 'recipe' books

ORIGINS: Western Europe
DATES: 1st century CE–today
PURPOSE: Magical understanding, achieving an intention

From the very earliest times, magical practitioners have greatly valued books of spells, as we have seen with Babylonian tablets and the Greek Magical Papyri (see page 34). Their European equivalents are known as grimoires, or 'grammars' of magic (some etymologists maintain that 'grimoire' and 'grammar' have the same root).

11th century CE

The term 'grimoire' entered common usage in English in the early 19th century with the publication of Francis Barrett's famous grimoire *The Magus*. A grimoire is a magical manual containing spells and incantations, lists of angels, demons and correspondences, and instructions for the making of charms and talismans. Most of them are claimed to be of ancient origin, using the names of famous figures such as the biblical King Solomon; although this is rarely the case in actuality, many grimoires do draw upon the work of classical writers such as Pliny.

The most famous grimoires date from the Middle Ages and the Renaissance, such as the 11th-century *Picatrix* (*Ghāyat al-Ḥakīm* in the original Arabic), which describes celestial magic, astrology and the making of talismans. At four hundred pages, the *Picatrix* is one of the most comprehensive astrological and magical texts ever produced. It delves into the theories behind magic:

'The fact about a talisman is that its name is reversed (The letters of the word talisman in Arabie are "talsam" and when this combination is reversed, it becomes "maslat", which means domination, control); it is domination because its essence is coercion and control. It functions according to the purpose it was composed for: overpowering and coercing, by using numerical ratios and placing astrological secrets in certain bodies at appropriate times and by using incenses that are powerful and capable of bringing out the spirit of that talisman.'

OPPOSITE *Saul and the Witch of Endor by Jacob Cornelisz van Oostsanen, 1526.*

LEFT *Illustration from the grimoire known as The Picatrix, 11th century CE.*

Handbooks of magic

The *Sworn Book of Honorius* is based on the name of Honorius of Thebes (we do not know who actually wrote it, or precisely when) and is first mentioned in a French trial in 1347. It may have been compiled by a group of magicians. It contains instructions for attaining visions of hell, heaven and purgatory, as well as spells for apprehending thieves and commanding demons. The 16th-century English magician John Dee (see pages 105 and 118) owned a copy of this grimoire, which emphasizes the importance of the angelic powers.

Magical texts under the name of Solomon were found throughout the Mediterranean in the early Christian era, but the *Key of Solomon* itself is likely to date to 14th- or 15th-century Italy. There are several versions and translations and it is divided into two books. The *Key of Solomon* makes it clear that magical success only occurs through the intervention of God. In addition, magic has to be done at the correct planetary hour, using the right symbols and correspondences. Purification is important. The second book goes into detail regarding animal sacrifice. All this will, the *Key* claims, allows the practitioner to become invisible, find lost treasure and summon demons.

The Italian magician Giovanni Pico della Mirandola (1463–1494) divides magic into two kinds: goetia, which relies on the summoning of demonic forces, and theurgy, which relies on divine forces such as archangels and gods. Dating from the 17th century, the anonymously compiled first book of the *Lemegeton* – the *Lesser Key of Solomon* – is also called the *Ars Goetia*, and has had a significant impact on modern magical practice. The *Lemegeton* was influenced by Jewish Kabbalism and Arabic alchemy.

In Scandinavia, we find 'Black Books' (*Svarteboken*), the Germanic and Scandinavian grimoires that were grouped together under the title *Cyprianus*, after St Cyprian of Antioch, in the 17th century. Along with healing charms, these contain details on molybdomancy (*støyping*): the art of divination using molten church lead.

BELOW LEFT *The magical circle and triangle used in the evocation of the seventy-two spirits of the Ars Goetia, 1904.*

BELOW RIGHT *Illustration from the* Clavis Inferni (The Key of Hell), *by Cyprianus, 18th century.*

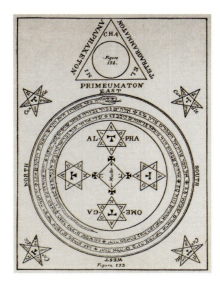
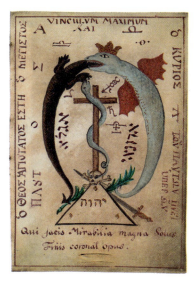

Other grimoires include the *Book of Simon the Magician*, the *Petit Albert* (Little Albert) and the *Dragon Rouge* (Red Dragon, also known as the *Grand Grimoire*). All of these grimoires were popular at the time of publication and are still used by magicians today. The *Petit Albert*, published in the 18th century, was widespread throughout France. As well as recipes for household items such as soap, it has instructions for a variety of things, such as getting rid of pests in crops, spells for swift movement of people or horses, and ordinary recipes for culinary purposes. It also contains instructions on how to make the 'Hand of Glory': take a hand from a hanged man, mummify it in nitre and cover it in wax to make a candle. If it is placed in a building, it will render everyone within it incapable of movement.

After printing became widespread throughout Europe, earlier grimoires, such as the *Dragon Rouge*, became popular. Its dates are uncertain, but although it claims in the text to be 16th century, it was probably compiled in the early 19th century from prior works. As with many printed grimoires, it was exported to French colonies in Africa and subsequently influenced Voodoo (see page 150). It contains details of how to make a pact with a demon and thus to use the demon for doing one's bidding, such as making oneself invisible, attracting love, winning money and contacting the spirits of the dead.

There are modern grimoires, too, such as Gerald Gardner's *Book of Shadows*, which contains instructions for Wiccan rituals (see page 154). The English magician and writer Andrew Chumbley published *The Azoëtia*, a grimoire for the practice of his Sabbatic magic, in 1992, and *ONE: The Grimoire of the Golden Toad* in 2000.

BELOW LEFT *Woodcut from an edition of the book of Albertus Magnus – the* Petit Albert.

BELOW RIGHT *Frontispiece for an edition of the* Grand Grimoire, *1821.*

CHARMS AND TALISMANS

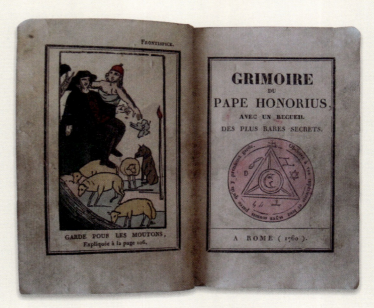

GRIMOIRE DE PAPE HONORIUS

KEY OF SOLOMON VOL 2

18th century CE

SVARTEBOKEN (CLAVIS INFERNI)

DRAGON ROUGE

ELIZABETHAN AMULETS

Protective amulets of Elizabethan England

ORIGINS: Britain
DATES: 1558–1603 CE
PURPOSE: Protection, luck

The Elizabethans used a variety of amulets, which were available from magical practitioners. Charms imbued with the power to cure cattle of illnesses, to make children sleep soundly, to cure toothache and to protect the wearer in battle are just some of the magical objects they would have purchased. In addition, many people would have worn a cross, not only to demonstrate their religious devotion, but also for protection against evil.

Elizabethan physicians would carry amulets made of dried blood and dead toads, said to contain a stone that would ward away diseases. *Memento mori* (artistic representations of death, such as skulls) were also used as talismans. Queen Elizabeth I herself carried an agate amulet, said to ensure that she always had at least one loyal supporter: agate is also believed to bestow good fortune upon the person who carries it.

Gold coins, known as angels, were carried to ward off disease, such as the King's Evil (scrofula). Shakespeare gives an explanation of this sickness and its cure in *Macbeth* (see page 186).

Such coins would be holed, so that they could be worn around the neck, and are double sided. One example, minted between 1578 and 1581, depicts St Michael slaying a dragon. They were given out in royal ceremonies to people who were afflicted with scrofula – the 'evil' in question. Elizabeth I took part in such a ceremony in 1575 in Kenilworth.

ABOVE *Queen Elizabeth's Entry into Kenilworth Castle,* from John Cassel's Illustrated History of England, Volume II, *by William Howitt, Cassell, Petter, and Galpin, London, 1858.*

OPPOSITE *Queen Elizabeth I by Federico Zuccari, c. 1540–1609.*

ABOVE *Edward the Confessor applies the Royal Touch.*

THE KING'S EVIL, SHAKESPEARE

'Tis call'd the evil:
A most miraculous work in this good king;
Which often, since my here-remain in England,
I have seen him do. How he solicits heaven,
Himself best knows: but strangely-visited people,
All swoln and ulcerous, pitiful to the eye,
The mere despair of surgery, he cures,
Hanging a golden stamp about their necks,
Put on with holy prayers: and 'tis spoken,
To the succeeding royalty he leaves
The healing benediction.'

OPPOSITE *A collection of amulets.*

ENGLISH HAMMERED GOLD ANGEL COIN
DEPICTING ST MICHAEL AND THE DRAGON,
1590–1592

JOHN DEE'S CRYSTAL,
USED FOR CLAIRVOYANCE
AND CURING DISEASE, 1582

1500–1550 BCE

DEVOTIONAL PENDANT,
LATE 16TH OR EARLY 17TH CENTURY,
PROBABLY SPANISH

THE HOCKLEY PENDANT,
A GOLD MEDIEVAL RELIQUARY DEPICTING
A FEMALE SAINT, 16TH CENTURY

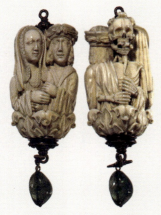

ROSARY TERMINAL BEADS,
NORTH FRENCH OR SOUTH NETHERLANDISH
c. 1500–1525

GOLD MEMENTO MORI PENDANT

PART FIVE
CURSES AND HEXES

EGYPTIAN CURSES

Curses of ancient Egypt

ORIGINS: Egypt
DATES: *c.* 3100–332 BCE
PURPOSE: Attacking enemies

Ancient Egyptian magical practitioners offered curses and hexes (written or spoken maledictions against one's enemy to bring about their misfortune), and also protection against this kind of magic. The 'mummy's curse' remains one of the most enduring folk legends in Egypt, such as the curse on Tutankhamun's tomb: 'Death shall approach on rapid wings to him who disrupts the King's tranquillity.'

Lord Carnarvon, who funded the excavation of Tutankhamun's tomb in 1922, died shortly afterwards (he was actually killed by blood poisoning and pneumonia). In fact, relatively few Egyptian tombs contain curses aimed at those who would disturb the grave – warnings and requests not to trespass are much more common.

Execration figures are found throughout Egyptian history, such as the 400 figurines found buried in an Old Kingdom (*c.* 2700–2200 BCE) cemetery in Giza. These take the form of small clay tablets with a crude head at the top, and inscribed with the name of the target. A larger tablet figure names the main target of the curse as the Nubians, Egypt's neighbours to the south, whereas the smaller figures name specific individuals. Here, the objects of the curse are foreign warriors who might harm Egypt. 'Dangerous speech' is also mentioned, which may be a reference to curses placed by the Nubians. Essentially, this is a 'binding' spell – a curse to limit the harm caused by others.

We also have an example of a curse text from a Late Period (*c.* 713–332 BCE) wooden tablet that was used as an amulet to protect the wearer against the Evil Eye, invoking several of Egypt's most powerful gods (see text below).

The man who carried this amulet, Pedamunnebnesuttawy, is named, which means that the spell is linked to him and cannot be used by anyone else; it is specifically for his protection.

PROTECTION AGAINST THE EVIL EYE

'Sekhmet, her arrow is in you, the magic of Thoth is in your body, one who is in the brazier of Horus who is in Three Hundred Town, the Great God who resides in the House of Life, he blinds your eyes...'

Present Day

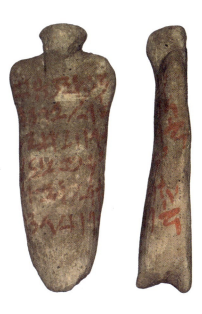

LEFT *Ancient Egyptian execration figurines made of unbaked clay inscribed with curses written in hieratic script. Royal Museums of Art and History, Brussels.*

BELOW *Egyptian magical figures inscribed with faded red paint listing the names of enemies. Met Museum, New York, USA, c. 1802–1550 BCE.*

LEFT *Howard Carter (kneeling) opening the tomb of Tutankhamun in the Valley of the Kings, Egypt, in 1922.*

c. 1802–1550 BCE

191

5000 BCE

CURSES OF BABYLON AND ASSYRIA

The practice of cursing in ancient Babylon and Assyria

ORIGINS: Mesopotamia
DATES: *c.* 2000–900 BCE
PURPOSE: Vengeance, attacking enemies

We have evidence for a number of Babylonian curses, of various forms. As with other Middle Eastern and Mediterranean societies, legal oaths included self-cursing: those testifying in court would need to swear on the weapon of a god that they were telling the truth or would fulfil a contract, with dire consequences if they did not. The Law Code of Hammurabi (r. *c.* 1792–1750 BCE) states: (below left)

THE LAW CODE OF HAMMURABI

'May the god Nergal … have him beaten with his mighty weapon and shatter his limbs like those of a clay figure.'

The Code of Hammurabi has a conclusion containing around thirty curses. Treaties between warring rulers could also contain curses against anyone who broke the agreement. A treaty written up by the Neo-Assyrian king Esarhaddon (r. *c.* 681–669 BCE) has in the region of one hundred, including the one below.

ESARHADDON TREATY CURSE

'May Kubaba, the god[dess of] Carchemish, put a serious venereal disease within you; may your [urine] drip to the ground like raindrops.'

AŠŠUR-NERARI V TREATY

'This head is not the head of a spring-lamb, it is the head of Mati'ilu ... If Mati'ilu should sin against this treaty, just as the head of this spring-lamb is cut off ... so may the head of Mati'ilu be cut off.'

A further treaty featuring curses was the Neo-Assyrian treaty between Aššur-nerari V and his vassal Mati'ilu, the king of Arpad, in the 8th century BCE. It is likely that this was accompanied by an animal sacrifice (see above).

In the same region, we often find curse-breaking incantations, or *Namerimburrudû*, which are designed to avert the curses that would befall you on breaking an oath or treaty. The Library of Ashurbanipal (see page 19) contains some examples of these on clay tablets.

OPPOSITE *Cast of Kubaba, British Museum, 20th century.*

ABOVE LEFT *Law code stele of King Hammurabi, c. 1792–1750 BCE.*

LEFT: *Part of the code of Hammurabi, 1755–1750 BCE.*

1755–1750 BCE

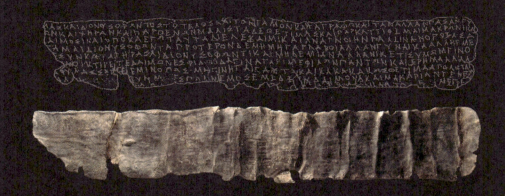

THE PELLA CURSE TABLET

'Of [Theti]ma and Dionysophon the ritual wedding and the marriage I bind by a written spell, and of all other wo[men], both widows and maidens, but of Thetima in particular, and I entrust to Makron and [the] daimones [spirits], and (only) when I should dig up again and unroll and read this, [?] that she might wed Dionysophon, but not before, for I wish him to take no other woman than me, and that [I] grow old with Dionysophon, and no one else. I [am] your supplicant: Have pity on [Phil?]a, dear daimones, for I am (a) dagina? of all my dear ones and I am abandoned. But guard [this] for my sake so that these things do not happen, and wretched Thetima perishes miserably ... but that I become happy and blessed.'

GREEK CURSES

Curses found in ancient and later Greece

ORIGINS: Greece
DATES: *c.* 900 BCE–600 CE
PURPOSE: Vengeance, binding

The ancient Greeks employed an extensive range of curses, which were often inscribed on tablets known as *katadesmoi* (κατάδεσμοι, **literally 'bindings down'). It is likely that the Roman** *defixiones* **derived from this custom (see pages 30 and 35).**

We have an example of a Greek curse from Antioch, inscribed on a 4th-century CE curse tablet found in a well (right).

Iao is the Greek version of Yahweh, the name of the Abrahamic god and 'the chariot of Pharaoh' is a reference to the Book of Exodus. Babylas was possibly a Christian, and we do not know what he did to offend the person who cursed him – some scholars have suggested that he might have been a rival greengrocer.

The Macedonian artefact named the Pella curse tablet dates from 4 BCE and relates to a forthcoming marriage (see opposite).

Makron is likely to have been the person in whose grave this tablet was placed. The idea is that his spirit would have taken the curse down to the chthonic spirits, the *daimones*, of the underworld, and beseeched them to help the curser.

ANTIOCH CURSE

'O thunder-and-lightning-hurling Iao, strike, bind, bind together Babylas the greengrocer. As you struck the chariot of Pharaoh, so strike his [Babylas'] trickery.'

4th century BCE

OPPOSITE *The Pella curse tablet, 4th century BCE.*

RIGHT *Ancient Greek binding spell, 4th century BCE.*

CURSES AND HEXES

A CURSE AGAINST MIND AND BODY

SPELL FOR VICTORY IN A MILITARY TRIAL

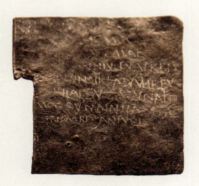

CURSE AGAINST THEFT FOUND IN BATH

CURSE WITH MAGICAL FORMULAS

CURSE TABLET ENGRAVED WITH
GREEK LETTERS AND MAGIC SIGNS

ROLLED
CURSE TABLET

ROMAN CURSES

Curses of the Roman Empire

ORIGINS: Italy
DATES: 27 BCE–476 CE
PURPOSE: Vengeance, attacking enemies, binding

Curse tablets were commonly used throughout the Roman empire, cast into sacred springs, nailed to walls or buried in graveyards, or close to the workplace of the target of the curse. Known as *tabulae defixiones*, they were made of clay or metal, often lead, although there are some examples that were made of limestone or papyrus.

Typically, they have a nail hammered through them to lend additional force to the curse, which is often a type of binding spell. The name comes from *defigo*, 'to pierce', and the tablets were probably inscribed by professional scribes. Some were written backwards – a traditional sign of negative magic.

Romans cursed their rivals in business, in court cases and in love, as well as requesting vengeance on those who had wronged them. We have examples of around thirty curse tablets dating from between 200 and 400 CE from the Roman baths in Bath, UK, which appeal to the Romano-British goddess Sulis Minerva for justice if, for instance, a stolen item is not returned (see also page 45). Most of the Bath *defixiones* relate to thefts from the public baths themselves.

Some curse tablets tried to influence the outcome of sporting events, such as this curse from Carthage that was aimed at the 2nd-century CE gladiator Vincenzus Zarizo (right).

OPPOSITE *Curse tablets found across the sites of the Roman Empire.*

RIGHT *Head of Sulis Minerva.*

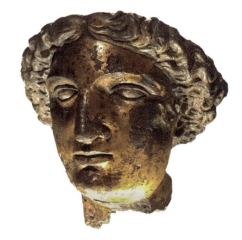

70–100 CE

DEFIXIO FOR A GLADIATOR

'Entangle the nets of Vincenzus Zarizo, may he be unable to chain bears, may he lose with every bear, may he be unable to kill a bear on Wednesday, in any hour, now, now, quickly, quickly, make it happen!'

SAXON AND VIKING CURSES

Curses of the Saxon and Viking period

ORIGINS: Britain and Scandinavia
DATES: *c.* 2nd century–1066 CE
PURPOSE: Vengeance, attacking enemies

Like the ancient civilizations to their south, the Saxons adopted the practice of writing curses into legal documents, such as this example contained in the will of Wulfgyth, which was originally written in 1046 CE (opposite).

Curses were also invoked against various medical conditions, such as a short curse against a boil – '*Her ne scealt thu timbrien*' ('Here not build your timbered house') and a longer one against a cyst (right).

Curses would have invoked the Christian pantheon, as with the example of the will opposite, but pre-Christianization would have involved an appeal to the Saxon gods (see page 54). However, some curses rely simply on a system of correspondences (see page 164).

The Vikings also employed curses and these appear in Norse legend, such as the curse with which Frey's servant Skirnir threatens a giant's beautiful daughter, Gerðr; she will be overcome by lust and madness, will lose her status and will end up sitting on the cold hill above Hel. Cowed, Gerðr submits to Skirnir and Frey's demands.

A CURSE AGAINST A CYST

'May you be consumed as coal upon the hearth, may you shrink as dung upon a wall, and may you dry up as water in a pail. May you become as small as a linseed grain, and much smaller than the hipbone of an itchmite, and may you become so small that you become nothing.'

OPPOSITE *A 12th-century copy of the original Will of Wulfgyth, which was written in 1046.*

12th century CE

THE WILL OF WULFGYTH

'And he who shall detract from my will which I have now declared in the witness of God, may be deprived of joy on this earth, and may the Almighty Lord who created and made all creatures exclude him from the fellowship of all saints on the Day of Judgment, and may he be delivered into the abyss of hell to Satan the Devil and all his accursed companions and there suffer with God's adversaries without end and never trouble my heirs.'

CURSES AND HEXES

BARTMANN JUG

16TH-CENTURY GERMAN BELLARMINE JUG, ALSO CALLED A BARTMANNKRUG OR BEARDMAN JUG

BELLARMINE USED AS WITCH BOTTLE

X-RAY OF THE GREENWICH WITCH JAR

CURSE PROTECTION BOTTLE

AMERICAN CIVIL WAR WITCH BOTTLE

WITCH BOTTLES

A protection against witches' curses

ORIGINS: Europe
DATES: 17th century CE
PURPOSE: Protection against witchcraft

Witch bottles, dating from the 17th century, were designed to trap curses and rebound them upon the curser. Typically they are ceramic, stoneware or glass bottles, such as Bartmann jugs imported from Germany's Rhineland, which were filled with a variety of magical items or substances, such as pins, nails, thorns, tangled threads, needles and human urine.

These bottles were often placed in cellars or walls and beneath the hearth, and are found across Europe and the UK, particularly East Anglia. Their use spread to the USA, such as the Essington witch bottle from Delaware County.

A salt-glazed witch jar discovered in Greenwich, UK (opposite), was analysed by archaeologists from the Maritime Trust. An X-ray showed pins clustered in the neck, indicating that the bottle was probably buried upside down. Tomography scans indicated that the bottle had been partly filled with urine, as well as navel fluff, nail clippings and a leather heart pierced with a nail, plus brimstone or sulphur (traces of iron sulphide were found in the bottle). The nail clippings appeared manicured, suggesting to the researchers that someone of high status had been involved in creating the bottle.

Joseph Glanvill tells the story of a man whose wife had been cursed in his *Saducismus Triumphatus: Or, Full and Plain Evidence Concerning Witches and Apparitions* (1681). The man was advised to: 'Take your Wive's Urine ... and Cork it in a Bottle with Nails, Pins and Needles, and bury it in the Earth The Man did accordingly. And his Wife began to mend sensibly But there came a Woman from a Town some miles off to their house, with a lamentable Out-cry, that they had killed her Husband ... her Husband was a Wizard, and had bewitched this Mans Wife and that this Counter-practice prescribed by the Old Man ... was the death of that Wizard that had bewitched her.'

ABOVE *Rusty nails found in a witch bottle.*

OPPOSITE *A selection of witch bottles found in Europe and the USA.*

CURSES AND HEXES

DEMONOLOGY

The practice of summoning demons

ORIGINS: Europe and Asia
DATES: Ancient times to the present day
PURPOSE: Summoning demons

Summoning demons to do one's bidding has been a part of occult practice since early times. Greek magical practice referred to a *demon/daimon* (δαίμων), meaning an entity with god-like powers, but the word may come from Indo-European and refer to a diviner.

To the early Greeks, some mortals could be transformed into *daimones*, resembling spirit guides. In the 1st century CE, commentators such as Josephus refer to a book belonging to King Solomon that contained instructions for summoning demons. *The Testament of Solomon* was written at some point in the first five centuries CE and contains details of the Ring of Solomon, a magical talisman that the king was said to have used to bind demons in jars and control them. The idea that demons could be manipulated by the magician filtered into much later grimoires, including the *Key of Solomon* (see pages 180–182).

Over time, the concept of demonic forces became increasingly negative; in the Bible, for example, demons are seen as evil spirits, a characterization they have retained throughout Western history into modern times, although some contemporary occultists regard them as having a more neutral identity.

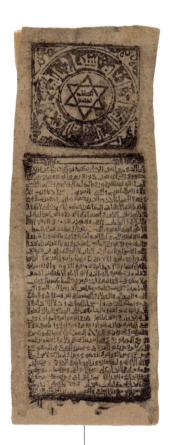

RIGHT *Talismanic scroll bearing Solomon's Seal, 11th-century Fatimid Caliphate.*

OPPOSITE *King Solomon on his throne, Johann Sadeler after Chrispijn van den Broeck, 1575.*

202

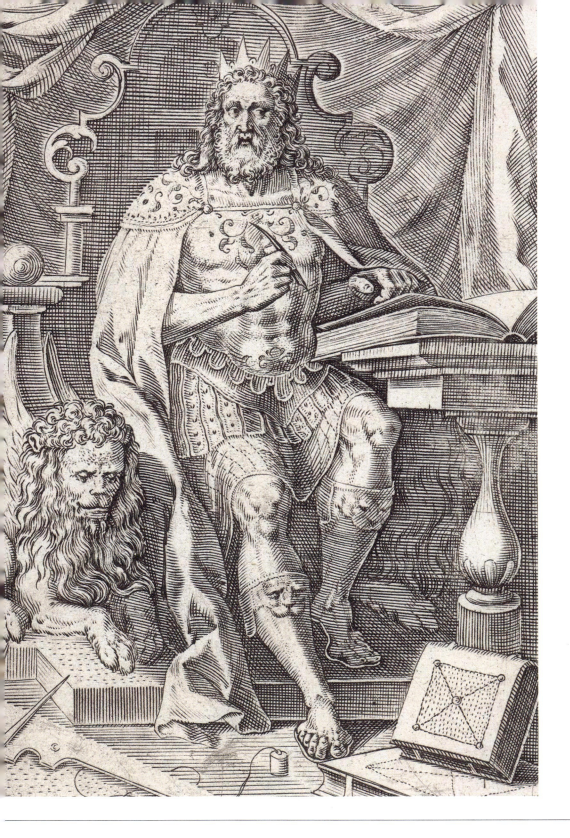

11th century CE

The demon class system

In many grimoires, demons are organized into hierarchies, similar in complexity to the accompanying angelic hierarchies, which vary according to which commentator you happen to read. In the 18th-century *Grimoire Verum*, the hierarchy mirrors that of the European aristocracy, with Lucifer, Beelzebub and Astaroth at the top, and other demons divided into a series of lesser ranks – dukes, earls and so forth – below them. Lucifer rules Europe and Asia, Beelzebub rules Africa, and Astaroth rules the Americas. Some of these entities may have ancient roots: Astaroth, although presented as male in the *Grimoire Verum*, probably derives from the ancient Near Eastern goddess Astarte.

There are also spirits that do not fall into either the angelic or the demonic hierarchies, such as the Wandering Princes, spirits who cannot enter either heaven or hell and so wander the Earth. Some are negative in character, and some are positive, and there are hundreds if not thousands of them. These entities, too, are held to be contactable by the magician. In most grimoires, each demon has a sigil that constitutes its name, and which enables the magician to contact it.

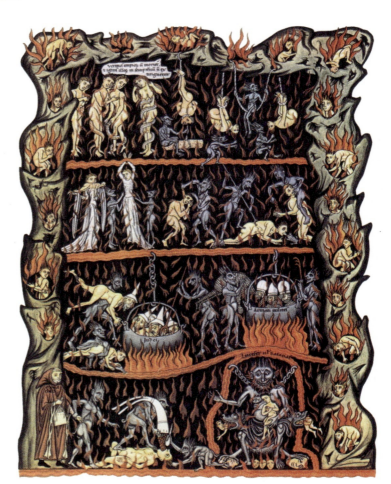

Hell, an illustration from the Hortus Deliciarum, *Herrad of Landsberg, 1180.*

18th century CE

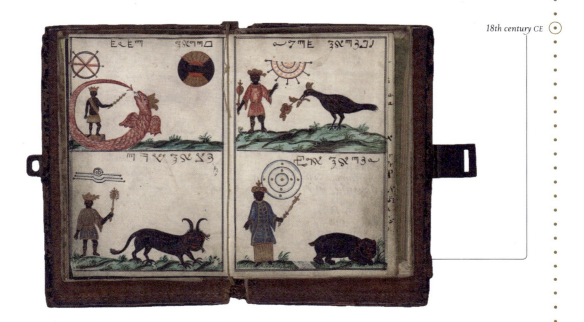

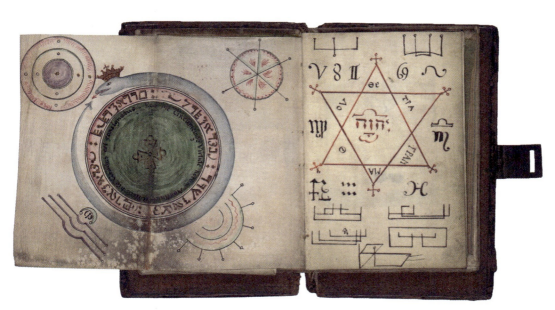

TOP *Kings of the East, West, South and North, from the* Book of Cyprianus, *18th century.*

ABOVE *The* Clavis Inferni *(The Key of Hell) by Cyprianus, 18th century.*

Summoning a demon

Most grimoires suggest caution when one is engaged in demonic conjuration. Unlike most modern ritual magic, in which the magician draws a protective circle and works within it, conjuration typically involves two locations: a circle, in which the magician stands, and a triangle (perhaps drawn in chalk) a few feet away, in which the spirit is conjured. This is for protection: if the neophyte magician wishes to conjure a demon, the latter must be contained in case it turns on the person who has summoned it. Thus a kind of magical containment field needs to be set up, in which the demon can manifest safely with less risk to the magician.

Once the circle and triangle are drawn, the demon is summoned, as in this invocation to the demon Paimon in Johann Weyer's *Illustrated Encyclopedia of the Hierarchy of Demons* (1563), to the demon Paimon (see opposite).

Once the demon is summoned, a contract is typically made between the magician and the demon, in which the magician stipulates their will and the demon agrees to carry out the task that the magician has set. This agreement is secured in various ways; in some contracts, the demon is threatened by the magician, for instance, by desecrating the demon's sigil – essentially a piece of sympathetic magic, in which harming the demon's name will harm the demon itself. In other contracts, the demon is given the opportunity to redeem itself in the eyes of God and the angelic hierarchy, by performing a beneficial service for the magician. This reflects a theology in which the denizens of Hell are fallen angels, and may one day be allowed back into paradise. In other types of contract, the magician offers something in exchange, such as a sacrificed mouse (human sacrifice does not feature in most demonic contracts, nor does the offer of a human soul).

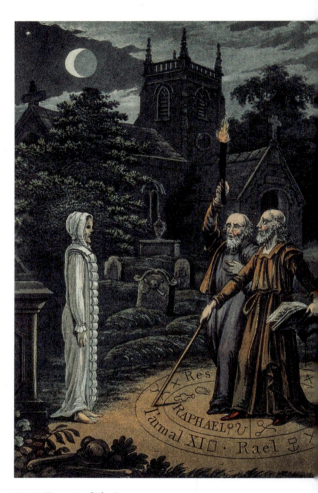

ABOVE *Engraving of John Dee and Edward Kelley evoking a spirit in a graveyard, c. 1790.*

OPPOSITE *The sigil of the demon Paimon.*

INVOCATION TO THE DEMON PAIMON

'Note, that at the calling up of him, the exorcist must looke towards the northwest, bicause there is his house. When he is called up, let the exorcist receive him constantlie without feare, let him aske what questions or demands he list, and no doubt he shall obteine the same of him.

Looking in the direction of the northwest, a circle must be drawn and the words of the invocation must be spoken aloud in a clear, firm voice as follows:

"I conjure thee Paimon by the power of the everlasting virtue of the highest that thou shalt appear in my presence and do my bidding lest thee suffer the everlasting torment and suffering for thy disobedience.

Let thee in my presence do no harm that no hair of my head or evil, bodily or ghostly befall me. Let thee in my presence allow no spirit take hold and linger beyond their calling so that thee may suffer for their trespass.

I conjure thee Paimon that thou shalt act as mediator in my communication and that thou shalt now offer me access to the spirit (name the name of the spirit with which ye wish to communicate) so that I may learn of them and theirs. Fail not in this calling and in thy chains need be let them be bound that they may do what of them I ask and answer all of them that I ask."'

Johann Weyer's *Illustrated Encyclopedia of the Hierarchy of Demons*, 1563.

CURSES AND HEXES

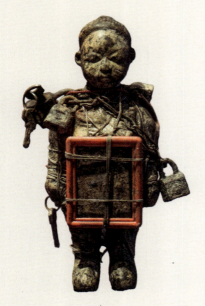

WUTUJI
BOCIO

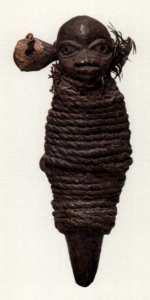

BOCIO
(VODUN HUMAN FIGURE)

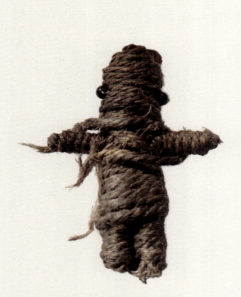

NEW ORLEANS
HOMEMADE DOLL

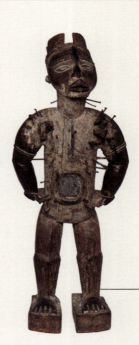

POWER FIGURE
(NKISI NKONDI)

VOODOO DOLLS

Cursing through the use of effigies

ORIGINS: Africa
DATES: Ancient times to the present day
PURPOSE: Vengeance, protection

19th century CE

One of the best known manifestations of Voodoo (see page 150) in popular culture is the voodoo doll. Poppets have been found across all cultures and times, used for cursing and healing, and Voodoo is no exception. As we have seen, Voodoo is a syncretic religion, and fetish forms were a common African practice to ward off evil spirits.

In the Congo, these forms are known as *nkisi* ('sacred medicine'). The term *nkisi* is used for a variety of holy objects, such as ceramic pots, animal horns, shells or gourds, thought to contain spiritual powers or spirits (called *mpungo*). Graves, as containers for the spirits of the dead, are also considered *nkisi*.

In Benin and Togo, in Western Africa, we find *bocio* figures. Here, personal items, plus cloth, rope, nails or tacks, were driven into the figure to activate its power, and we may draw links back to the bound figures found throughout Egyptian and Mediterranean magic in ancient times.

In New Orleans, this kind of talismanic magic is known as *gris gris* (pronounced *gree gree*), meaning 'grey', i.e. between black and white. *Gris gris* refers to a ritually prepared object, such as a doll or a small cloth bag filled with magical ingredients, and also to the act of working the *gris gris*, which functions as a spell or charm. In New Orleans, there are four principal categories of *gris gris*: love; power and domination; luck and finance; and uncrossing (curse breaking).

The use of voodoo dolls was common among the slave population in Louisiana during the 18th and 19th centuries. Dolls would have been bound with cat gut or twine and stuck with pins or fish bones. Today, commercially made voodoo dolls are available.

Voodoo dolls from Togo, 20th century (top left), Benin, 20th century (top right), New Orleans (bottom left) and Congo, 19th century.

PART SIX
SECRET SOCIETIES

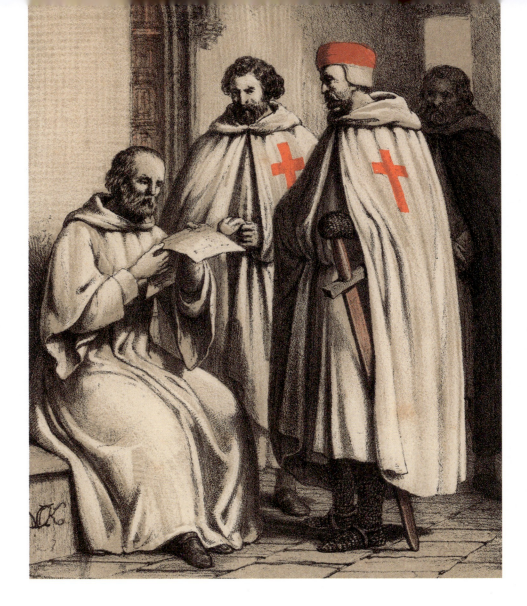

| HOLY SEPULCHRE OF JERUSALEM | KNIGHTS HOSPITALIER | KNIGHTS TEMPLAR | KNIGHTS OF SAINT THOMAS | TEUTONIC KNIGHTS |

TOP *The Knights Templar.*
ABOVE *Badges of Christian military orders.*

THE KNIGHTS TEMPLAR
A Catholic military order

ORIGINS: Jerusalem, Israel
DATES: c. 1119–1312
PURPOSE: Military organization

Founded around 1119 CE, the official name of this Catholic religio-military order was the Poor Fellow Soldiers of Christ and of the Temple of Solomon, usually termed the Knights Templar or simply the Templars. In the 14th century, accusations of blasphemy and worship of idols, among others, were made against the Templars, and though the accusations are likely to have been false, the organization has been linked to the occult ever since.

The order was founded by the French knight Hugues de Payens and abbot Bernard of Clairvaux to protect pilgrims on their journey through the Holy Land. The knights' headquarters were in Jerusalem, and they were active throughout the Crusades.

The Templars were a strict, hierarchical organization, recognizable by their uniform of a white mantle with a red cross, worn over armour. They were one of the most effective, and feared, fighting units of their day and they became a wealthy order, receiving support for the struggle in the Holy Land. In 1139 Pope Innocent II issued a Papal bull exempting the Templars from local law and paying taxes: they could pass through any border unchallenged. With this power behind them, the Templars grew in strength.

Despite their military renown, around 90 per cent of the 15,000 to 20,000 Templars were not soldiers, but involved in finance. They established a form of early banking system, including the invention of the cheque. Their structures can still be found in Europe, for example, London's Temple Church and the Avalleur and Fresnoy commanderies in Europe, as well as fortresses across the Holy Land. At one point, the Templars owned the entire island of Cyprus.

After the Crusades were abandoned, support for the Templars began to wane and, due to their wealth and influence, they began to be seen as a threat, particularly by King Philip IV of France (r. 1285–1314), who owed considerable sums to the order and who participated in rumours about their blasphemous initiation ceremonies. The Templars were accused of desecrating the cross, homosexual practices, financial fraud and the worship of idols such as Baphomet. Some Templars confessed under torture. They were officially disbanded in 1312 by Pope Clement V, but passed into legend, with tales of lost Templar treasure abounding throughout the Middle Ages. Some Templars were said to have travelled to Scotland and fought with Robert the Bruce at Bannockburn. There is also a legend that the Templars saved the Holy Grail from destruction and hid it in Rosslyn Chapel in Midlothian.

THE ROSICRUCIANS

Metaphysical and occult society

ORIGINS: Germany
DATES: *c.* 1614–today
PURPOSE: Spiritual organization

Two anonymous manifestos published in 1614 and 1615 in Germany purported to describe a mystical alchemical and philosophical order whose aim was to transform Europe. These were known as the *Fama Fraternitatis RC* (The Fame of the Brotherhood of RC [Rosy Cross]) and *Confessio Fraternitatis* (The Confession of the Brotherhood of RC). They were joined by a third work, *The Chymical Marriage of Christian Rosenkreuz*, in 1616.

'Frater C. R. C.', or Christian Rosenkreuz, is said in the manifestos to be a German doctor, born in 1378, who had travelled to the Holy Land to attain mystical wisdom. It is unlikely that Rosenkreuz was a real person, and even at the time of publication readers assumed that the figure was allegorical (or simply a hoax). Some historians attribute these works to Lutheran theologian Johann Valentin Andreae (1568–1654), but his authorship is not firmly established.

Despite the mystery about their origins, the ideas contained within these manifestos proved popular and enduring. They influenced later occult writers such as the English alchemists Elias Ashmole and Robert Fludd (see page 74), German alchemists Adrian von Mynsicht and Michael Maier, and French librarian and writer Gabriel Naudé. The Rosicrucian manifestos also inspired Freemasonry (see page 216) and later occult orders such as the Golden Dawn (see page 220), and Rosicrucianism is still extant today, in the form of the order known as the Ancient and Mystical Order Rosæ Crucis, which has been headquartered in San Jose, California, since 1927.

This order maintains that its origins lie in the mystery schools of ancient Egypt, and that its teachings have been passed down in secret throughout history, via Greece and Rome to the rest of Europe, and to the Americas in the 17th century. The idea of a secret order is central to Rosicrucianism, which is a blend of Hermetic, Judaic and Gnostic thought. Its symbol is a rose upon a cross.

17th century CE

THE ROSE CROSS

THE FELLOWSHIP OF THE ROSY CROSS

UNICURSAL HEXAGRAM

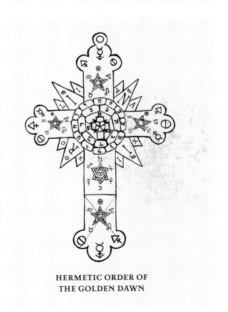

HERMETIC ORDER OF THE GOLDEN DAWN

ABOVE *The symbols of four occult orders inspired by the Rosicrucian manifestos.*

OPPOSITE *Brass Rose-Cross, the design of which is based on a 17th-century original.*

MASONIC SEALS

THE FREEMASONS

International order based on secret rituals

ORIGINS: London, UK
DATES: 1717–today
PURPOSE: Male fraternity

The origins of the order known as the Freemasons, or Masons, are opaque and often sensationalized. It is a charitable and social organization, but one that has become linked to occult practices, and it features in this book primarily because it has influenced some of the Western Mystery Tradition's most influential occult organizations, including the Hermetic Order of the Golden Dawn (see page 220) and the Ordo Templi Orientis (see page 226).

It is likely that the order has its roots in medieval stonemasons' guilds, in which itinerant masons would use certain words and signs, such as hand grips, to demonstrate that they were members of a trained fraternity and not just jobbing builders. Documents called the Old Charges date from 1425 to 1700, and many Masons consider these to be a historical record. But many legends have accrued about its origins; early Masonic texts suggest that the group started in ancient Egypt, whereas other commentators, such as the English essayist Thomas De Quincey (1785–1859), linked it to the Rosicrucians (see page 214). It was also connected to the Templars (see page 212) by the Scottish-born Chevalier Ramsay in 1737, around the same time that the Scottish Freemason William Preston asserted that its roots were Druidic (see page 48).

The first Grand Lodge of London and Westminster was founded on 24 June 1717, at the Goose and Gridiron Tavern in St Paul's Churchyard, but there were lodges across England prior to this. Elias Ashmole was initiated into a lodge in Warrington in 1646, and there are records of gentlemen being admitted to lodges throughout the 17th century. The first Grandmaster was Antony Sayer and in 1723 the Grand Lodge published *The Constitutions of the Free-Masons*. The Grand Lodges of Ireland and Scotland were established in 1725 and 1736 respectively.

Freemasonry is based on a grade system, a structure that many occult organizations have subsequently adopted. It is an all-male organization, although the form known as co-Masonry admits women. All applicants must hold a belief in a Supreme Being, although the definition of this is rendered quite loosely. Although it is based on a sequence of initiations and has some ceremonial regalia, Freemasonry denies it has an occult element, defining itself as a 'society with secrets' not a 'secret society'.

Masonry is one of the most successful social/charitable groups in the world, with an estimated 6 million members in over 50 countries.

Masonic seals, taken from The History of Freemasonry *by Thomas C Jack, 1883. The lithographs capture some of the symbolism associated with the Freemasonry.*

SECRET SOCIETIES

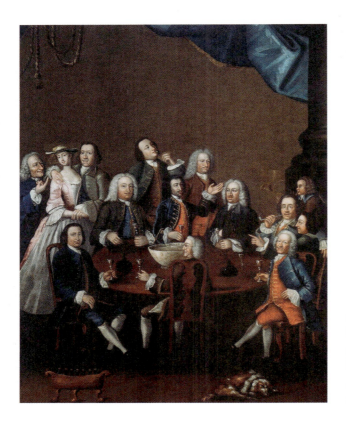

LEFT *Group portrait of the Limerick Hellfire Club by James Worsdale, 1736.*

BELOW *Medmenham Abbey on the Thames by William Tomblesom, 1835.*

OPPOSITE *Philip, Duke of Wharton, 18th century.*

THE HELLFIRE CLUB

Occult group dedicated to pleasure

ORIGINS: London, UK
DATES: 1746–81
PURPOSE: Male fraternity

In the 18th century, gentlemen's clubs proliferated, dedicated to many different pursuits. The Grand Tours popular among the aristocratic youth produced clubs devoted to Italian or Turkish culture, and from the Tour emerged the Hellfire Clubs, which were mainly set up as parodies or joke organizations.

The first was established by Sir Philip, Duke of Wharton in London in 1719. He was a man of letters, but also said to be a drunkard, a rioter, an infidel and a rake. He later became a Masonic Grandmaster. The Irish versions were nastier and more violent than Wharton's, and seem to have involved some kind of black magic. But the most famous of the Hellfire Clubs' incarnations was the club established at West Wycombe by Sir Francis Dashwood, Member of Parliament for New Romney. In 1751, Dashwood leased Medmenham Abbey on the Thames from a friend and had it rebuilt in a late Gothic style, popular at the time. The motto '*Fait ce que tu voudrais*' ('Do what thou wilt') was placed over the door, taken from François Rabelais's 16th-century novels *Gargantua and Pantagruel*. Dashwood established a men's club here, the Monks of Medmenham, lampooning the idea of the closed, celibate austerity of an actual monastery (the name 'Hellfire Club' was not used by members and was attached to the group by later commentators). It is not known if the group actually practised occultism, but Dashwood was known to have had an interest in magic and in Kabbalism (see page 66). He built a series of caves into the surrounding chalk hills, possibly following a pattern based on the journey through the Tarot trumps (see page 106) or the Eleusinian mysteries (see page 128).

The core members of the club were said to number thirteen, like a coven. They included Dashwood's brother, the Earl of Sandwich, satirical journalist John Wilkes and a collection of the local lesser gentry and professional men. Benjamin Franklin was a member for a time, before relocating to America. Dashwood died in 1781 and the club came to an end, but there have been various recreations of it ever since.

THE HERMETIC ORDER OF THE GOLDEN DAWN

Magical organization based primarily on Egyptian and Celtic religion

ORIGINS: London, UK
DATES: 1888–today
PURPOSE: Spiritual development, magical practice

This occult society was founded in London in 1887–1888 by Samuel MacGregor Mathers, William Wynn Westcott and William Woodman. Its founders claimed that they had adopted the order from the work of a German Rosicrucian (see page 214), Anna Sprengel, who was in contact with an otherworldly group known as the Secret Chiefs.

It is unlikely, however, that Sprengel actually existed; much of the impetus behind the Golden Dawn seems to have come from English esotericist Anna Bonus Kingsford, who had founded an organization known as the Hermetic Order in 1884, emerging from a rift in the Theosophical Society (see page 224).

The Golden Dawn drew upon many different sources, from ancient Egyptian texts to Greek ritual and Celtic myth and legend.

It had some famous members, including the poet W. B. Yeats, writers Arthur Machen and Algernon Blackwood, and, for a time, occultist Aleister Crowley (see pages 144, 226 and 237), and often shared members with other cultural or political societies. George Bernard Shaw, though not a member of the Golden Dawn himself, was friendly with several people in the organization

BELOW *The founding members of the Hermetic Order of the Golden Dawn.*

DR WILLIAM WOODMAN

SAMUEL MACGREGOR MATHERS

WILLIAM WYNN WESTCOTT

Rosicrucian symbol of the Hermetic Order of the Golden Dawn, 19th century.

MAGICAL SYMBOLS OF THE STELLA MATUTINA

LAMEN OF THE CANCELLARIUS, WHO KEPT THE RECORDS OF THE GOLDEN DAWN FOR THE INNER RC ORDER

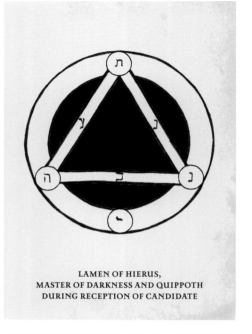

LAMEN OF HIERUS, MASTER OF DARKNESS AND QUIPPOTH DURING RECEPTION OF CANDIDATE

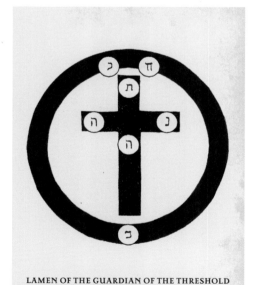

LAMEN OF THE GUARDIAN OF THE THRESHOLD OF ENTRANCE, AND PREPARER FOR THE ENTERER THEREBY

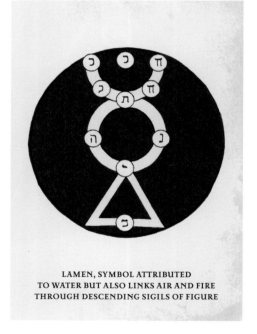

LAMEN, SYMBOL ATTRIBUTED TO WATER BUT ALSO LINKS AIR AND FIRE THROUGH DESCENDING SIGILS OF FIGURE

through his connection with the Fabians. Like many occult societies, the Golden Dawn was prone to schism and divided many times during its history, forming splinter groups such as the Stella Matutina (Morning Star) and eventually disbanding in the 1930s. Stella Matutina's Hermes Temple in Bristol kept going until 1970, and the Smaragdum Thallasses Temple, an offshoot of the Stella Matutina also known as Whare Ra, in Havelock, New Zealand, was in existence until 1978; there are still Golden Dawn practitioners in the country. Other descendants of the Golden Dawn still exist in the UK, Europe and the USA, among other countries.

Membership in the Golden Dawn was based on grades. Candidates would progress from grade to grade via an initiation ritual in which the initiate was blindfolded, questioned and challenged. This provided the foundation for Crowley's Minerval ritual (see page 144), and the structure of the Golden Dawn in turn took much from the organizational principles of Freemasonry (see page 216) and Rosicrucianism (see page 214). It also borrowed from Kabbalistic and Hermetic principles.

The Golden Dawn admitted women on a basis of equality, and some of the most influential occultists in the Golden Dawn were female, such as heiress Annie Horniman and actress Florence Farr. All the male founders of the Golden Dawn were Masons, and Aleister Crowley, one of its most notorious members, claimed to have attained a high Masonic grade (though he is not currently recognized by the Grand Lodge of England).

As an initiatory order, the Golden Dawn did not at first practise magic *per se* but concentrated on meditation and philosophical enquiry. In 1892, however, its members felt that they had progressed far enough into their work to set up an 'inner', more advanced, form of working, to complement the 'outer'. Soon, the Order expanded outwards, with temples being set up in other British towns and other countries. The Order gained its rituals from the Secret Chiefs, entities on the inner plane who allegedly communicated their wishes through Mathers. Over time, however, members questioned why the Secret Chiefs did not communicate through anyone else, and began to challenge Mathers's authority. The Order fragmented into separate organizations and now there are several groups claiming it as their own originator. As we have seen, it influenced both Crowley's Ordo Templi Orientis and Gerald Gardner's Wicca (see pages 154 and 228).

OPPOSITE *A collection of magical symbols used in the Hermes Lodge of the Stella Matutina, an offshoot of the Golden Dawn.*

RIGHT *Annie Horniman, shown here at her graduation, was a patron of Mathers. She helped finance and became a member of the Hermetic Order of the Golden Dawn, 1910.*

ABOVE *Illustrations of copper coins found in Guatemala depicting Ouranos – claimed in some Victorian texts to be the first god of the people of Atlantis.*

RIGHT *Annie Besant, theosophist, centre left, at an assembly of the Order of the Star of the East, 1925.*

ABOVE *The seal of the Theosophical Society.*

LEFT *Madame Helena Blavatsky, co-founder of the Theosophical society, 19th century.*

THE THEOSOPHICAL SOCIETY

Philosophy based around the knowledge of God

ORIGINS: New York, USA
DATES: Late 19th century
PURPOSE: Spiritual organization

Helena Blavatsky was a Russo-German aristocrat born in 1831 in Russia. At the age of seventeen, she married Nikifor Vladimirovich Blavatsky, a local Russian governor, but soon left him and set off on her travels. She visited the East, where she claimed to have encountered a number of supernatural beings called the Masters of the Ancient Wisdom, such as an entity known as Master Morya. She also claimed that she had been trained in the mastery of psychic abilities.

By the 1870s, Blavatsky had moved to Europe and become involved in the Spiritualist movement. She had many esoteric interests, including a belief in the magic of the lost continent of Atlantis, allegedly the home of a super-race. In 1873, Blavatsky moved to the USA and met a military officer, lawyer and journalist named Henry Steel Olcott. Together they created the Theosophical Society in 1875. Two years later, Blavatsky published *Isis Unveiled*, which draws on Hermeticism (see page 36) and Neoplatonism and claims to reveal an 'ancient wisdom' underlying all of the world's religions – a hallmark of many occult beliefs and groups. In founding Theosophy, Blavatsky and Olcott sought a 'synthesis of science, religion, and philosophy', as Blavatsky put it in *Isis Unveiled*.

Although many of Blavatsky's autobiographical claims are dubious, and although she perpetrated a number of frauds in her mediumship, she did leave a genuine and lasting legacy in Western occultism. It is thought that she was the first Western occultist to use the terms 'right hand' and 'left hand' path to denote positive and negative magic respectively. She can also be credited with opening up Western occultism to an interest in Eastern thought: the fascination of 20th-century occultists with India can be attributed to her.

In 1879, Blavatsky and Olcott moved to India and converted to Buddhism, but continued to promote Theosophy. In 1886, Blavatsky moved back to London, where she published her work *The Secret Doctrine* among other books. She died in 1891. The Theosophical Society continues today, though Blavatsky herself was declared a fraud in her lifetime by the Psychical Research Society in Cambridge.

ORDO TEMPLI ORIENTIS

Magical group closely associated with Aleister Crowley

ORIGINS: Germany/Britain
DATES: 1910s–today
PURPOSE: Ceremonial magic

Ordo Templi Orientis (OTO) is an occult society originally founded by Carl Kellner and Theodor Reuss at the beginning of the 20th century. Nowadays it is most closely associated with Aleister Crowley, who took it over after Reuss's death.

In its early days, OTO was modelled closely on Freemasonry, with other influences such as the Swedenborg Rite, the Ancient and Primitive Rite of Memphis and Misraim, and Martinist principles. Crowley drew it away from Masonry, while retaining the grade system of degrees, and merged it with his own philosophy of Thelema, which he outlined in various works, most notably the *Book of the Law* (*Liber al vel Legis*, 1904). Central to this is the principle of following Pure Will, which is seen as paramount. Adherents of OTO point out that Taoism was also an influence on Crowley. Thelema is a hermetic path and emphasizes the development of the higher self.

Central to the order is the service of the Gnostic Mass, also known as Liber XV, which is a blood rite involving menstrual blood (baked into cakes and then re-baked and consumed as a sacramental wafer. Crowley wrote this in 1913, stating 'I wished ... to construct a ritual through which people might enter into ecstasy as they have always done under the influence of appropriate ritual.' Members also undertake a series of initiatory rituals consisting of thirteen numbered degrees and twelve un-numbered degrees.

Various deities are involved in OTO's underlying Thelemic theology, which draws heavily on ancient Egyptian religion and features deities such as Nuit, Hadit and Ra-Hoor-Khuit, a version of the god Horus. It also includes the goddess Babalon, the Scarlet Woman who represents female sexuality but also Mother Earth, the archetypal mother. According to Crowley, she sometimes has human avatars and appears in the Biblical Book of Revelations as the Great Whore.

Karl Germer was appointed by Crowley as his successor. Ordo Templi Orientis is still in existence today and is found worldwide.

RIGHT *Lamen of the Ordo Templi Orientis.* OTO

RIGHT *Aleister Crowley, 1898.*

BELOW *Lamen of the Ordo Templi Orientis.*

SWEDENBORG

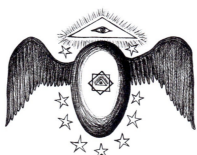

ANCIENT AND PRIMITIVE RITE
OF MEMPHIS-MISRAÏM

MARTINIST

EARLY WICCA

The beliefs of contemporary witchcraft, developed by Gerald Gardner

ORIGINS: Britain
DATES: 1940s
PURPOSE: Magical practice

Wicca is sometimes called the 'religion' of witchcraft, as it deals with devotional practice to the God and Goddess as well as spellcraft. It was devised by a retired tea planter, Gerald Gardner, in the mid-20th century.

Gardner claimed to have been initiated into a New Forest coven in 1939, almost certainly the Rosicrucian Order Crotona Fellowship rather than a surviving coven practising a traditional form of witchcraft. They may have drawn some of their beliefs from folklore and the practice of local cunning folk, as well as from anthropology and the Order of Woodcraft Chivalry, a version of the Scouts founded by the naturalist Ernest Westlake in 1916 that operated in the New Forest and worshipped a moon goddess and a horned god. The latter also borrowed a number of Masonic beliefs, and practised rituals based on the four quarters. Gardner used all this as a basis for Wicca, plus his own sources such as conversations with Aleister Crowley.

In the mid-1940s, Gardner founded the Bricket Wood coven in Hertfordshire. In 1949 he published *High Magic's Aid*, followed by a number of other books on witchcraft, and in 1954 he bought the Museum of Magic and Witchcraft on the Isle of Man, which he ran until his death in 1964. His legacy, and that of his priestesses, who included Doreen Valiente, Eleanor Bone, Patricia Crowther and Lois Bourne, was long lasting. Wicca was taken up by others, most notably Alex Sanders and his wife Maxine, and journalist Stuart Farrar and his wife Janet. Sanders, a former spiritual healer, was particularly influential, developing Gardner's ideas in more diverse directions, including the inclusion of homosexuality into what had been a binary gender practice. Under Gerald Gardner, Wiccans were highly secretive, but the movement gained greater prominence in the 1960s and 70s with the involvement of people such as Alex Sanders.

Wicca spread across the English-speaking world, particularly to the USA and the Antipodes. It was brought to America by Raymond Buckland, an initiate of Gardner's, who founded the Long Island Coven and later went on to develop Seax-Wicca, his own form of the craft. The 1734 Tradition also grew in the USA, emerging from Robert Cochrane's version of witchcraft.

The two main forms of Wicca today are Gardnerian, named after Gerald, and Alexandrian, named after Sanders, but there are other varieties, such as the American women-only form known as Dianic Wicca, formed by Zsuzsanna Budapest in Los Angeles in the early 1970s. This was followed by the American activist Starhawk's Reclaiming tradition, which is both feminist and political.

Most practising Wiccans have discarded the outdated anthropological theories on which Gardner based much of Wicca. It is a fast-growing religion, particularly appealing to women as a consequence of its emphasis upon the divine feminine. It has been popularized through portrayals in film and television. Many people now self-initiate rather than relying upon the coven system. A great deal of Wiccan material has been revealed by writers, such as the Farrars in their books *Eight Sabbats for Witches* (1981) and *The Witches' Way* (1984).

ABOVE RIGHT *The pentacle, a pentagram contained in a circle, is a symbol commonly used in Wicca.*

RIGHT *Empedocles' four elements (fire, air, water and earth), woodcut from Lucretius' De rerum natura, 1472.*

BELOW *The Woodcraft Folk May Day Rally, 1950.*

BELOW RIGHT *Gerald Gardner, called by some, 'the father of modern witchcraft', 20th century.*

PART SEVEN
SITES OF SIGNIFICANCE

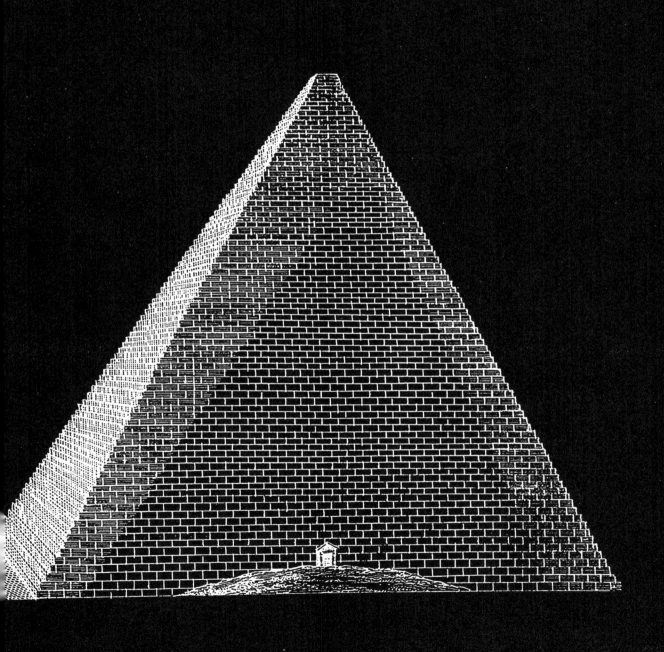

SITES OF SIGNIFICANCE

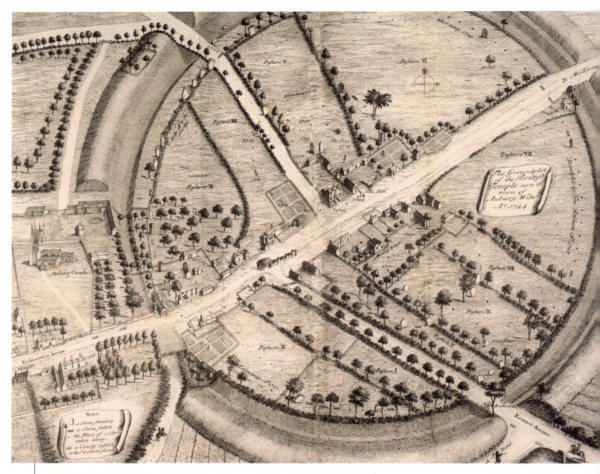

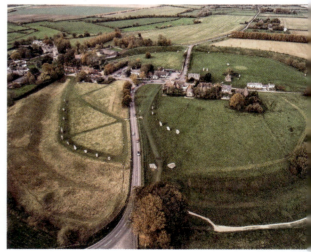

AVEBURY

Neolithic monument comprising three stone circles

PLACE: Wiltshire, UK
DATES: *c.* 3000–2200 BCE
PURPOSE: Ritual monument

Avebury is situated in Wiltshire, England, close to the old town of Marlborough and just over 32 kilometres (20 miles) north of Stonehenge (see page 234). It is famous for being the only village sited within a stone circle, for the Avebury henge is an extensive monument, consisting of a very large complex of stone circles and earthworks.

Built between 2850 and 2200 BCE, the original Neolithic stone circle was comprised of some one hundred stones, and incorporated two smaller stone circles as well as a large ditch and bank. These stone circles and the earthworks were themselves part of a much bigger ritual landscape, which includes West Kennet Long Barrow, a large chambered tomb, and the enigmatic Silbury Hill, an artificial chalk mound.

Though we do not know the original purpose of the Avebury henge, archaeologists assume that it was used for conducting rituals. There are few archaeological remains within the stone circle itself, suggesting that the circles were reserved for special use. It fell into disuse by the Iron Age, and in medieval times a village was built amid the stones, which sustained considerable damage as a result. The site is run by the National Trust and English Heritage, and is a UNESCO World Heritage Site.

Some contemporary esoteric writers see the Avebury henge as a star temple: writer and engineer Alexander Thom suggested that the site has an alignment with the star Deneb, in the constellation of Cygnus. Others believe that the crop circles which appear in the Wiltshire landscape around Avebury have a mystical significance, although there is substantial evidence that these are man-made. Claims have also been made that the site is a centre for leylines. These ideas are contentious, although further investigation of Avebury as part of the wider ritual context of Salisbury Plain and Wiltshire may yet reveal indications of astronomical alignments. Avebury is also a centre of modern Paganism and, as at Stonehenge, rituals are conducted here at the solstices and equinoxes and sometimes the cross-quarter days.

OPPOSITE TOP *Map of Avebury by William Stukeley, engraving, 1724.*

OPPOSITE BOTTOM LEFT *A standing stone at Avebury Henge.*

OPPOSITE BOTTOM RIGHT *An aerial view of Avebury.*

STONEHENGE

Neolithic stone circle situated on Salisbury Plain

PLACE: Wiltshire, UK
DATES: 3000–1600 BCE
PURPOSE: Ritual monument

Archaeologists believe that Stonehenge was constructed in several different stages, with the installation of the earthworks around 3000 BCE being the earliest, followed by the placement of the other stones between 2600 BCE and 2200 BCE. Some of the stones were quarried locally, but others are bluestones from the Preseli hills in Pembrokeshire.

There are various theories about how they were transported to Salisbury Plain, including the contentious hypothesis that they were already set up in an existing stone circle that was relocated wholesale. Further investigation of the site, and of the wider context of Salisbury Plain, is still being undertaken.

We do not know what the purpose of Stonehenge was. The site has astronomical connections, such as solar alignments with both the winter and summer solstices: the sun rises over the Heel Stone on the summer solstice, and sets over it at the winter solstice. Astroarchaeologists have suggested that the site has lunar alignments and was used to predict lunar eclipses; equinoctial alignments have also been claimed. However, many of these theories have met with robust criticism, and there is some evidence that the site was only used around the winter solstice.

Whatever the original purpose of the monument, it is now a centre for worship and celebration by modern Pagan groups, including several of Britain's modern Druidic orders. These events usually take place around the solstices, with the summer solstice proving particularly popular with the public: thousands of people gather at the monument around 21 June to watch the sun rise above the henge. The monument can also be hired for other Pagan celebrations, such as handfastings (modern Pagan wedding ceremonies). Stonehenge is managed by English Heritage and is a UNESCO World Heritage Site.

OPPOSITE TOP *Illustration of Stonehenge, 1645.*

OPPOSITE BOTTOM *A restored plan of Stonehenge showing the aerial view, cross-section and elevation, by Charles Knight, 1845.*

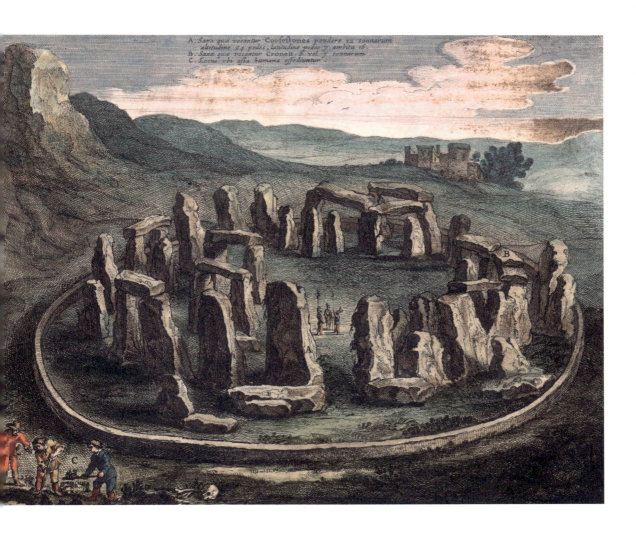

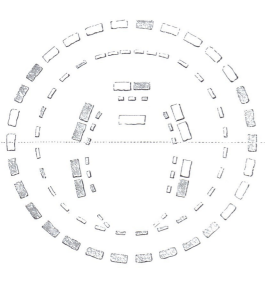

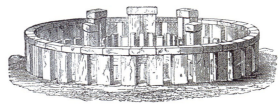

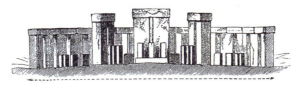

SITES OF SIGNIFICANCE

RIGHT *Engraved map of Egypt, with illustrations of Cairo, Alexandria, temples at Karnak and Pyramids and Sphinx at Giza.*

BELOW *An aerial photograph of the pyramids.*

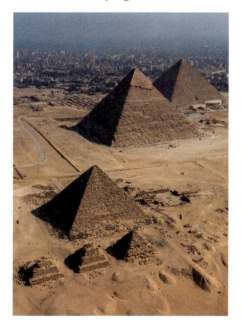

RIGHT *Scrapbook page created by the American traveller William Vaughn Tupper, which includes a diagram of the interior of the tomb. c. 1892,*

THE PYRAMIDS OF GIZA

Ancient Egyptian tombs

PLACE: Cairo, Egypt
DATES: *c.* 2575–2465 BCE
PURPOSE: Funerary monument

The pyramids of ancient Egypt are an early manifestation of religious devotion and power, but their influence upon the occult world has lasted for centuries, affecting Enlightenment thought, Theosophical beliefs in the late 19th century, plus the work of Aleister Crowley and beyond.

The pyramids of Giza are among the world's most iconic monuments, towering into the skies near Cairo. They are tombs for pharaohs, and derive from the slab-shaped monuments known as *mastaba* (Arabic for 'bench') tombs, usually constructed from mud bricks. These mastaba structures evolved into step tombs built of stone. Over time, these developed into the huge pyramids that are some of the wonders of the ancient world.

The 4th Dynasty King Khufu (known as Cheops to the Greeks) commissioned the first pyramid at Giza. This was completed around 2560 BCE, with two further pyramids being built for Khufu's son Khafre and his successor, Menkaure. The Great Sphinx that guards the pyramid complex appears to represent Khafre, sharing his facial features, but there are many theories about its origins, and it has been suggested that the body is much older.

The pyramids were built by skilled labourers, housed nearby. Materials such as granite and wood were brought from Aswan and Lebanon, carried on boats along the Nile. The pyramids are part of larger complexes, including, for example, temples and solar boat pits. Originally, they would have been covered with facing stones. Within the pyramids are burial chambers, which can still be visited today.

Resting place for pharaohs

When a pharaoh died, their body would be preserved, then wrapped in linen and contained within a number of coffins: Tutankhamun's coffin, for example, was made of solid gold, then encased in two wooden coffins, and finally a sarcophagus of red quartzite. He, however, was buried much later and in the Valley of the Kings rather than in a pyramid. Menkaure's pyramid contained a simpler wooden coffin for the pharaoh. A variety of grave goods have been found in tombs from different periods of Egyptian history, including weapons and jewelry. *Ushabti* ('answerer' or 'follower') figurines were also placed in tombs in some periods to ensure that the deceased person had helpers in the afterlife. Some of these figures carry a hoe or a basket, indicating that they would grow crops for the deceased, whilst others would carry out domestic tasks. The name of the person to whom they would answer – the deceased – would be inscribed on them in hieroglyphics. These little figures were produced in bulk, and many still survive today.

Excavations of the pyramids began in the 19th century, but the monuments are still giving up their mysteries: a hidden corridor inside the Great Pyramid was discovered in 2023.

The pyramids and occultism

Egyptian culture has continued to exert an influence over Western occultism. Isaac Newton, writing about alchemy, believed that the pyramids held keys to the nature of the apocalypse and also studied them in relation to his work on gravity: measurements used by the Egyptians could, Newton believed, justify his own work. In the 19th century, members of the Hermetic Order of the Golden Dawn practised a revived form of Egyptian ritual, and Aleister Crowley, whilst travelling to Egypt in 1904 for his honeymoon, conducted rituals of his own within the Great Pyramid. His wife, Rose, claimed to be channelling an Egyptian entity, Aiwass, who informed much of Crowley's magical practice, and who told Crowley that the Aeon of Osiris was ending and would be replaced by the Aeon of Horus.

Later, the occultist Dion Fortune also took an interest in Egyptian ideas, particularly in the form of the worship of the goddess Isis. Pyramidology has been an interest of many others working with the Western tradition: there is still a belief in some circles that the pyramids were built by refugees from Atlantis, thus tying into Theosophical thought and the work of Madame Blavatsky.

Illustrations of the Great Pyramid at Giza, Egypt, 1744.

EXTERIOR INTERIOR

1820 CE

LEFT *A topographical map of the valley of Biran Ell Malook, in which the tombs of the kings are situated, 1820.*

BELOW *Howard Carter (holding a magnifying glass) leaning over the mummy of Tutankhamun as the first incision was made in the mummy's wrappings, 1926.*

LEFT *Bust of Tutankhamun being carried from his tomb in the Valley of the Kings, Egypt, 1922.*

SITES OF SIGNIFICANCE

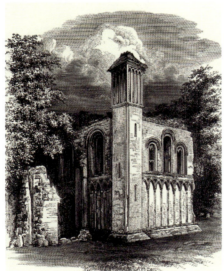

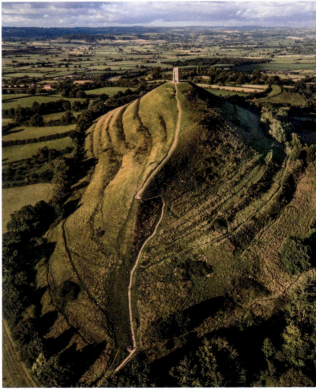

TOP *View of Glastonbury by Wenceslas Hollar, 1655.*

ABOVE *Illustration of the ruins of Glastonbury Abbey, St Joseph's chapel.*

RIGHT *Glastonbury Tor, aerial view.*

GLASTONBURY

Town in the southwest of the UK associated with modern Paganism and other esoteric beliefs

1655 CE

PLACE: Somerset, UK
DATES: 7th century CE–today
PURPOSE: Historical site of witchcraft

Glastonbury is known as one of the earliest Christian sites in Britain and the home of one of the wealthiest abbeys in Europe, which was brought down on the orders of King Henry VIII at the start of the Reformation. Today, the town is famous not only for giving its name to one of the world's biggest music festivals, held at nearby Pilton, but also for being arguably the most Pagan-friendly town in Britain.

Analogous to Salem and Sedona (a well-known centre for esoteric thought) in the USA, Glastonbury is a home of contemporary Paganism and the New Age. Its esoteric reputation began early in its history. Legends hold that Christ's uncle, Joseph of Arimathea, visited the town and planted in the ground his staff, which then flowered into a thorn tree. He also brought with him two cups: one that had caught the blood of Christ as he suffered on the cross, and one that had been used by Christ as a chalice at the Last Supper. The chalice, known as the Holy Grail, vanished, but its story became interwoven with that of King Arthur in the cycle of tales known as the Matter of Britain via the works of the 12th-century French poets Robert de Boron and Chrétien de Troyes.

In the late 13th century, the monks of Glastonbury Abbey announced the discovery of two graves in the abbey grounds. One contained a woman's skeleton, and the other the body of a man beneath the inscription 'Here lies Arthur the King', in Latin. These, they claimed, were the bodies of King Arthur and his queen, Guinevere. The graves were a tourist attraction until the destruction of the abbey, and can still be seen amid the ruins. The town's associations with the Holy Grail and King Arthur have led to it becoming popular with occultists. The gardens of the Chalice Well, for example, are still associated with the Grail legend in various forms.

THE SERPENT MOUND

Native American religious monument

PLACE: Ohio, USA
DATES: 300–100 BCE/1000–1200 CE
PURPOSE: Ritual monument

The Serpent Mound is a Native American earthwork in Ohio that takes the shape of a huge snake. When the geoglyph was built is debated, with suggestions ranging from 300–100 BCE (the Adena culture) to a more recent view that it is much later, dating from 1000–1200 CE (the Fort Ancient culture). It is possible that the Adena culture were indeed the original builders and the mound was later modified by the Fort Ancient people.

It has also been proposed that, if of the later date, the mound may have been constructed in relation to the appearance in the skies of Halley's Comet. There are conical burial mounds around the serpent, but no burials on the site itself. Some have suggested that the mound is a platform, sustaining structures (such as ceremonial poles) that have not survived.

The serpent is over 396 metres (1,300 feet) long and sits on the site of an ancient meteor strike. The rattlesnake is a common totemic symbol throughout the Mississippian tribal peoples, although the Ohio serpent is not depicted with a rattle. Its open jaws enclose a round object, perhaps representing an egg, the sun or the snake's own eye. Like Stonehenge (see page 234), it is aligned with the sun at the winter and summer solstices, suggesting that the solar alignment was important to whichever culture constructed it.

Contemporary Native American esoteric practitioners also attribute significance to the serpent, comparing the seven curves of the snake to the seven spiritual 'gates' that a person must pass through before becoming a *dawan*, a medicine worker. The aspiring *dawan* must walk the serpent and accomplish a number of tasks at each stage, before reaching the head of the snake and achieving enlightenment. The mound has been preserved as a National Historic Landmark, and may in future become a UNESCO heritage site.

1848 CE

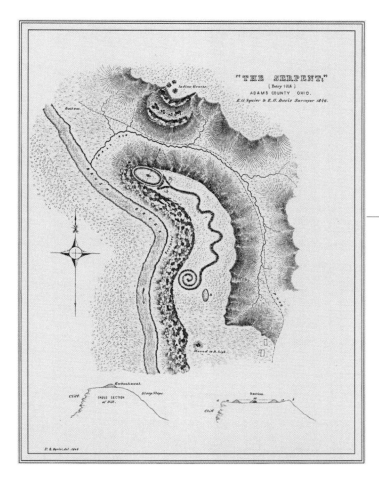

RIGHT *Plate XXXV, Great Serpent in Adams County, Ohio, from* Ancient Monuments of the Mississippi Valley *by Ephraim George Squier and Edwin Hamilton Davis, 1848.*

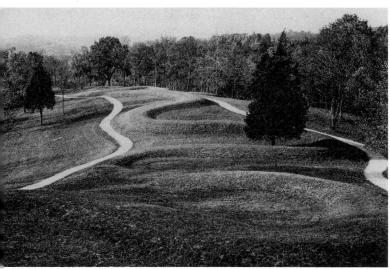

ABOVE AND LEFT *Ancient serpentine structures. The serpent symbol, and the worship of the reciprocal principles of nature, are found in a large number of ancient mounds and monuments created by Native Americans.*

SITES OF SIGNIFICANCE

RIGHT *Early photo of the Spectre of the Brocken, 1934.*

BELOW *The witches' altar on the Brocken, Harz, Germany, a historical illustration, 1877.*

OPPOSITE *Illustration depicting Walpurgisnacht drawn by August von Kreling in Johann Wolfgang von Goethe's* Faust, *published in Munich, 1874.*

THE BROCKEN

Natural formation associated with witches

PLACE: Harz mountains, Germany
DATES: 8th century CE–today
PURPOSE: Historical site of witchcraft

The Harz mountains are a low, forested area of northeastern Germany. It is a beautiful region with a number of medieval towns, and is also home to a number of legends associated with witchcraft, particularly around the Brocken, the highest peak in the Harz. This mountain is known for a curious natural phenomenon, the Brocken Spectre, in which people see their own enormous shadows projected onto mist.

The Brocken is also where witches gather on Walpurgisnacht (Walpurgis Night, or May Eve), a Pagan festival held on 30 April, in order to dance and meet the Devil – although the name refers to the 8th-century Abbess Walpurga, who was known for fighting against witchcraft, the festival goes back to pre-Christian times. Johann Wolfgang von Goethe described the meeting of witches in *Faust* (1808) (below).

Walpurgisnacht is still celebrated throughout the Harz in towns such as Bad Grund, Braunlage and Thale. In Quedlinburg, a well-preserved medieval town, you can see apotropaic symbols carved into beams to guard against witchcraft and other threats. The area, as with other regions of Germany, was subject to extensive persecutions of witches. Today, you can visit the Hexentanzplatz (literally 'Witches' Dance Floor'), a plateau in the mountains said to be a Saxon sacrificial ground and now a theme park.

'Now to the Brocken the witches ride; The stubble is gold and the corn is green; There is the carnival crew to be seen, And Squire Urianus will come to preside. So over the valleys our company floats, With witches a-farting on stinking old goats.'

(*Faust*, Johann Wolfgang von Goethe)

SITES OF SIGNIFICANCE

SALEM

City associated with the New England witch trials

PLACE: Massachusetts, USA
DATES: 1692–1693
PURPOSE: Historical site of witchcraft

Like Pendle in the UK, the city of Salem in Essex County, Massachusetts, is best known for its witch trials, a series of hearings and prosecutions that took place between February 1692 and May 1693.

The witch panic in Salem stemmed initially from the behaviour of a number of teenage girls who began having fits and bodily contortions. It was decided that this was a result of witchcraft, and three women were blamed: two were impoverished and one was a Caribbean slave.

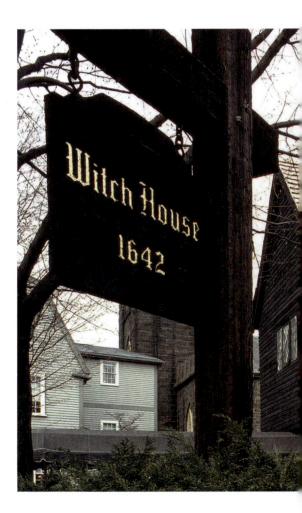

'Now I am condemned to die, the Lord above knows my innocency then and likewise does now as at the great day will be known to men and angels – I petition to your honours not for my own life for I know I must die and my appointed time is set but the Lord he knows it is that if it be possible no more innocent blood may be shed.'

Mary Esty testimony

When the case came to trial, the slave, Tituba, confessed that she had undertaken dealings with the Devil. Paranoia spread, others were blamed, and the trials eventually resulted in the hanging of nineteen people (see page 84), ordered by Judge John Hathorne, known as the Hanging Judge, one of the main prosecutors of witchcraft in the USA.

The testimony of Mary Esty, hanged 22 September 1692, evokes the horror of the time, in which 200 people were accused of witchcraft (above).

From these dark events has emerged a burgeoning tourist industry that has led Salem, like Glastonbury (see page 240), to open a plethora of witchcraft-themed businesses. The town is popular with contemporary Pagans and has featured extensively in popular culture, appearing for instance in the television shows *Bewitched* (1964–1972) and *Sabrina the Teenage Witch* (1996–2003). Given the prominence of Salem's legacy, the witch trials are unlikely to be forgotten.

OPPOSITE *Illustration of Tituba by John W. Ehninger, 1902.*

LEFT *The Witch House in Salem.*

ABOVE *Martha Cory and her persecutors, USA, 1870s.*

SITES OF SIGNIFICANCE

ABOVE *Bird's-eye view map of New Orleans, 1851.*

RIGHT *Dancing in Congo Square by Edward Winsor Kemble, 1886. Congo square was a marketplace where slaves and free Blacks went to buy and sell goods, dance, socialize and maintain an African community.*

NEW ORLEANS

American city associated with voodoo

PLACE: Louisiana, USA
DATES: 19th century–today
PURPOSE: Historical site of witchcraft

New Orleans is one of the world's main centres of contemporary magical practice, with its long history of voodoo (see page 150) and hoodoo. The first voodoo service was allegedly held here on Dumaine Street, moving to Bayou St. John and the shores of Lake Pontchartrain after attracting the attention of the police. Although not banned in legislation, voodoo gatherings did face persecution by the police, as they were seen as potentially disruptive.

The city is famous for residents such as Marie Laveau, the Creole 'Voodoo Queen of New Orleans', whom a local newspaper heralded for being 'gifted with beauty and intelligence, she ruled her own race, and made captive of many of the other'. Born as a free woman of colour around 1801, Laveau became a hairdresser to wealthy women, but also held gatherings at Congo Square in the city in which she entered into possession and took magical commissions from participants. She also held a voodoo service every St John's Eve, a celebration that is still carried out in Bayou St. John today. Laveau died in 1881 and was buried in the 'Widow Paris' tomb in St. Louis Cemetery No. 1, still one of the city's main tourist attractions. Her role as a voodoo priestess was assumed by Marie II, who is generally considered to have been her daughter or grand-daughter.

Laveau is not the only famous magical practitioner in New Orleans: the State of Louisiana recognized witchcraft as a religion in 1972, licensing occultist Mary Oneida Toups (1928–1981) to run tours. Adopting the 'Witch Queen' title, Toups chartered the Religious Order of Witchcraft, held ceremonies and ran two witchcraft shops in the French Quarter. Today, both voodoo and witchcraft are alive and well in 'the Big Easy', with offerings of pound cake still left for hoodoo Saint Expedite, and botanicas and witchcraft shops found throughout the city.

GLOSSARY

ALCHEMY: an early form of chemistry, in which practitioners believed they could turn base metals into gold. Eastern alchemy focused to a greater degree on the attainment of immortality.

ALMANAC: a book containing a calendar and facts such as the phases of the moon, the predicted weather and information of general interest.

AMULET/TALISMAN: an item, such as a piece of jewelry, with a sacred symbol upon it; a natural object such as a stone or gem; or words written on parchment, to bring luck or protection to the wearer.

ASTROLOGY: the study of the stars and signs of the zodiac to predict the future or gain insights into the personality. There are different historical zodiacs; the one used in the West today has its origins in Babylonian times.

ATHAME: a ritual knife used by Wiccans, often with a black handle.

BLACK MASS: a ritual performed by historical Satanists as a perversion of the Catholic Mass, with the aim of summoning the Devil.

CROSS QUARTER DAYS: seasonal festivals celebrated by modern Pagans – Imbolc (1 February); Beltane (1 May); Lughnsadah (1st August), Samhain (31 October) – which fall between the solstices and equinoxes.

CUNEIFORM: an ancient form of writing in the Near East used by carving letters onto clay with a reed stylus.

CUNNING FOLK/MEN/WOMEN: people who practised folk magic, usually for pay. This includes love spells, magic for healing purposes, and the removal of curses.

CURSE: a magical imprecation made against an enemy, either verbally or in writing, for instance to cause their ill health or death.

DEFIXIONES: a Classical form of curse common in Greek and Roman times, often inscribed upon a small lead tablet and buried or thrown into water at a sacred place.

DEMONOLOGY: the practice of undertaking a magical ritual to summon demons, usually to do the bidding of the summoner, for example in matters of love, lust, wealth or power.

DIVINATION: the art of predicting the future via a variety of methods, such as pendulums or a scrying glass. In the Classical world, particularly, there were a great many forms of divination, such as studying the flight of birds.

DOWSING: the art of using divining rods or a pendulum to find water or precious metals beneath the earth.

DRUIDRY: the religion of the ancient Celts and now a revivalist form of modern spirituality.

EQUINOX: the two points in spring and autumn when day and night are of an equal length, usually falling around 21 March and 21 September.

GEOGLYPH: a design on the landscape made by earthworks, the placement of stones or ditches. The Nazca lines are an example of a geoglyph.

GOETIA: magic undertaken for personal gain, such as attracting wealth, or cursing. In ancient Greece, the term had connotations of fraud.

GREEK MAGICAL PAPYRI: Egyptian spells, hymns and rituals from Greco-Roman Egypt, translated into Greek and inscribed upon papyri.

GRIMOIRE: a book containing magical spells and incantations, plus lists of symbols and magical correspondences.

HAGSTONE: a stone such as flint with a naturally occurring hole in it, held to be lucky in folklore.

HELLFIRE CLUB: there were several 18th-century gentlemen's clubs bearing this name, devoted primarily to the pursuit of hedonism and moral transgression.

HERMETICISM: a religious and philosophical system allegedly based upon the teachings of Hermes Trismegistus.

INCANTATION: words uttered to a deity or spirit to produce a particular result.

INDO-EUROPEAN: the family of languages spoken over most of Europe and Asia, up to northern India, which includes Indic (including Sanskrit), Iranian, Anatolian, Armenian, Hellenic (Greek), Albanian, Italic (including Latin and the Romance languages), Celtic, Tocharian, Germanic (including English, German, Dutch and the Scandinavian languages), Baltic and Slavic (including Russian, Czech, Bulgarian and Serbo-Croat).

INITIATION: a ritual to introduce a person to a particular religion or magical path, such as Wicca.

KABBALAH: a mystical Jewish system of thought which seeks to describe the universe as a series of emanations from the mind of God.

LIBATION: a liquid offering poured upon the ground in honour of a deity or spirit.

MAGIC: the act of affecting the world by means of the human will, aided by tools (such as a wand), invocations to spirits or spells.

MAGIC SQUARE: a form of talisman based on letters or numbers.

NEOPLATONISM: the reinterpretation of the philosophy of Plato, conducted by Plotinus in the 3rd century CE.

OCCULT: the idea that there is a secret set of principles beneath reality which can be apprehended by the occult practitioner and used for their advantage.

OUIJA BOARD: a device used to contact the dead or spirits.

PAGAN: a member of a pre-Christian religion in ancient times. Today, the follower of a revivalist spiritual path which worships multiple deities, sometimes known as 'Neo Pagan'.

PALMISTRY: divination of the future or the personality by studying the lines on someone's palm.

PENDULUM: a weight on the end of a chain or string which is used as an oracular device to answer questions.

PENTAGRAM/PENTACLE: a symbol belonging to many historical religions but now primarily adopted by Wicca, in the form of a five-pointed star (pentagram). If the star is contained within a circle, it is known as a pentacle.

QUERENT: someone who asks a question of a diviner or a divinatory system, such as the Tarot.

RITUAL: a form of dramatized ceremony undertaken, for example, in devotional praise of a deity, or to produce a particular magical result.

ROSICRUCIANISM: a 17th-century movement combining occultism, Hermeticism, Jewish mysticism and Christian Gnosticism.

SATANISM: historically a practice devoted to the worship of the Devil, but now more likely to take the form of non-religious activism.

SCRYING: using a dark glass or other methods, such as a pool of ink, to see the future.

SNAKE STONE: a fossilized ammonite used as a protective charm.

SOLSTICE: the two days in the year which have the longest night and the shortest day (winter solstice), and the shortest night and the longest day (summer solstice).

SPELL: a form of ritualized words used to generate a particular magical result, such as a love spell to attract love.

TAROT: dating from the Renaissance, a series of pictorial cards portraying archetypal figures and situations, used to divine the future.

TEMPLARS: a religio-military order dating from the 12th century and active in the Crusades.

THELEMA: a form of occult philosophy made famous by its adoption by Aleister Crowley.

THEORY OF CORRESPONDENCES: lists of magical correspondences between items across various categories, such as links between a star or zodiac sign, herbs, gemstones, animals and deities.

THEOSOPHY: a mystical philosophy dating from the late 19th century and heavily influenced by Eastern thought.

THEURGY: in this context, a form of Neoplatonic magical practice.

VOODOO: one of the religions of the African diaspora, mainly practised in the Caribbean and the southern USA.

WESTERN MYSTERY TRADITION: also known as Western esotericism, a loose set of philosophies which include Neoplatonism, Rosicrucianism, Kabbalism and individual phenomena such as the study of the Tarot.

WICCA: revivalist witchcraft developed primarily in the 1950s in the UK by Gerald Gardner, and taken on by others such as Alex Sanders.

WITCH BOTTLE: an anti-witch device consisting of a bottle filled with urine, needles and pins, in which a witch or their magic could become ensnared.

WITCH TRIAL: the persecution of people accused of practising witchcraft in Europe and the USA from the Middle Ages onwards.

INDEX

A
1734 Tradition 228
AA 144
Adam of Bremen 61
Aesir 62, 64
Agamemnon, Mask of 135
Agrippa, Cornelius 101, 140, 164–8
Aiwass 144, 238
alchemy 6, 11, 72–9, 81, 147, 180, 238
 Greek 10
 Hermeticism 37, 39, 40
 Rosicrucianism 214
almanacs 105
amulets 10, 160, 161
 Anglo-Saxon 16–17, 176–7
 Egyptian 9, 27, 170–1, 190
 Elizabethan 184–7
 Greek 30, 31, 34, 172–3, 174
 Norse 65
 Roman 44, 45, 46, 174–5, 196
 witchcraft 83
Amun-Ra 125
angels 40, 52, 140, 146, 147, 164, 168, 179, 180, 206
 Angelic Script 165
 Kabbalah 70
Anglo-Saxons 6, 10, 54–9, 155
 amulets 16–17, 176–7
 curses 198–9
 rituals and rites 138–9
 snake stones 176–7
ankh 27, 170, 171
Anubis 22, 23
Aphrodite 32, 157
apkallu 20
Apollo 32, 42, 43, 131, 133
Apuleius 28, 29, 46
Ares 30, 32, 42
Aristotle 74, 94, 95, 96, 165
Artemis 131, 133, 157
Arthur, King 241
Asclepius 23
Asgard 62
Ashmole, Elias 214, 217
Assyria *See* Mesopotamia
Astaroth 204
Astarte 19, 204
astral plane 70
astrology 6, 8, 11, 81
 Arabic 95, 101, 103
 Behenian (fixed) stars 101, 102
 decans 90, 95
 doctrine of correspondences 39, 101, 164–6
 Egyptian 9, 27, 90–3
 Golden Dawn 147
 Greek 9, 10, 94–5, 101
 grimoires 101, 102–3, 179, 180
 herbs and 101, 102, 164, 168
 Hermeticism 37, 40
 horary 105
 houses 95, 141
 Kabbalah 70
 Mesopotamian 9, 20, 90, 95
 natal 90, 95, 104–5, 141
 Renaissance 40, 100–5, 141
 rising sign 95
 Roman 46
 Tarot and 108
 zodiac 90–2, 95, 105, 141, 165
astronomy 56, 92–3, 105, 147, 233, 234, 242
athame 147
Athelstan, Code of 58
Athena 32, 42
Atlantis 225, 238
augurs 46
Avebury 232–3
Avicenna 74, 75

B
Baal 19
Babalon 226
Babylonia *See* Mesopotamia
Bacon, Roger 74
Balder 56, 62
Bald's Leechbook 56
Baphomet 152, 154, 213
bards 50
Barrett, Francis 179
Bastet 91
Beelzebub 19, 152, 153, 204
Bembo, Bonifacio 106, 109
Berossus 95
Besant, Annie 224
Bible 96, 202
binding spells 30, 45, 190, 195, 197, 202
Black Books 56, 180, 183
black magic 6, 9, 21, 32, 40, 152, 219
Black Mass 142–3, 152–3
black mirrors 118–19
Blackwood, Algernon 220
Blavatsky, Helena 224–5, 238
Bond, Elijah 113
Bone, Eleanor 228
Book of the Dead 24
Boudicca 50
Bourne, Lois 228
Brahe, Tycho 104, 105
Bride 52–3
Brocken 244–5
Buckland, Raymond 228
Budapest, Zsuzsanna 228
Burney Relief 16

C
calendars 27, 141, 154, 155
canopic jars 124
Cardano, Girolamo 105
Celts 6, 10, 48–53, 147, 155
Cernunnos 49
Cerridwen 157
chakras 70
Champollion, Jean-François 35
charms 160, 162–3
 Anglo-Saxons 56, 59, 138–9
 Assyrian 21
 Chinese 160, 163
 Egyptian 9, 27, 170–1
 Greek 30, 34, 35, 172–3
 Islamic 161
 Merseburg 56
Charon 134–5
Chaucer, Geoffrey 74, 105
cheiromancy 96
Chevreul, Michel Eugène 116
China 160, 163, 169
 alchemy 72, 74
 I Ching 108, 109
 oracle bones 118
 palmistry 96
 pendulum divination 116
 planchette writing 112–13
chirology 96
Christianity 11
 Anglo-Saxons 56, 59, 139, 177
 Black Mass 142–3
 charms and amulets 160, 161
 Druidry and 50
 Freemasonry 11
 Glastonbury 240–1
 Gnosticism 11
 heresy 82, 84, 87, 105
 Hermeticism 11, 40
 Knights Templar 82, 152, 212–13
 magic opposed by 81–7, 105, 113, 115, 116, 140
 mysticism 147
 Norse occultism 62, 65
 Rosicrucianism 11
 sephirotic 69
Chumbley, Andrew 181
Circe 32, 81
Cnut (Canute) 57
Cochrane, Robert 155, 228
Coffin Texts 24, 25
coins 160, 174, 184, 187
correspondences, doctrine of 39, 101, 164–9, 179, 198
Court de Gébelin, Antoine 106
covens 82, 155, 156, 219, 228
crop circles 233
Crowley, Aleister 6, 11, 70, 71, 108, 144–5, 220, 223, 226–7, 228, 237, 238
Crowther, Patricia 228
Crusaders 161
Crusades 213
crystal ball 118–19
Cuchulain 50
cunning folk 81, 87, 177, 228
curses
 curse dolls 83
 curse tablets (*defixiones*) 10, 30, 35, 45, 190, 194–7
 Druidry 50
 Egyptian 9, 27, 190–1
 Greek 10, 30, 35, 194–5
 Mesopotamian 192–3
 removal 81
 Roman 196–7
 Saxon and Viking 198–9
 Voodoo 208–9
 witch bottles 200–1
Cyprianus 180, 205

D
Dagda 53
D'Arpentigny, Casimir Stanislas 96
Dashwood, Sir Francis 219
decans 90, 95
Dee, John 105, 118, 180, 187, 206
defixiones 10, 30, 35, 45, 190, 194–7
degree ceremonies 11, 155, 226
Demeter 128–9, 132
demons and demonology 9, 81, 152, 180–1, 183, 202–7
 Anglo-Saxon 56
 binding 202
 classification 204
 Greek 29, 34, 195, 202
 Medieval Europe 81, 82
 Mesopotamia 18, 19
 Renaissance 140, 194
 summoning 6, 29, 35, 40, 82, 140, 179, 180, 202–7
Devil-worship 245
 See also Satanism
Diana 32, 155–7
Dianic Wicca 155, 228
Diodorus Siculus 50

Diogenes Laertius 50
Dionysus 173, 174
Dis 53
Discourse on the Eighth and Ninth 41
Discovery of Witches 84
divination 8, 9, 16, 19, 20–1, 81, 147
 Anglo-Saxons 59
 astrology *See* astrology
 dowsing 114–15, 116–17
 Druidry 50
 I Ching 108, 109
 molybdomancy 180
 Norse 62, 64, 65, 98–9
 oracle bones 118
 Ouija boards 112–13
 palmistry 96–7
 pendulums 115, 116–17
 planchette writing 112–13
 runes 62, 65, 98–9
 scrying 118–19, 147
 Tarot 8, 70, 106–11
 Voodoo 150
dolls and figurines 20–1
 execration 126, 190–1
 Greek 30
 Roman 44, 45
 Voodoo 150, 208–9
 witchcraft 83
dowsing 114–15, 116–17
Dragon Rouge 181, 183
dream interpretation 19, 56
Druidry 6, 11, 48–50, 161, 217, 234

E
earthworks 233, 234, 242–3
Edgar, canon law edict 57
Egyptians 6, 8, 9, 11, 22–7, 30, 72, 144, 146–9
 astrology 9, 27, 90–3
 charms and amulets 9, 27, 170–1, 190
 curses 9, 27, 190–1
 gods and goddesses 9, 22, 23–4, 25, 90, 91, 122, 124–5, 126
 Greco-Roman 10, 35, 41
 mummification 122–4, 127, 170, 239
 Pyramids 236–9
 rituals and rites 122–7, 170
 sacrifice 125–6
 scrying 118
Eiximenis, Francesc 168
Eleisinian mysteries 128–9, 219
elements 74, 78–9, 97, 155, 166, 229
elf shot 34, 35
elixir of life 74

Emerald Tablet 37, 38–9, 76
Empedocles 32
enchantment 10, 45, 54
Eric Bloodaxe 59
Esus 50
eternal life 27, 72, 74, 77
Evil Eye 44, 45, 172, 173, 190
execration 126, 190–1
exorcism 9, 18, 19, 46
Eye of Horus 26, 27
Eye of Providence 11

F
familiars 46, 80, 82, 84
Farr, Florence 147, 223
Farrar, Stuart and Janet 228, 229
fertility 9, 27, 62, 132, 170, 173
Ficino, Marsilio 37, 74, 105, 140
figurines *See* dolls and figurines
Fludd, Robert 74, 214
Fortune, Dion 6, 11, 238
fossils 177
Fraternitas Saturni 152
Freemasonry 6, 11, 40, 106, 152, 155, 214, 216–17, 219, 223, 226, 228
Freyja 56, 62, 63, 64
Freyr 62, 63
Frigg 62
funeral rites 122–5, 127, 134–5
Fylgjur 62

G
Galdrastafir 65
Ganesha 160
Gardner, Gerald 155, 181, 223, 228–9
Gaucher, André 148
Germer, Karl 226
ghosts 9, 18, 30, 54
Gilgamesh 19
Giza 236–9
Glastonbury 240–1
Gnosticism 11, 143, 214
Gnostic Mass 226
gods and goddesses
 Anglo-Saxon 56, 139, 177
 binding 30
 Celtic 49, 50, 52–3, 155
 Egyptian 9, 22, 23–4, 25, 90, 91, 122, 124–5, 126, 144, 148–9, 155, 170, 190, 226
 Greek 28, 32, 128–9, 132–3, 152
 Irish 53
 Mesopotamian 16–19, 192
 Norse 62–3, 64, 155

Roman 42–3, 45, 136
 sacrifices to *See* sacrifice
 Saxon 155
 Wiccan 154–5
goetia 28, 30–1, 35, 40, 180–1
Golden Dawn, Hermetic Order of 6, 11, 70, 71, 108, 144, 155, 214, 215, 217, 220–3, 238
 rituals and rites 146–9, 223
golem 66
gorgoneion 172, 173
Gray, William 6
Greek Magical Papyri 10, 34–5, 72, 179
Greeks 6, 8, 10, 11, 28–35, 72, 156
 amulets 30, 31, 34, 172–3, 174
 astrology 9, 10, 94–5, 101
 curses 10, 30, 35, 194–5
 gods 8, 9, 30, 32, 42, 128
 Hades (underworld) 32, 33, 42
 Hermeticism 36–7
 palmistry 96
 poppets 30
 Pythian Oracle 116
 rituals and rites 128–35
 scrying 118
grimoires 6, 19, 28, 140–1, 143, 178–83
 alchemy 180
 Black Books 56, 180, 183
 Cyprianus 180, 205
 demonology 202, 204–7
 Grimoire Verum 204
 Key of Solomon 11, 146, 147, 180, 182, 202
 Lesser Key of Solomon (Lemegeton) 35, 180
 Picatrix 101, 102–3, 179
gris gris 209
Grosche, Eugen 152
Gwydion 53

H
Hades 32, 128–9, 132–3
Hadit 226
Halley's Comet 56, 242
Hammurabi, Code of 192, 193
hamsa 162, 163
Hand of Glory 181
Harald II 56
Hathor 122, 123, 144
Hathorne, Judge John 246
'Hávamál' 98, 99
healing magic 9, 19, 32, 46, 50, 81, 174, 184

amulets 161
 Anglo-Saxon 56, 176–7, 198
 doctrine of signatures 74, 75
 Egyptian 27
 Greek 31
 Merseburg Charm 56
 Spagyric medicine 77
Hebrew alphabet 66–7, 106, 147
Heimdall 62
Heka 9, 23–4, 27
Hekate 32, 44, 45
Hellfire Club 218–19
Hera 32
herbs
 amulets 161
 Anglo-Saxons 56
 astrology and 101, 102, 164, 168
 beekeeper's herb 101
 doctrine of correspondences 164, 168–9
 Druidry 50
 Greeks 32
 Nine Herbs Charm 56
 Norse 65
 Romans 47
 Sumerian 19
 witchcraft 81, 82
heresy 82, 84, 87, 105
Hermes 32, 37, 96
Hermes Trismegistus 9, 37–9, 95, 106
Hermeticism 6, 11, 36–41, 95, 144, 214, 223, 225, 226
 astrology 37, 40
 Emerald Tablet 37, 38–9, 76
 Golden Dawn 6, 11, 70, 71, 108, 144, 146–9
 Prayer of Thanksgiving 41
 Renaissance 40–1, 140
 Tarot 106
Hermetic Order 220
Herodotus 125–6
Hexentanzplatz 245
hexes *See* curses
Hod 62
Holy Grail 213, 241
Homer 32, 135
Honorius 165, 180, 182
hoodoo 249
Hopkins, Matthew 84
horned god 154–5, 157, 228
Horniman, Annie 223
horoscopes 90, 141
Horus 23, 26, 190, 226, 238
Humanism 40
Huysmans, Joris-Karl 143

INDEX

I
Ibn Fadlan 61
I Ching 108, 109
ideomotor response 113, 115, 116
Iduna 63
impetrations 20
incantations 24, 30, 31, 32, 35, 46, 140, 161, 173, 174
India 169, 225
 alchemy 72
 astrology 95
 nauratan 161
 Nazar battu 152
 palmistry 96
initiation rites 11, 41, 46
Irpa 56
Ishtar 19
Isis 22, 23, 26, 124, 148–9, 238
Islamic occultism 39, 81, 168
 alchemy 72, 74, 75
 astrology 95, 101, 103, 179
 charms 161
 Emerald Tablet 38–9
 Picatrix 179

J
Jābir ibn Hayyān 74
Japan 109, 118, 160, 161, 162, 163
Judaism 30, 40, 42, 66–71, 160, 163, 180, 214
Jupiter 42

K
Kabbalism 11, 40, 65, 66–71, 108, 144, 147, 180, 219, 223
Kellner, Carl 226
Kennard, Charles 113
Kepler, Johannes 105
Key of Solomon 11, 146, 147, 180, 182, 202
Khephra 144
Khoiak 148
Kibbo Kift 155
King's Evil 184, 186
Kingsford, Anna Bonus 220
Kircher, Athanasius 39
Kitâb sirr al-Halîka 39
knots 26, 30, 160, 161
kolossoi 30
Kramer, Heinrich 84

L
Lacnunga 56
lamassu 21
lamella 31, 34, 174
Laveau, Marie 249
LaVey, Anton 152
Lavoisier, Antoine 78
La Voisin 142, 143
Leland, Charles 156
Lesser Key of Solomon (Lemegeton) 35, 180

Lévi, Éliphas 6, 47, 70, 71, 146, 147, 152
leylines 233
Liber XV 226
Library of Alexandria 72
Library of Ashurbanipal 19
Lilly, William 104, 105
Loki 62, 63, 139
lost objects, locating 64, 81, 116
love charms and spells 27, 28, 30, 35, 46, 70, 81, 140, 163, 166
Lucan 50
Lucifer 152, 204
lucky charms 160, 162–3, 174
Lupercalia 136

M
Ma'at 24, 25
Mabinogion 53
Machen, Arthur 220
magic 8, 9
 high 8, 28, 32, 40, 140, 180
 low 8, 28, 30–1, 35, 40, 140, 180–1
magic squares 168, 169
magos 10, 45
magus 45
Maier, Michael 214
maleficum 81
Malkuth 69, 70, 147
Malleus Maleficarum 84, 140
Mannus 56
manus fica 45, 173
maqlû 20–1
Marduk 17, 18, 20
Mars 42, 166–7
Masters of the Ancient Wisdom 225
Mathers, Moina 148
Mathers, Samuel MacGregor 147, 148, 220, 223
Matres (Matronae) 53
Medea 81
Medicinale Anglicanum 56
mediumship 46, 64, 112–13
Mellet, Comte de 106
memento mori 184, 187
Mercurius Trismegistus 36
Mermet, Abbé 116
Merrill, James 113
Mesopotamia 9, 16–21, 81, 179
 astrology 9, 20, 90, 95
 curses 192–3
 gods 16, 17, 18, 19, 20
 palmistry 96
metaphysics 77, 214
Michelet, Jules 143
Midgard 62
milagros 162, 163
mind map 70
Minerva 42, 197

Minerval ritual 144, 223
Mithras 35, 42, 43
Moloch 19
molybdomancy 180
moon 32, 38, 69, 156–7, 168, 228
 See also astrology
 Drawing Down 156–7
Morrigan 53
mummification 24, 122–4, 127, 170, 239
Mut 125
Mynsicht, Adrian von 214
mysticism 147, 233
 Christian 147
 Kabbalah 66–71
 Nostradamus 118
 Rosicrucianism 214–15

N
Nag Hammadi 40–1
natural magic 6
natural philosophy 37
Naudé, Gabriel 214
necromancy 10, 81, 140, 181
Neith 124
Neoplatonism 11, 140, 164, 225
Nephthys 124
Neptune 42
New Orleans 150–1, 208–9, 248–9
Newton, Sir Isaac 77, 238
Njord 62
Nodens 53
Norns 62
Norse occultism 6, 10, 11, 61–5, 155
 curses 198–9
 runes 62, 65, 98–9
Nostradamus 118
Nosworthy, Helen Peters 113
Nuit 226
Nut 90

O
occult, meaning 6
Odin *See* Woden
Olcott, Henry Steel 225
Oluf Olufsen Bagge 60
Opening of the Mouth 122, 125
Oracle, Pythian 116
oracle bones 118
Ordo Templi Orientis 11, 144–5, 217, 223, 226–7
Osiris 22, 23, 24, 93, 126, 148–9, 238
Ouija boards 112–13

P
Paganism 11, 40, 53, 59, 154–7, 160, 233, 234, 241, 245, 247

palmistry 96–7
Pan 8, 152
Paracelsus 40, 74, 77, 78
peeping *See* scrying
pendulum divination 115, 116–17
pentagram/pentacle 147, 155, 160, 166, 229
Persephone 45, 128–9, 132–3
Petit Albert 181
phallic amulets 44, 45, 132, 173, 174–5
Philosopher's Stone 74, 78
Picatrix 101, 102–3, 179
Pico della Mirandola, Giovanni 40, 105, 180
planchette writing 112–13
planets 69, 70, 74, 77, 78, 101, 164, 166, 168
 See also astrology
Plato 32, 41, 95
Pliny the Elder 46, 160, 161, 164, 165, 173, 179
poisons 10, 45, 54, 83
poppets *See* dolls and figurines
possession 64, 249
precognition/prediction 32, 46, 64
 See also astrology; divination
 augurs 46
 omens 56
prehistoric paintings 9
Preisendanz, Karl 35
prisca theologia 40–1
prophylactics 18
protective (apotropaic) magic 9, 45, 47, 139, 161, 163, 172, 173, 174, 245
 See also amulets
protective eye 160
witch bottles 200–1
Przybyszewski, Stanisław 152
Psyche 33, 134
Ptolemy 90, 94, 95, 101, 103, 105
Pure Will 226
Pythagoras 11, 32

Q
Qin Shi Huang 74
Queen of the Night 16

R
Ra 144
radiesthesia *See* dowsing
Ran 56
Reclaiming 229
reincarnation 40, 50
religion *See also* Christianity; Judaism
 syncretism 35, 37, 40, 41, 209

Renaissance
　alchemy 74
　astrology 40, 100–5, 141
　grimoires 140–1, 179, 180
　Hermeticism 40–1, 140
　Neoplatonism 11, 140, 164
　rituals and rites 140–1
　Tarot 106–7
Reuss, Theodor 226
Rhiannon 53
Rhodes, H.T.F. 143
Rig 56
right and left hand paths 225
Ripley, George 74, 75
rituals and rites
　Black Mass 142–3
　Egyptian 122–7, 170
　Golden Dawn 146–9, 223
　Greek 128–35
　initiation 11, 41, 46
　Ordo Templi Orientis 226
　Renaissance 140–1
　Roman 136–7
　Satanism 152–3
　Saxon 138–9
　Thelema 143, 144–5
　Voodoo 150–1
　Wiccan 154–7, 181
Robert of Chester 74
Romans 10, 42–7
　amulets 44, 45, 46, 174–5, 196
　curses 196–7
　gods 42–3, 45, 136
　poppets 44, 45
　rituals and rites 136–7
Rosicrucianism 6, 7, 11, 40, 95, 214–15, 217, 220, 221, 223, 228
Rosslyn Chapel 213
runes 62, 65, 98–9, 177
　Runes of Honorius 165

S
Sabbat 82, 155, 157, 181, 229
sacrifice
　Celts 50, 51, 53
　Egyptians 125–6
　Greeks 132
　grimoires 180
　human 50, 51, 54, 61, 206
　Mesopotamians 18, 19, 193
　Norse 61
　Romans 136–7
　Saxons 53, 59, 139, 245
　summoning demons 206
Sade, Marquis de 143
Saladin 144
Salem 84–5, 87, 241, 246–7
Sámi shamans 87
Sanders, Alex 155, 228
Santeria 150–1
Satanism 6, 113, 142–3, 152–3
scapegoating 18, 130–1

scarab 27, 170, 172–3
scrying 118–19, 147, 187
seances 113
Seaxneat 56
Seax-Wicca 228
Secret Chiefs 220, 223
Sedona 241
seers 19, 54, 64–5
seidre 64
Sekhmet 22, 23, 190
Selket 124
sephiroth 68–71
Serpent Mound 242–3
sex magic 144
shamanism 87
shapeshifting 62
Shaw, George Bernard 220
sigils 204, 206–7
signatures, doctrine of 74, 75
Silbury Hill 233
Sleipnir 62
Smaragdum Thallasses Temple 223
Snorri Sturluson 61, 64
Solomon, King 11, 35, 146, 147, 179–80, 182, 202–3, 213
Spagyric medicine 77
spells 6, 9, 10, 27, 28, 30, 34
　See also charms; grimoires
　alchemical 77
　Egyptian 26, 27
　Greek 30, 32, 34, 35
　Roman 46
Sphere, the 147
Sphinx 237
spirits
　Roman lares 136
　summoning 6
　Voodoo 150–1
Spiritualism 225
spiritus mundi 164
Sprengel, Anna 220
Starhawk 229
Stella Matutina 222, 223
Stoics 95
Stonehenge 234–5
stones
　bloodstones 161
　gemstones 39, 101, 163, 164, 168, 170, 172, 173, 177, 184
　hagstones (adder stones) 160, 177
　henges 232–5
　snake stones 176–7
Strabo 50
Sumer See Mesopotamia
sun 38, 69
　See also astrology
suovetaurilia 136–7
symbols 160, 162–3
　alchemical 78–9
　runes 62, 65, 98–9

sympathetic magic 9, 126, 206
syncretism 9, 35, 37, 40, 41, 209

T
Tacitus 49, 50, 54
talismans 140, 160, 161, 172, 179
　astrological 102, 105
　doctrine of correspondences 168
Taoism 72, 163, 226
Taranis 50
Tarot 8, 70, 106–11, 147, 219
Templars 82, 152, 212–13, 217
Teutates 50
Thelema 143, 144–5, 226
Theosophy 6, 7, 11, 144, 155, 220, 224–5, 237, 238
Thesmophoria 132–3
theurgy 28, 32, 40, 180
Thor 62, 63, 65, 177
Thoth 26, 37, 72, 74, 106, 108, 190
Thunor 56, 139
Tiamat 17
totems 9, 242
trance mediumship 46, 64, 118, 156–7
treasure, locating 28, 81, 114–16, 140, 180
Tree of Life 68–71
trees 49, 59, 60, 62, 138, 139, 241
Trewythian, Richard 105
Tuisto 56
tumi 162, 163
Typhon 45
Tyr 62

U
unconscious, accessing 118
underworld
　Egyptian 122, 170
　Greek 32–3, 42, 128–9, 132–5, 195
　Mesopotamian 17
　Roman 45
Unicursal hexagram 214
Uvall 34, 35, 35

V
Vaettir 62
Valcourt-Vermont, Edgar de 96
Valiente, Doreen 155, 228
Valkyries 62
Valmiki 96
Vanaheim 62
Vanir 62, 64
Venus 136–7, 166–7
Vikings See Norse occultism
Virgil 46–7

visualization 11
volvas 64–5
Voodoo 150–1, 181, 208–9, 248–9
votive offerings 162, 163

W
Waite, Arthur 108
Walpurgisnacht 245
Wandering Princes 204
Warner, William John 96
Westcott, William 147, 220
Western Esotericism 11, 14–87
West Kennet Long Barrow 233
Westlake, Ernest 228
Whare Ra 223
Wharton, Duke of 219
Wicca 6, 11, 54, 223, 228–9
　rituals and rites 154–7, 181
wicker man 50, 51
Wilson, Colin 6
witch bottles 200–1
witchcraft 6, 8, 80–7, 116, 140, 178, 228–9
　Anglo-Saxons 54, 57, 58–9
　Brocken 244–5
　cauldrons 83
　Greeks 81, 156, 172
　herbs 81, 82
　Islamic 81
　Mesopotamia 81
　New Orleans 249
　Romans 81
　water witching 114–15
　witch's sabbath 82
　witch trials 81, 82, 84–7, 246–7
witch pins 85
witch's ball 83
Woden (Odin) 54, 55, 56, 62, 63, 64, 98, 99, 139
Woodcraft Folk 228, 229
Woodman, Dr William 147, 220
words
　doctrine of correspondences 168–9
　Kabbalism 66–7
　magic 46, 50, 172
　written backwards 197

Y
Yeats, W.B. 113, 147, 220
Yezidi 152
Yggdrasil 60, 62

Z
Zeus 32, 42, 128
zodiac 90–2, 95, 105, 141, 165
Zosimus of Panopolis 74

PICTURE CREDITS

T = top, B = bottom, L = left, C = centre, R = right

The publisher would like to thank the following for the permission to reproduce copyright material.

Alamy: 7 Charles Walker Collection; 11CL Andia; 24–25 Art Collection 2; 28 Abbus Acastra; 38 Heritage Image Partnership Ltd.; 39 Album; 43T Old Images; 54 Lamas; 55B World History Archive; 62BR PhotoStock-Israel; 63T Ivy Close Images; 71BL Charles Walker Collection; 83CR Heritage Image Partnership Ltd.; 83BL Steve Speller; 87BR INTERFOTO; 96 The History Collection; 131CR Penta Springs Limited; 134 Artefact; 141 R J Marshall - Tribaleye Images; 145 Associated Press; 148TR The Picture Art Collection; 150TL ivancana/Stockimo; 150CR Buddy Mays; 156CR The Picture Art Collection; 162CL dpa picture alliance; 165BR AF Fotographie; 179 Album; 181BL Charles Walker Collection; 183B Chronicle; 203 BTEU/RKMLGE; 206 Z4 Collection; 208BL David Leduc/Stockimo; 211 Colin Waters; 216TR Classic Image; 218B Antiqua Print Gallery; 220BL Album; 220BC The Picture Art Collection; 223 The Picture Art Collection; 224CR Skimage; 224BL Science History Images; 229BL Trinity Mirror/Mirrorpix; 231 Science History Images; 232T Chronicle; 238 Science History Images; 240BR Iain McCallum; 243BL Alpha Stock; 243BR Reading Room 200; 244TR Historical Images Archive.

Bridgeman Images: 37 Photo © Christie's Images; 199 Canterbury Cathedral Archives; 221.

Dreamstime: 18BR Michelle Bridges.

Getty Images: 11TR Heritage Images; 21 duncan1890; 31B Sepia Times; 33 Grafissimo; 46TL PHAS; 46TR Print Collector; 69CR Culture Club; 71TR Culture Club; 71BR Keystone; 76 Fototeca Storica Nazionale; 82 Design Pics Editorial; 83TL DEA/A. DAGLI ORTI; 89 Universal History Archive; 92BL Science & Society Picture Library; 93TR duncan1890; 94CL Print Collector; 117B Keystone-France; 129CL Florilegius; 136–137 mikroman6; 146CL Heritage Images; 161TR Heritage Images; 162BR Print Collector; 178 Heritage Images; 182T Heritage Images; 184 Universal History Archive; 185 Culture Club; 189 Universal History Archive; 193BL Kean Collection; 212T Hulton Archive; 216TL/CL/CR/BL/BR Universal Images Group; 224TR Ziegler; 239BL Heritage Images; 244B Bildagentur-online.

iStockphoto: 22 ZU_09; 56 duncan1890; 58CL duncan1890; 77BL ilbusca; 109TR/C/CR theasis; 112CR ilbusca; 130 ilbusca; 159 ilbusca; 177C ilbusca; 240CL duncan1890; 245 yuelan; 248BR benoitb.

Library of Congress, Washington, D.C.: (Public Domain) 5BC; 77CL; 85CR; 94TL; 102; 104T, 156TR; 236TR; 239CR.

The Metropolitan Museum of Art, New York (Public Domain): 9 The Cesnola Collection. Purchased by subscription, 1874–76; 18 (all) Purchase, 1886; 25CR Rogers Fund, 1932; 26 Purchase, Edward S. Harkness Gift, 1926; 44BR Gift of Miss Helen Miller Gould, 1910; 91TR/BR Rogers Fund, 1948; 118 Rogers Fund, 1909; 122–123 Rogers Fund, 1933; 123CL Fletcher Fund, 1919–1920; 124T Rogers Fund, 1935; 124B Gift of Theodore M. Davis, 1910; 127TC Rogers Fund, 1913; 127TR Gift of George D. Pratt, 1922; 127BL/BC/BR Gift of James Douglas, 1890; 129BR Rogers Fund, 1914; 133T Gift of Miss Matilda W. Bruce, 1907; 133B Fletcher Fund, 1928; 148BC Rogers Fund, 1961; 148BR Gift of J. Pierpont Morgan, 1917; 152 Purchase, Gifts of Irwin Untermyer, Ogden Mills and George Blumenthal, Bequest of Julia H. Manges and Frederick C. Hewitt Fund, by exchange; and Rogers and Pfeiffer Funds, 1982; 162CR Jan Mitchell and Sons Collection, Gift of Jan Mitchell, 1991; 171TL Theodore M. Davis Collection, Bequest of Theodore M. Davis, 1915; 171TR Gift of J. Pierpont Morgan, 1917; 171CL Gift of Mr. and Mrs. V. Everit Macy, 1923; 171CR Rogers Fund, 1936; 171BL Gift of Darius Ogden Mills, 1904; 171BR Purchase, Edward S. Harkness Gift, 1926; 172TR The Cesnola Collection, Purchased by subscription, 1874–76; 172CL Purchase, Schultz Foundation and Abraham Foundation Gifts, 1999; 172CR Gift of Miss Helen Miller Gould, 1910; 175CL Gift of A. Hyatt Mayor, 1960; 175CR Gift of Joseph H. Durkee, 1899; 187CL Robert Lehman Collection, 1975; 187BL/BCL Gift of J. Pierpont Morgan, 1917; 191C/CR Rogers Fund, 1933; 202 Gift of Nelly, Violet and Elie Abemayor, in memory of Michel Abemayor, 1978.

Shutterstock: 5BR Hein Nouvens; 15 Prachaya Roekdeethaweesab; 16 Tony Baggett; 17TR tolobalguer.com; 20 Fedor Selivanov; 23 EvrenKalinbacak; 27 Oksana Galiulina; 59 Morphart Creation; 63TL/CR Morphart Creation; 67 rizal2018; 83BR Kei Shooting; 92–93TL/CR hembro; 93CR hembro; 110–111 Roman Sibiryakov; 150BL Taigi; 150BR mikeledray; 161TCR Squeeb Creative; 162TL dimitris_k; 162TR Sunny_baby; 162BL Mega Pixel; 176TL Morphart Creation; 187TL Sponner; 193TL Dima Moroz; 212B garanga; 226 S and S Imaging; 232BL Kevin Standage; 235BL/CR/BR Hein Nouwens; 236CL ImAAm; 247TR Everett Collection; 248T Everett Collection.

Shutterstock Editorial: 229BR ANL.Collection. Public

Wellcome Collection Attribution 4.0 International: 44TL; 186; 187BR; 169BL; 182B.

Wellcome Collection Public Domain Mark: 78R; 80; 104CR; 114; 140; 154BL; 163; 183T; 205T.

Wikimedia Commons (Public Domain): 10; 17B; 19; 31T; 34CR; 36; 40; 41; 43B; 44CL; 45; 47; 48; 49; 51; 52; 53CR; 55T; 57; 60; 61; 62TR; 63CL; 63BL; 63BR; 64; 66; 68; 69BR; 71TL; 72; 73; 84; 85T; 85CL; 86; 87BL; 90–91; 91TL; 91BC; 94CR; 98; 100; 103T; 103B; 106, 107; 109TC; 109BR; 112TL; 112B; 115; 119; 121; 125; 129T; 132; 135CR; 135B; 138, 139; 141CL; 142; 143; 144; 146TC; 146BL; 149; 150TR; 153; 154BR; 156TL; 161BR; 165T; 165CL; 166; 167; 169TL; 169BR; 175T; 176; 180BL; 191BL; 194; 196TR; 196CR; 196BL; 204; 218TL; 219; 220BR; 227TR; 229CR; 235T; 239TL; 240TL; 243TR; 246BL.

Wikimedia Commons (No Known Copyright Restrictions): 29; 97; 123BR; 181BR.

Wikimedia Commons (Creative Commons)
CC BY 2.0 Generic: 109BL Photograph by Elstner Hilton, posted to Flickr by A. Davey; 146BR Julian P Guffogg.
CC BY-SA 2.0 UK: 200TL David Jackson.
CC BY-SA 2.0 Generic: 8 Carole Raddato; 137TR Russell-Cotes Art Gallery & Museum; 150CL Claudia Brooke; 187CR The Portable Antiquities Scheme/The Trustees of the British Museum; 196BR The Portable Antiquities Scheme/The Trustees of the British Museum; 200TR Hadley Paul Garland;
CC BY 2.5 Generic: 104CL © Marie-Lan Nguyen/Wikimedia Commons; 132CR Marie-Lan Nguyen (User: Jastrow), 2007; 196TL Marie-Lan Nguyen.
CC BY 3.0 Unported: 164 Johann Friedrich Christ.
CC BY-SA 3.0 FR: 25TR Rama (30 Giovanni Dall'Orto; 192 Rama.
CC BY-SA 3.0 Unported: 42 Asram; 43BL Wolfgang Sauber; 44BL Walters Art Museum; 83TR Malcolm Lidbury (aka Pinkpasty); 83CL Malcolm Lidbury (aka Pinkpasty); 200BR Malcom Lidbury (aka Pinkpasty); 208TL Claude Truong-Ngoc/Wikimedia Commons.
CC BY-SA 4.0 International: 44TR Dosseman; 75BC Michael Bakni; 123CR Allan Gluck, permissions ticket #2022102610001032. Manchester Museum AN 6286 (7); 131BL ArchaiOptix; 157 Bloomyjaz; 177TCR Arnold Mikkelsen; 191T U0045269; 196CL Mike Peel; 197 Hchc2009; 200CL Mike Peel; 214 AMORC, Rosicrucian Order/File:Mbstacy_cross.jpg; 232BR Delmar Owen; 246–247 SalemPuritan.
CC BY 4.0 International: 74 Wellcome Images; 75BR George Ripley, 1588. Wellcome Images; 127TL Wellcome Images; 180BR Wellcome Images; 187TR Wellcome Images.

Additional Images: 17CL/168CL/220/229TR Jane Lanaway; 32 Staatliche Museen zu Berlin, Antikensammlung (Berlin State Museums, Collection of Antiquities) (CC BY-SA 4.0 International); 34TL/CL/BL Courtesy of the University of Oslo Library Papyrus Collection (TL: P.Oslo.inv1c01; CL: P.Oslo.inv1c07; BL: P.Oslo.inv1c03); 44CR Image courtesy of the Johns Hopkins Archaeological Museum. Photography by James T. VanRensselaer. Accession Number: 485; 58BL Rochester Cathedral Archives; 65T/TCR/CR National Museum of Denmark. Photographs by Arnold Mikkelsen (CC BY-SA 4.0 International); 75T © J. Paul Getty Trust/The Getty Research Institute (Alchemical Equipment, ca. 1700. From "Traité de Chymie," [Treatise on Chemistry] (France, ca. 1700), pp 10–11. 950053.2); 172TL Getty Museum Collection (Public Domain); 172BL/BR Courtesy: Paphos Agora Project of the Jagiellonian University in Kraków, Poland. Photographs: W. Machowski. Object originally published by Professor Joachim Sliwa; 174 J. Paul Getty Museum (Digital image courtesy of the Getty's Open Content Program/Public Domain); 195 Photograph © Professor Alexander Hollmann; 200CR Photograph © Dr Alan Massey; 200BL Photograph of Civil War Witch Bottle © Robert Hunter; 201 Photograph © Dr Alan Massey; 208TR Yale University Art Gallery (Charles B. Benenson, B.A. 1933, Collection); 208BR Brooklyn Museum (Museum Expedition 1922, Robert B. Woodward Memorial Fund/CC-BY 3.0 Unported); 236BR Boston Public Library via Flickr (CC BY 2.0 Generic).

While every effort has been made to credit photographers, The Bright Press would like to apologize should there have been any omissions or errors, and would be pleased to make the appropriate correction for future editions of the book.

Thanks go to:

Naveh Barlowe; Esther Friesner; Laura Anne Gilman; James Gosling; Alexandra Honigsberg; Rob Rider Hill; Ronald Huttton; Kari Maund; Farah Mendlesohn; David Rankine; Shawna McCarthy; Sef Salem; Lauren Taylor; Carolyn Jones.

And to everyone in the esoteric community who gave up their time to answer questions.